CAPTURE™

Arkansas™

★ Presented by the Democrat-Gazette™

Foreword

It started out as a simple idea, really. We asked Arkansans to submit photos of our state — its beauty, its people and the life that exists within it. What we received was an overwhelming response from more than 1,500 photographers who captured the elements that make Arkansas what it is. Then people from throughout the state told us what they wanted to be included in their book. Through an amazing online community, we collected more than 1.7 million votes that shaped the book you hold in your hands.

This is yours, Arkansas. This is yours in so many ways. Your photos. Your faces. Your votes. Your voices.

The numbers are overwhelming:

1,529 photographers

32,358 photos

1,764,152 votes

This all adds up to what we think could be the best book of photography ever published in Arkansas. In this book you will find eight categories: People, Sports and Recreation, Institutions, Nature, Pets, Newsworthy, Scapes of All Sorts and Everyday Life.

Led by the *Arkansas Democrat-Gazette*, this book and online community was also supported by five local businesses: PC Hardware and Lighting, Deltic Timber, Abry Brothers, Central Arkansas Library Systems and Bedford Camera and Video. We thank them for their support and hope you will, too.

Images can be such a powerful force. Images that you can relate to are even more powerful. Thank you all for making this possible by sharing your creativity and allowing the world to see how truly great Arkansas is.

Have we captured your Arkansas? Turn the pages to find out.

Arkansas Democrat Gazette
Arkansas' Largest Newspaper

ArkansasOnline

Capture Arkansas staff

Arkansas Democrat-Gazette
501-399-3616

The Pediment Group, Inc.
360-687-6731

Promotions Director
Crystal Thurman

President
Brad Fenison

Promotions Manager
Tabitha Cunningham

Online and Creative Director
Chris Fenison

Copy Editors
Tammy Keith and Jeff LeMaster

Book Sales
Crystal Carter

Sales Staff
Marsha Johnson, Megan Rainey,
Peggy Morris and Lisa Williams

Grand prize

The grand prize, provided by Bedford Camera and Video, is a Fuji S100FS Digital camera package. The camera has 11.1 Megapixels, a 14.3X Wide Angle Zoom Lens, a 2.5" LCD Display, and Fuji's Face Detection and Auto Redeye Correct Technology. The prize package also includes a 2GB SD Memory Card, a carrying case and a tripod, and is valued at more than $1,100. The grand-prize winner for Capture Arkansas is:

GINGER'S FALLS *(front cover):* Ginger's Falls pours over pink sandstone, making it not only beautiful, but unique as well. ◉ HAROLD HULL

Table of Contents

About this book.

Capture Arkansas is a one-of-a-kind book project. It started with a simple idea: Lots of folks take lots of pictures of Arkansas — many of which would be worthy of publishing in a fine-art, coffee-table book. Knowing that thousands of photos would be submitted, the question was then posed: How do we pick the best from the rest? The answer was genius. We put the editing power in the hands of the people. Local people. People who know Arkansas. People just like you. Through an immersive online experience, we asked photographers, doctors, union workers, musicians, moms, right-handed people or anyone from any walk of life to vote for what they considered to be the photos that best capture Arkansas. From 32,358 photo submissions to the pages of this book, more than 1.75 million votes helped shape what you hold in your hands. Publishing, by vote. Enjoy it.

How to use this book.

Open. Look at the best pictures from throughout Arkansas. Repeat. Actually, maybe there's a little more to it. First, be sure to check out the prize winners in the back of the book (also marked with a ★ throughout). You'll also want to watch the DVD. It has more than a thousand photos! Here's the caption style so you understand what's going on in each photo:

PHOTO TITLE (location on page): Caption, mostly verbatim as submitted. 📷 PHOTOGRAPHER

Copyright info.

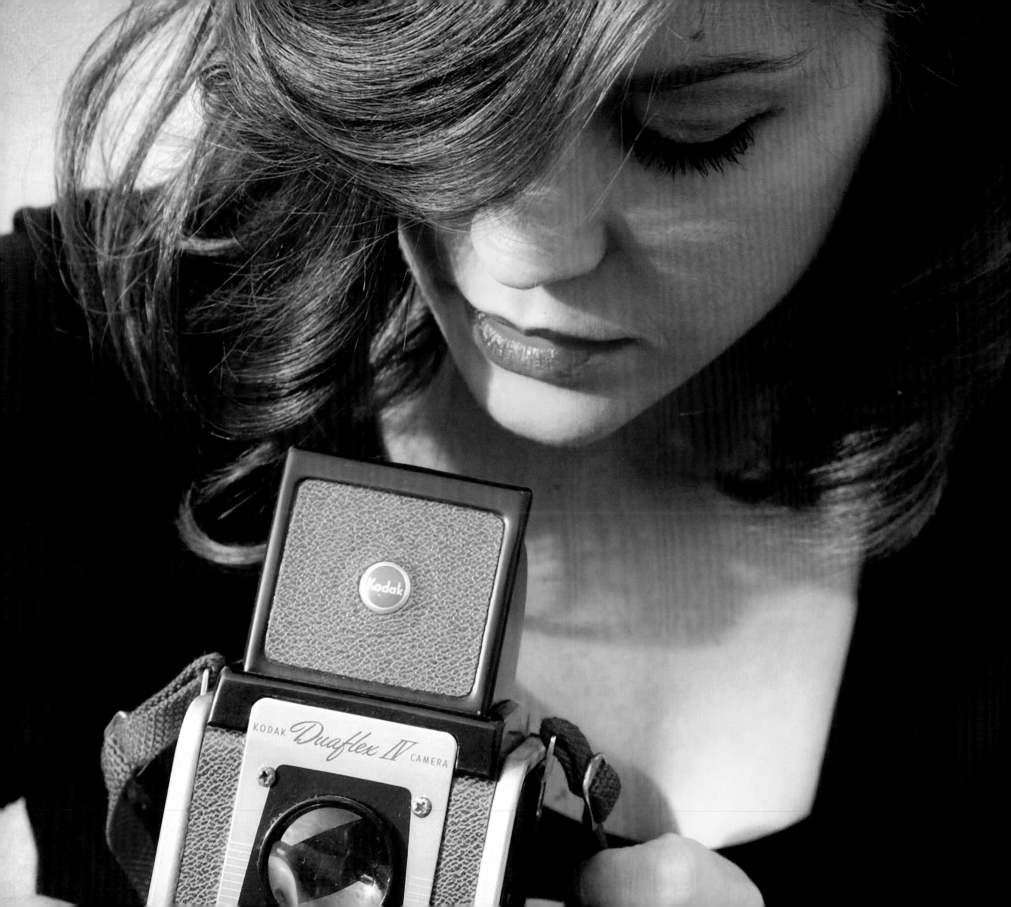

People

The images that impact us most are those that present the faces of our communities. We are inspired by the beauty and emotion that these photos capture. From the joy shining through a young boy's eyes to the history wrapped within the lines of an old man's wrinkles, the stories of life unfold within the pages of the People chapter.

Carefree children portray uninhibited happiness. They show the jubilation of sunny spring days and willingly embrace early milestones by blowing out candles on a birthday cake.

Three sisters share a laugh that almost made us cry. One older gentleman, puffing on his pipe and perhaps reflecting on days gone by, causes us to ponder the stories he could tell.

From young to old, joyful to serious, as you turn the page, allow these people a chance to speak to you as they have to us.

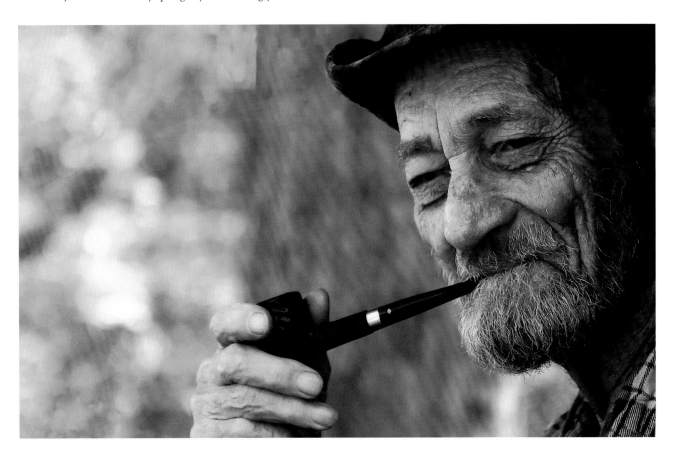

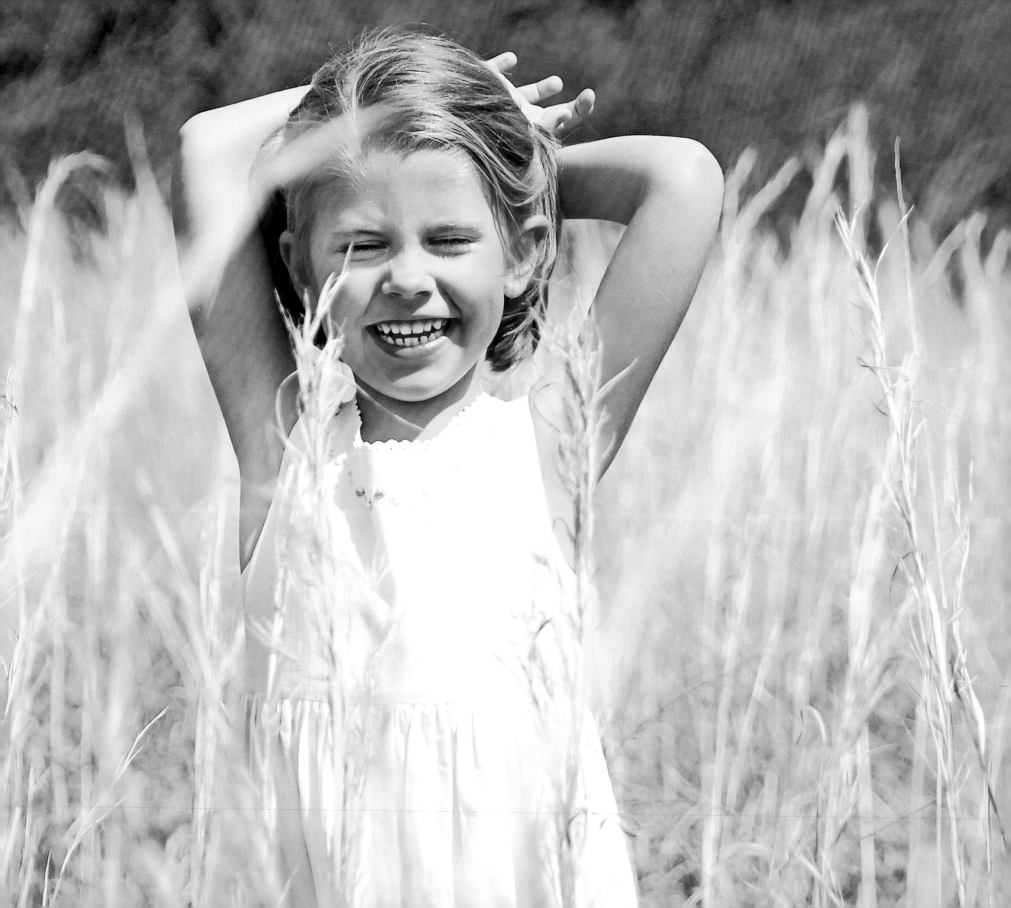

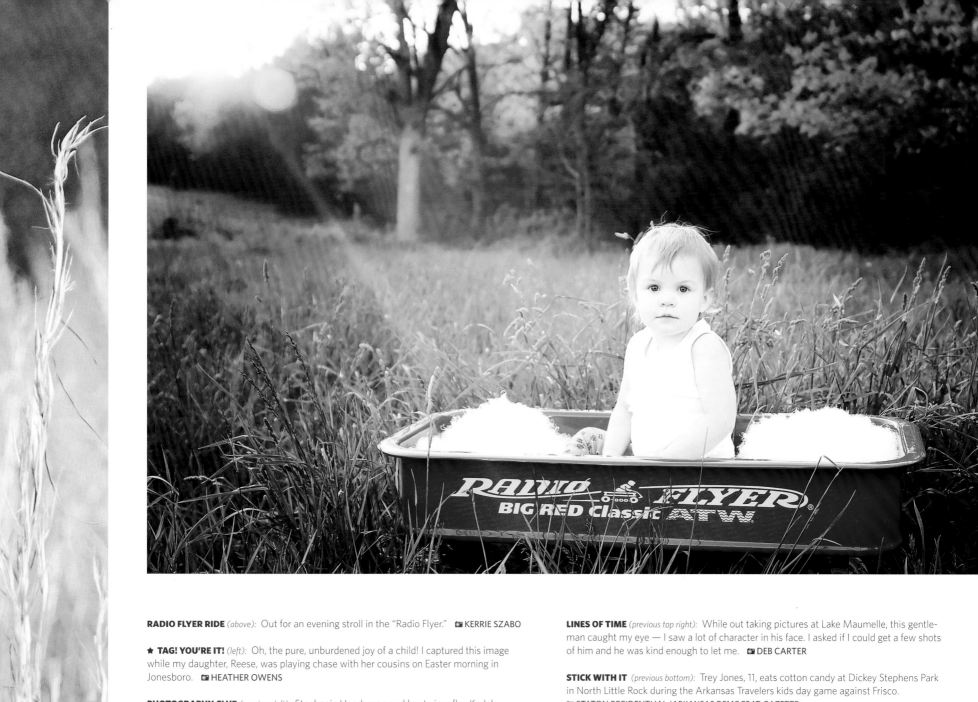

RADIO FLYER RIDE *(above):* Out for an evening stroll in the "Radio Flyer." 📷 KERRIE SZABO

★ **TAG! YOU'RE IT!** *(left):* Oh, the pure, unburdened joy of a child! I captured this image while my daughter, Reese, was playing chase with her cousins on Easter morning in Jonesboro. 📷 HEATHER OWENS

PHOTOGRAPHY CLUB *(previous left):* Stephanie Henderson and her twin reflex Kodak. 📷 DEREK HENDERSON

LINES OF TIME *(previous top right):* While out taking pictures at Lake Maumelle, this gentleman caught my eye — I saw a lot of character in his face. I asked if I could get a few shots of him and he was kind enough to let me. 📷 DEB CARTER

STICK WITH IT *(previous bottom):* Trey Jones, 11, eats cotton candy at Dickey Stephens Park in North Little Rock during the Arkansas Travelers kids day game against Frisco. 📷 STATON BREIDENTHAL/*ARKANSAS DEMOCRAT-GAZETTE*

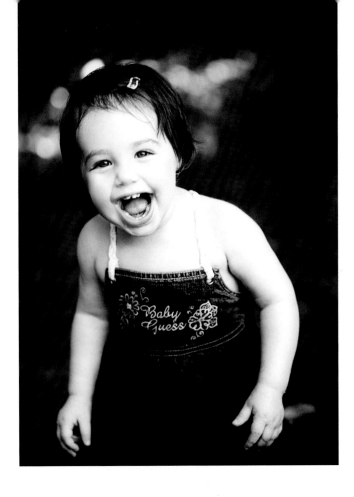

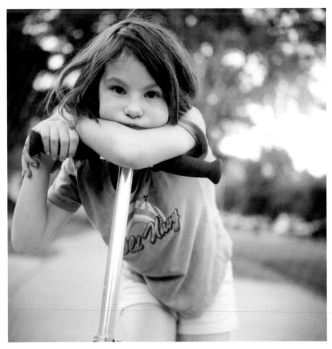

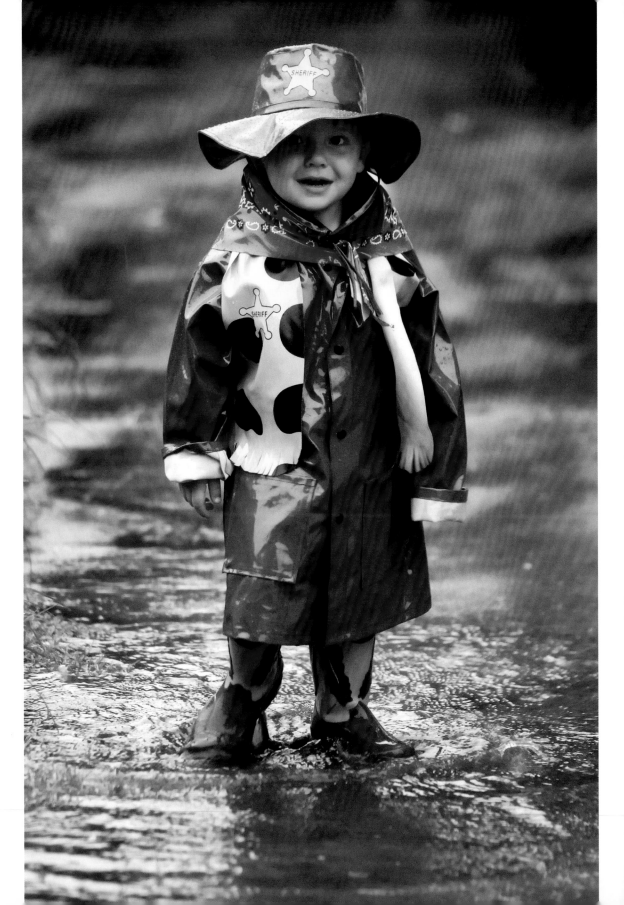

GIGGLES *(opposite top left):* The sweetest laugh! 📷 AMBER LANNING

I'M BORED *(opposite bottom left):* Sarah takes a break from a scooter ride on the sidewalk. 📷 MIKE KEMP

NEW SHERIFF'S IN TOWN *(opposite right):* Honorary Sheriff Hap Hall stands in a puddle following a rainstorm. 📷 BETH HALL

SUMMER'S LAZY DAYS *(below):* Zac Harp lying on the grass. 📷 STACEY BATES

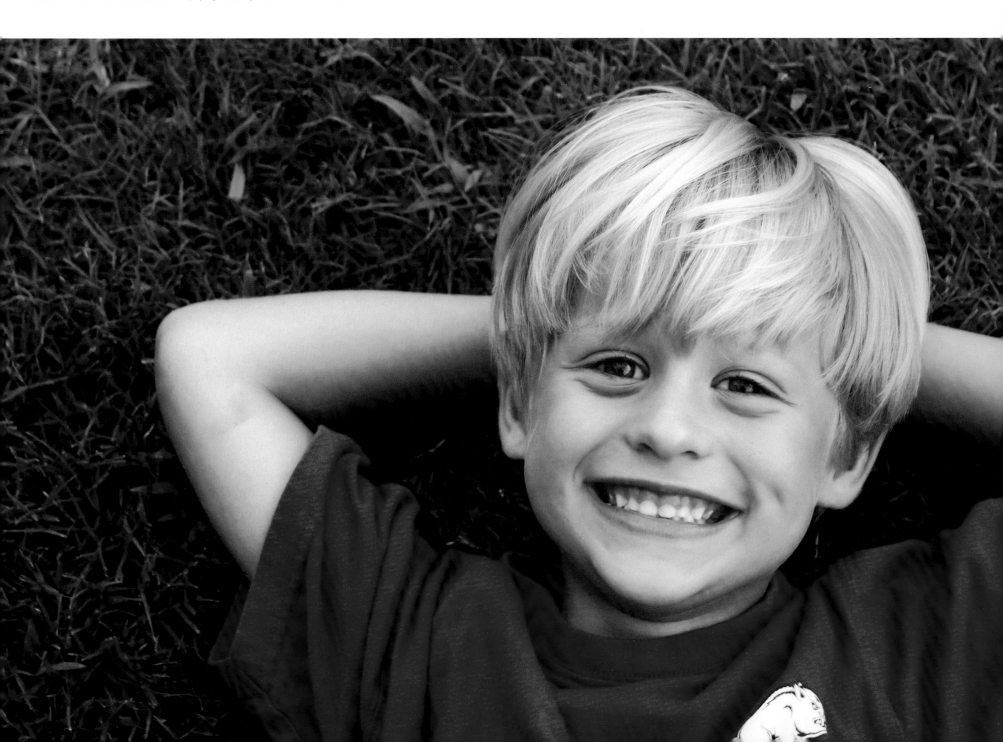

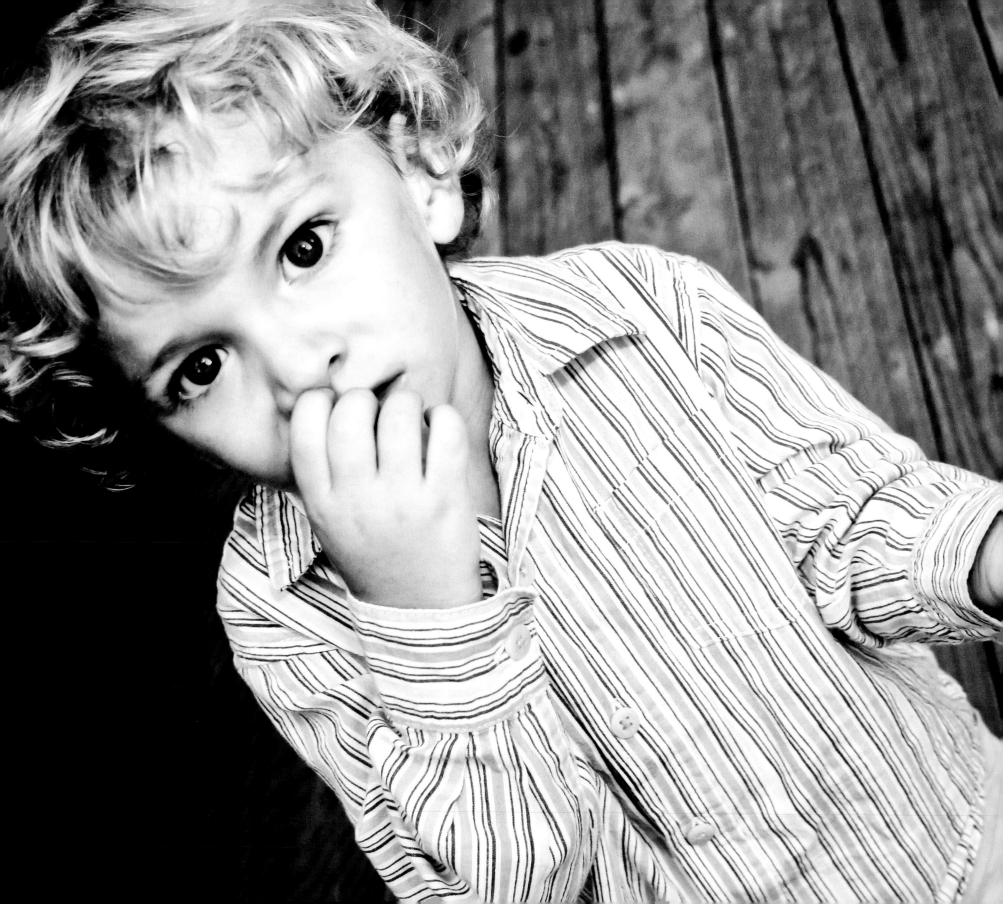

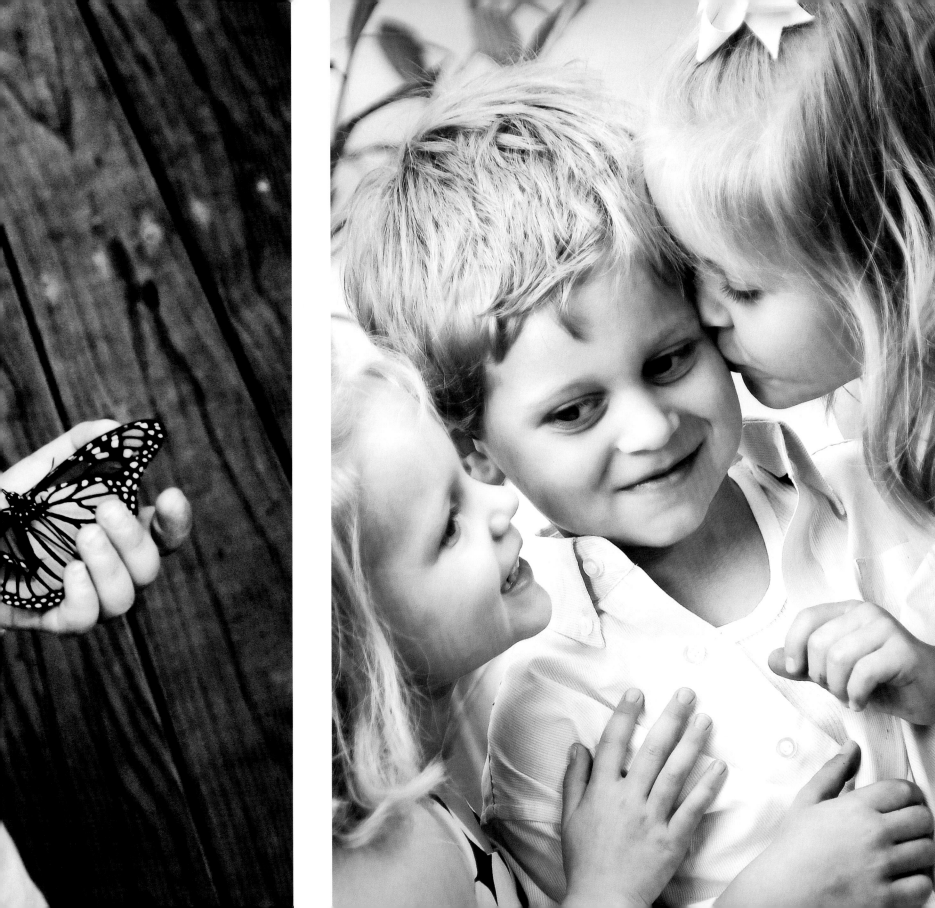

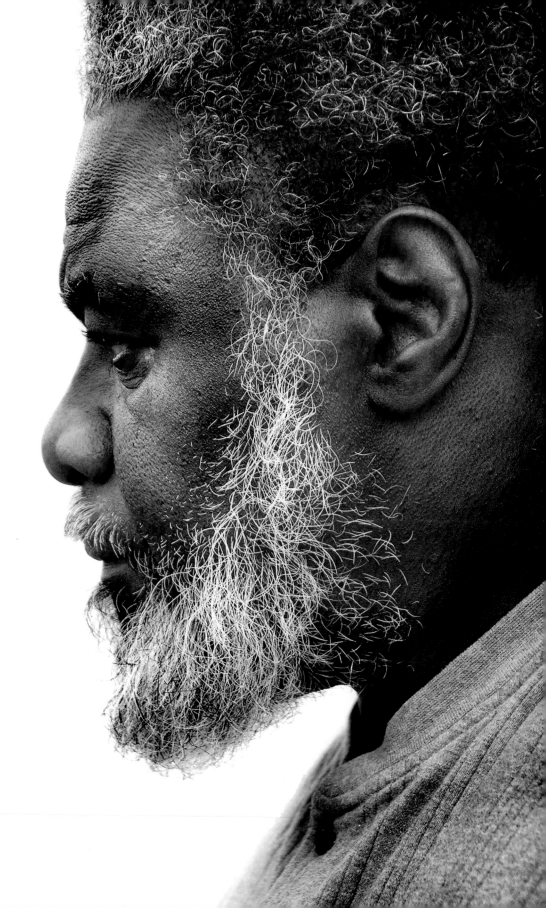

BUTTERFLY BOY *(previous left)*: Boy at a wedding holds a butterfly.
📷 KERRY GUICE

OH, BROTHER *(previous right)*: Two sisters and one brother; three beautiful children.
📷 TODD OWENS

HEART AND HANDS *(right)*: The Rev. Hezekiah Stewart works with Moody Chapel AME Church, along with Mount Nebo AME and the Watershed Community Development Agency to meet the needs of struggling families in Little Rock, Pulaski County and greater Arkansas. 📷 KIRK JORDAN

SISTERS *(opposite)*: Lexie, Sally and Lizzie, sisters. 📷 DIXIE KNIGHT

FRECKLES *(following top)*: A beautiful, young, freckle-faced girl wearing her old-time hat while in the Goldsby Public Library in Lepanto. 📷 DOUG TANNER

FARM THOUGHTS *(following bottom left)*: Cutting hay in the summer is a chore. Thoughts of the long day ahead consume this cattle farmer.
📷 JASON CRADER

★ **BOTH SIDES OF THE DOOR** *(following bottom middle)*: Three-year-old Jonah, and 10-month-old Avery guard the door to a weathered storefront in downtown Conway. 📷 SUMMER WILLIAMS

★ **LOOK AT ME, I'M 3** *(following right)*: Birthday at the Little Gym.
📷 TODD SMITH

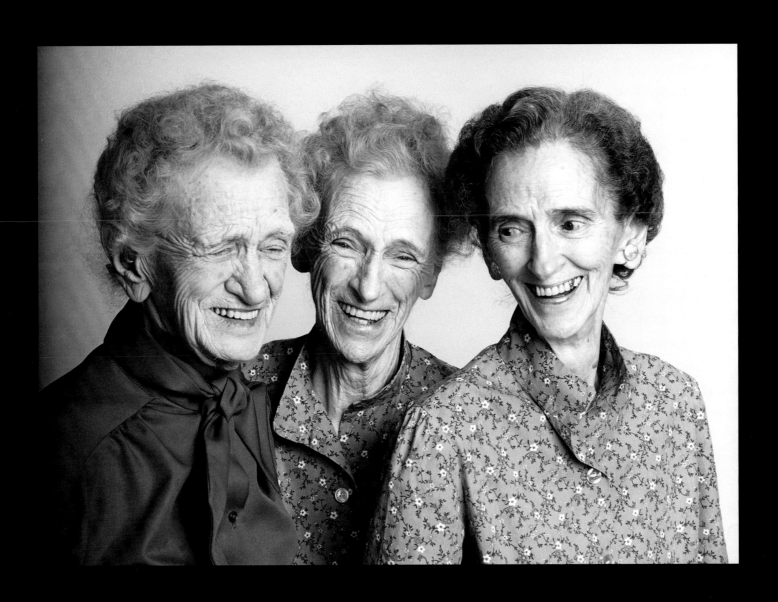

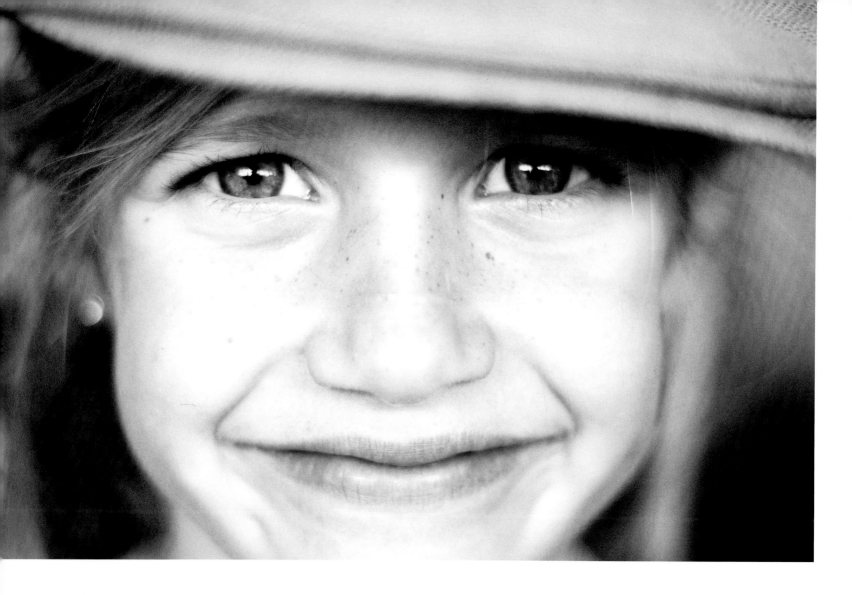

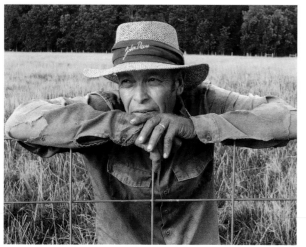

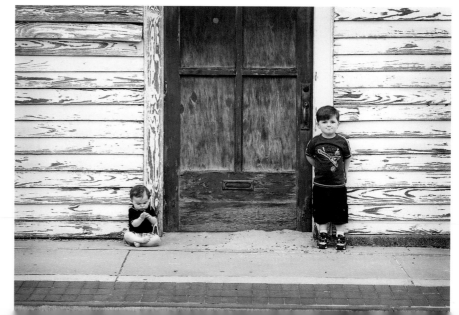

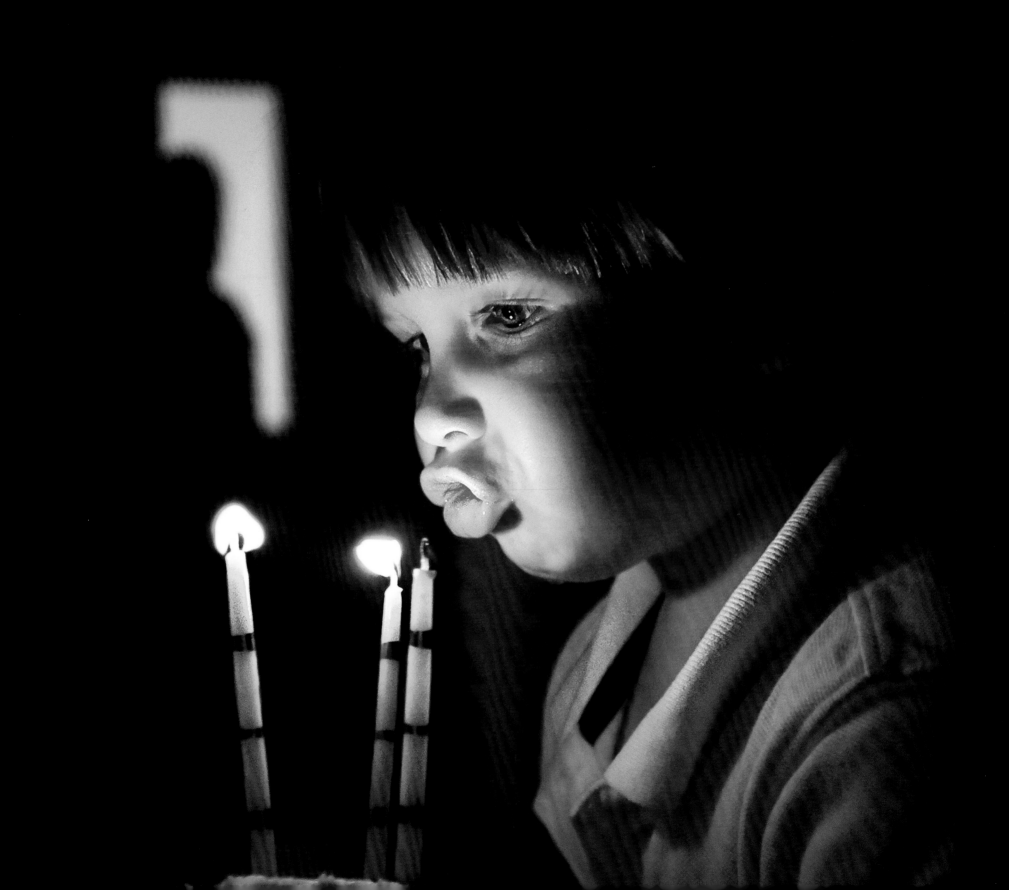

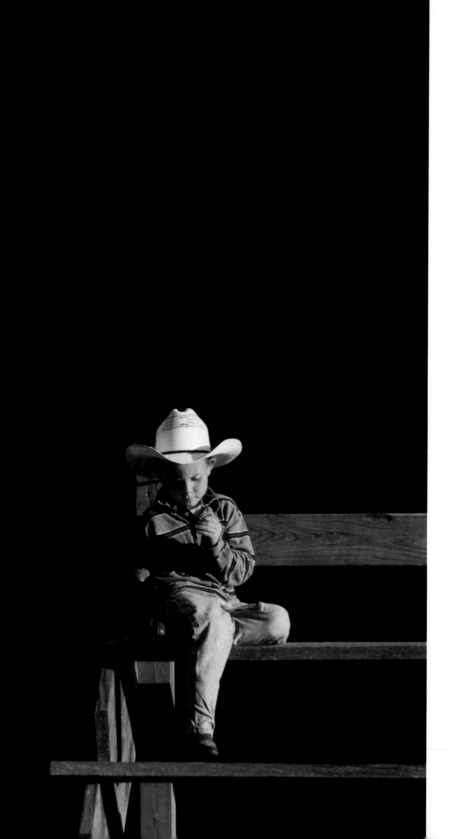

AT THE RODEO *(right):* Sunset portrait of a boy alone in the bleachers at H&H Ranch in Charlotte. 📷 ZACK JENNINGS

CECILIA *(far right):* I took this just minutes before a sudden deluge of rain. I was worried about using the pile of limbs as a backdrop, but when the clouds moved in, everything came together for a great moody scene. 📷 CHRIS BURNS

IF YOU CAN'T STAND THE HEAT *(following left):* Robert Hall, executive chef of campus dining at the University of Central Arkansas in Conway, poses in the kitchen of Christian Cafeteria. 📷 MIKE KEMP

THE NEW FACE OF ARKANSAS *(following top):* This is my niece, who was adopted from a Chinese orphanage when she was 4 years old. Full Arkansan now, she speaks with a lovely Southern drawl and will melt your heart with her thoughtfulness. 📷 DONNA EVANS

FOUR-LEGGED VOLUNTEER SPREADS SMILES *(following bottom):* Animal-assisted therapy volunteer "Maggie" gets a hug from an Arkansas Children's Hospital cancer patient during a party in the hospital playroom to celebrate the five-year anniversary of the T.A.I.L.S. program — Therapeutic Animal Interventions Lift Spirits. 📷 KELLEY COOPER

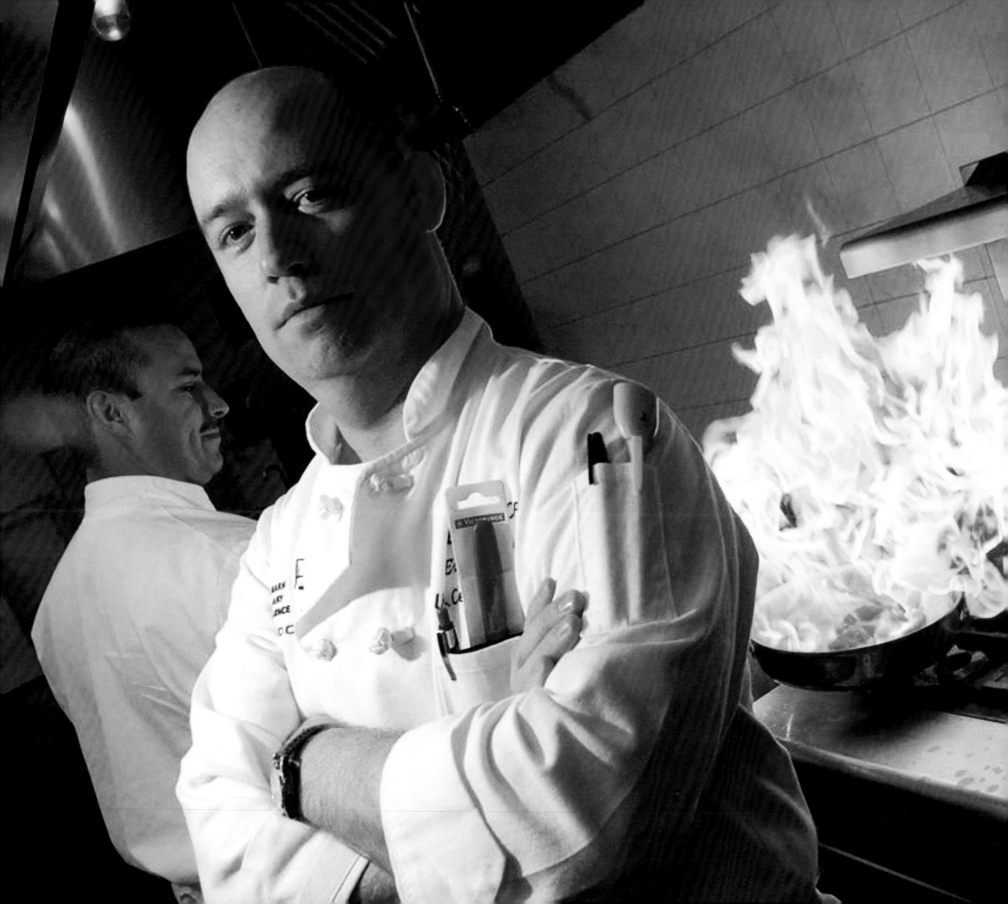

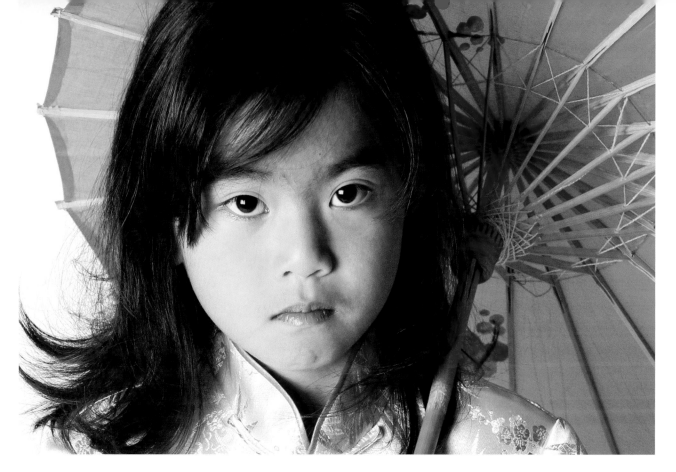
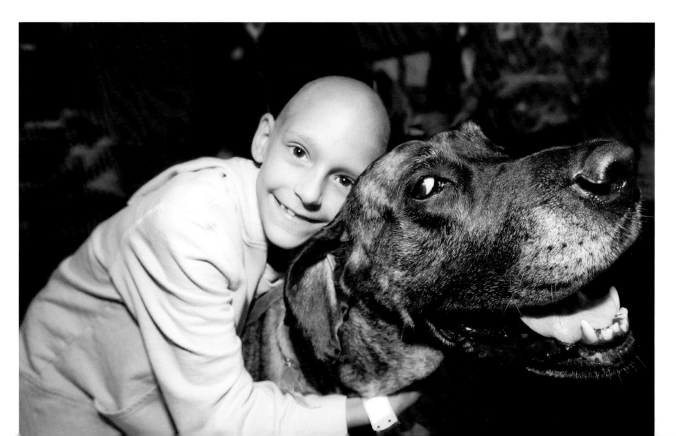

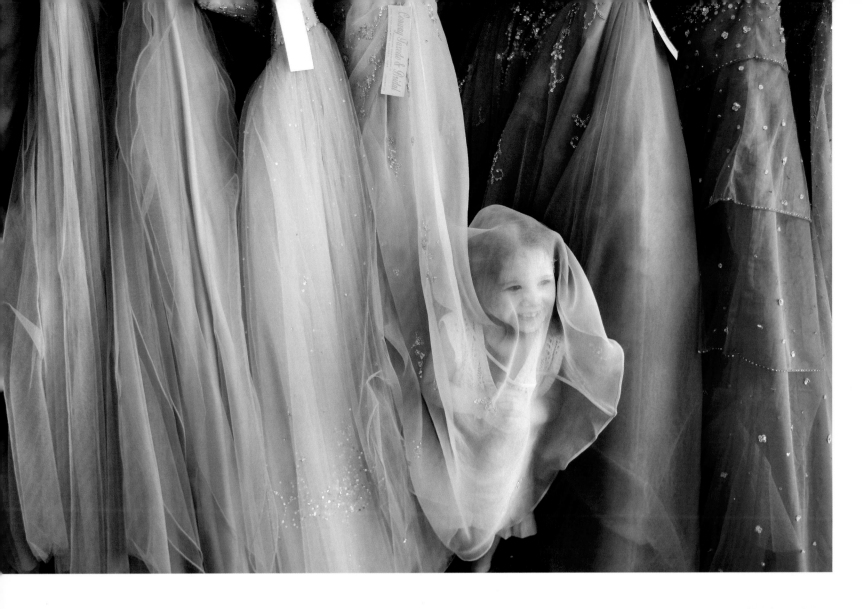

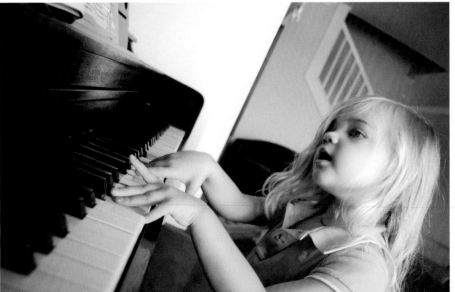

DRESS SHOP (*above*): Brooklyn Smith, 2, plays peek-a-boo with her mother behind prom dresses at Conway Tuxedo & Bridal. Smith goes to work everyday with her mother Sherry, who is co-owner of the store. 📷 BENJAMIN KRAIN/*ARKANSAS DEMOCRAT-GAZETTE*

SERENADE. (*right*): My little girl, serenading on a Saturday afternoon. 📷 ZAC CROW

UNTITLED (*far right*): Portrait. 📷 ML BAXLEY

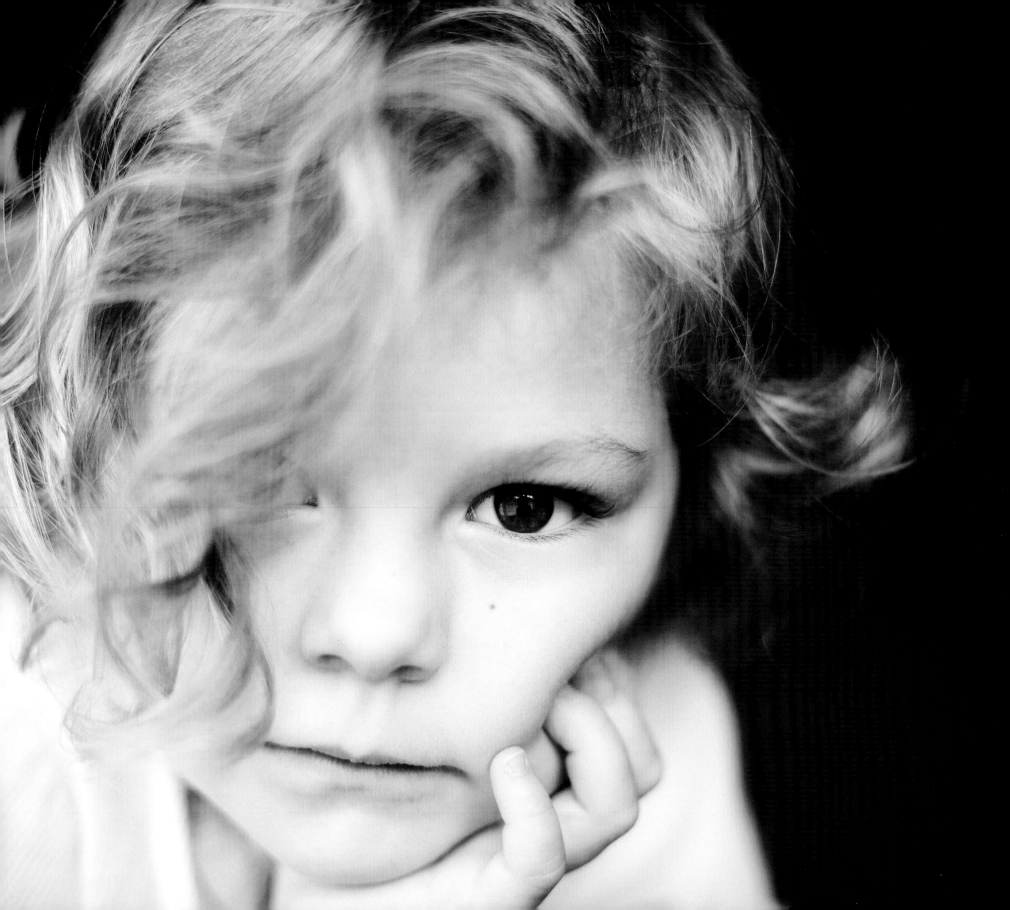

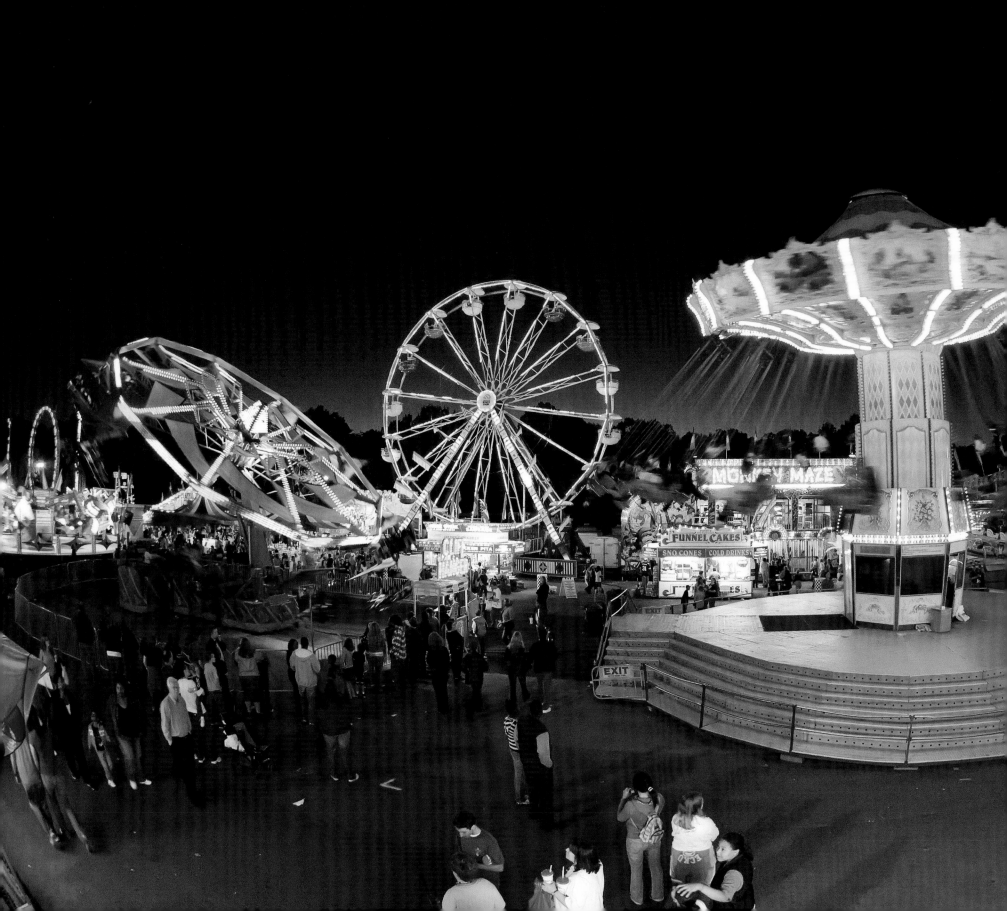

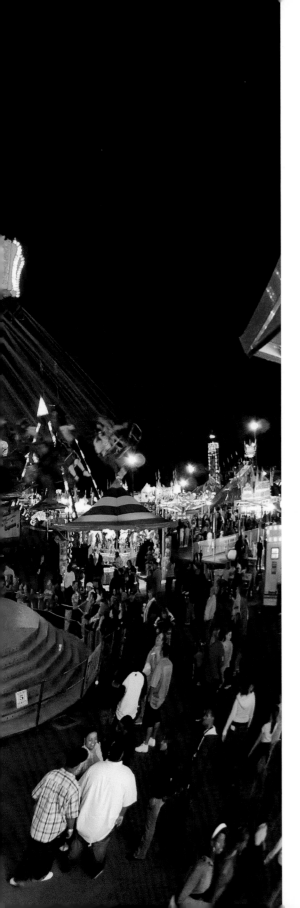

Sports & Recreation

SPONSORED BY DELTIC TIMBER

From summer to winter and the seasons between, Arkansas is full of activities that keep us moving, laughing and cheering. We like to be moved on the state fair's jostling carnival rides and atop a saddle on galloping horses. We'll take the easy day fishing or exploring the Buffalo River in a canoe with friends.

We can scream and shout with the best of them as we cheer on Razorbacks, Trojans, Red Wolves, Bears and more in traditional and beloved pastimes like football, basketball and baseball. True to our roots and heritage, we also mix in colorful Southern events like chuck-wagon and tiller racing.

The broad interpretation of this category is clear: Diverse and passionate, residents of Arkansas are more than one sport or one team. Here, in these vivid photos from throughout the state, Arkansans illustrate the various recreations that entertain us all.

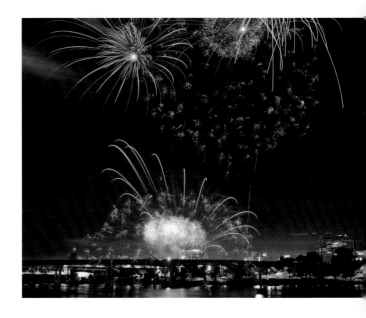

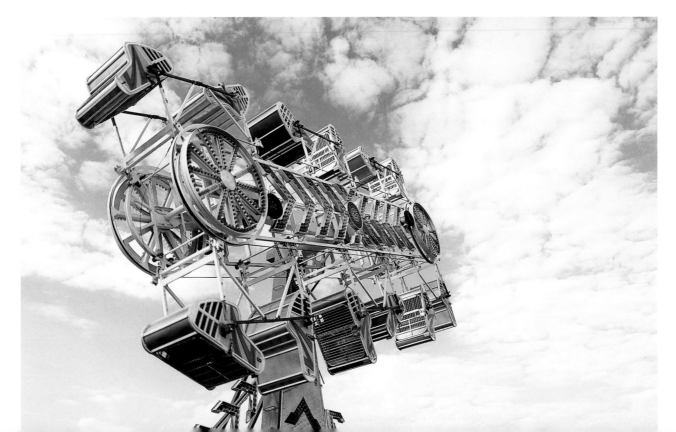

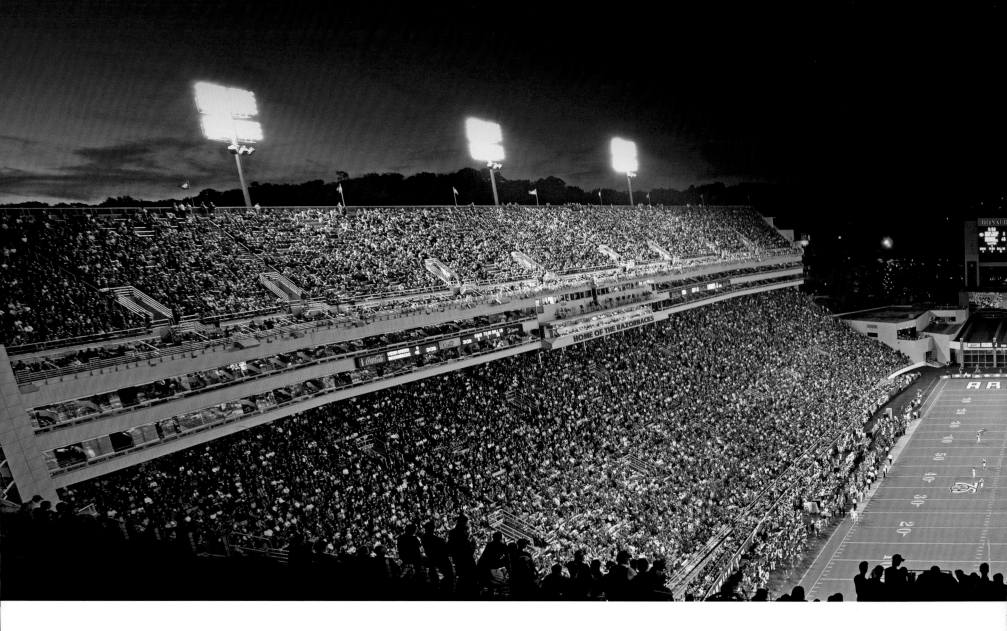

REYNOLDS RAZORBACK STADIUM *(above):* Donald W. Reynolds Razorback Stadium is home of the University of Arkansas Razorbacks football team in Fayetteville. 📷 JUSTIN MYERS

STATE FAIR *(previous left):* Arkansas State Fair 2007 from atop a cotton-candy stand in the midway. I was looking for something that showed the movement and energy of the fair. 📷 JASON BURT

POPS ON THE RIVER *(previous top):* Fourth of July fireworks in Little Rock. 📷 JOHN DAVIDSON

★ **ZIPPER IN THE SKY** *(previous bottom):* The Zipper was taken at the annual Crawdad Days festival held in May in

Harrison. The clouds were perfect that day and really made the colors on the carnival ride pop out. 📷 JESSICA KIBLING

CAN'T TOUCH THIS *(right):* "Can't Touch This" comes to mind as Darren McFadden hurdles a Missouri defender during the 2008 Cotton Bowl. 📷 BILL PATTERSON

WOO PIG SOOIE! *(opposite left):* Let's call those Hogs! You can feel the excitement for football season just looking at this photo. I was on the other side of the stadium and zoomed into the student section just as they began to call those Hogs! 📷 TERESA HAUSTEIN

RAZORBACKS *(opposite right):* Arkansas 48, South Carolina 36. Victory. 📷 GRANT HARRISON

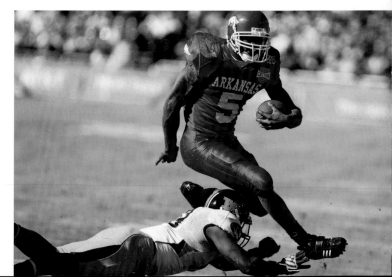

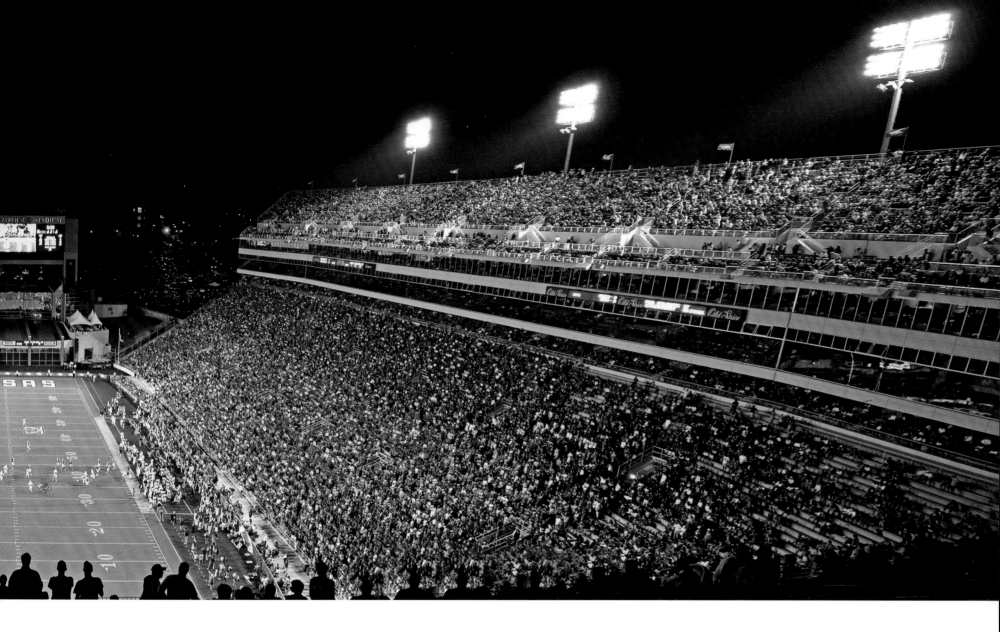

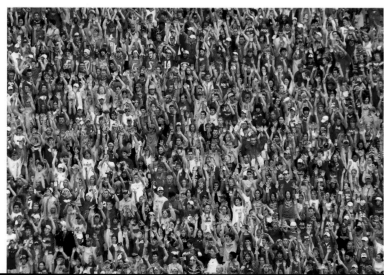

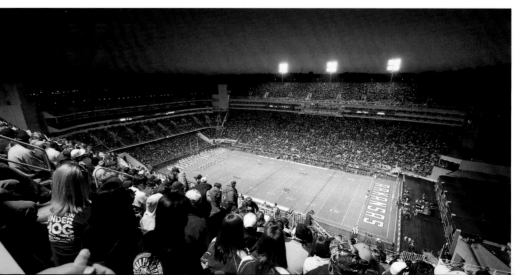

STATE FOOTBALL CHAMPIONSHIPS *(below)*: Sunset at the State Football Championships at War Memorial Stadium in Little Rock. ◼ CHARLES CLOGSTON

FOG FOOTBALL *(right)*: Ramay Junior High School football team practices their passing in the field beside their school in Fayetteville. ◼ AMELIA PHILLIPS/*ARKANSAS DEMOCRAT-GAZETTE*

GETTING READY TO RACE *(opposite top)*: Waiting on the start gun for the men's pro bicycle time trial at the 2007 Tri-Peaks bicycle race at Arkansas Tech University. ◼ MIKE COOPER

THE GRIDIRON *(opposite bottom left)*: It was at this moment, one pulling the other's mouthpiece, that the battle was on! ◼ DOUG TANNER

FOLLOW THE RUNNER *(opposite bottom right)*: A runner and his shadow on the streets of downtown in the Little Rock Marathon. ◼ JEFF DAILEY

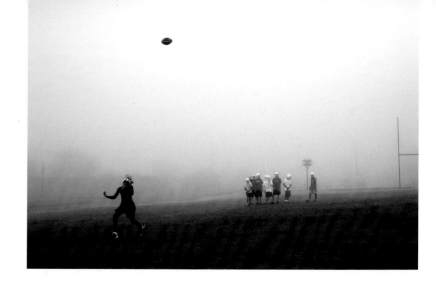

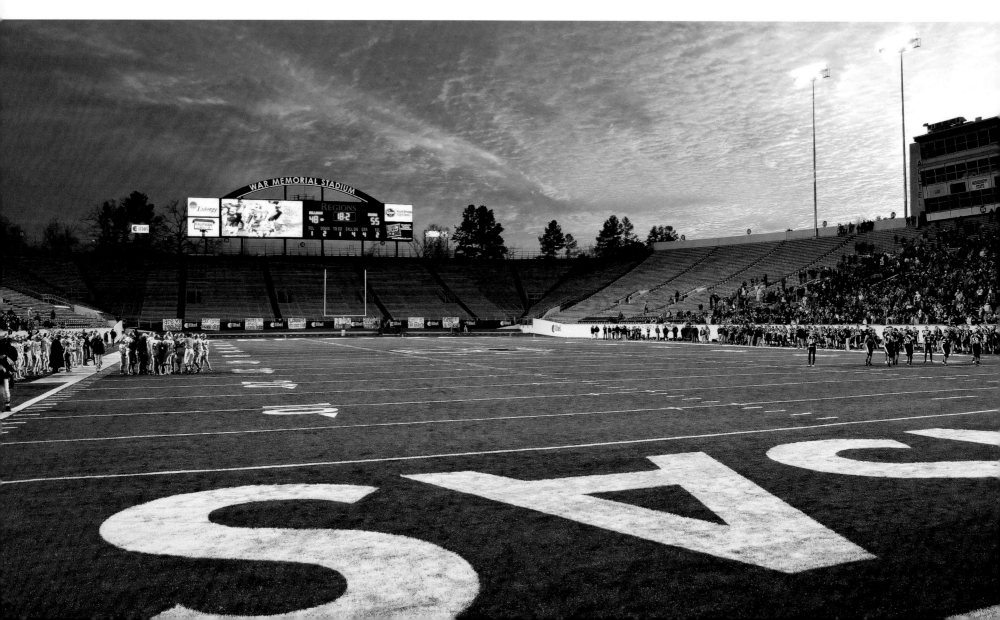

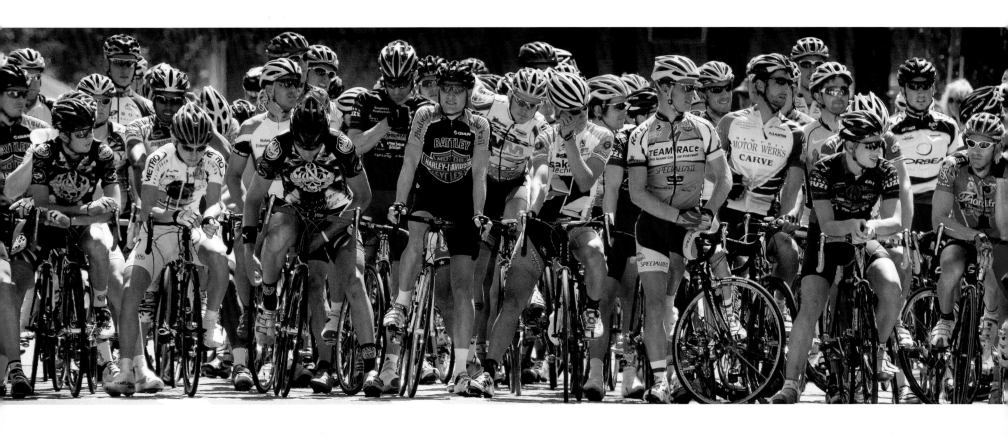

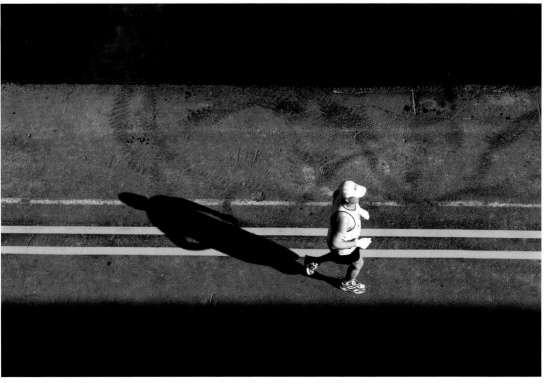

ALL CHALKED UP *(right):* Reanna Jiles gets chalked up while climbing the rock wall at Valley Fest in Russellville. ◉ DAVID HUFF

★ **THE BOYS OF SUMMER** *(far right):* Little Rock 8-Year-Old All Stars. ◉ ML BAXLEY

AROUND THE WORLD *(below):* Friends Michael Jay Hansen, 12, left, and Kyle Schoggin, 13, play around the world on the court at the city park in Poyen. ◉ DAVID HUFF

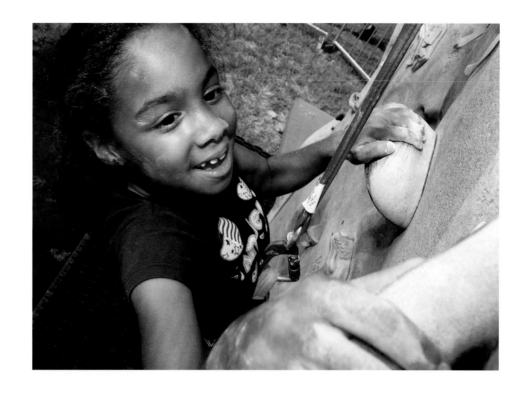

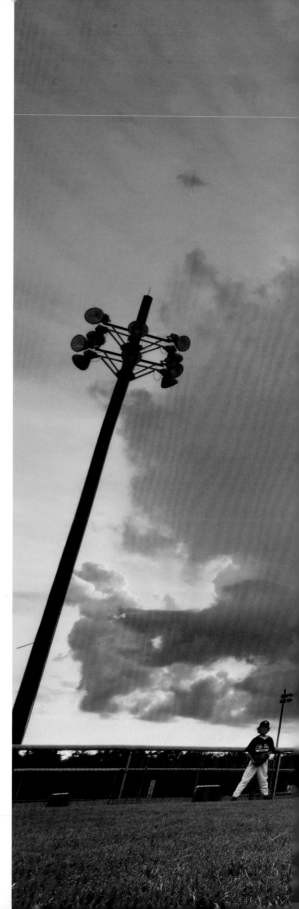

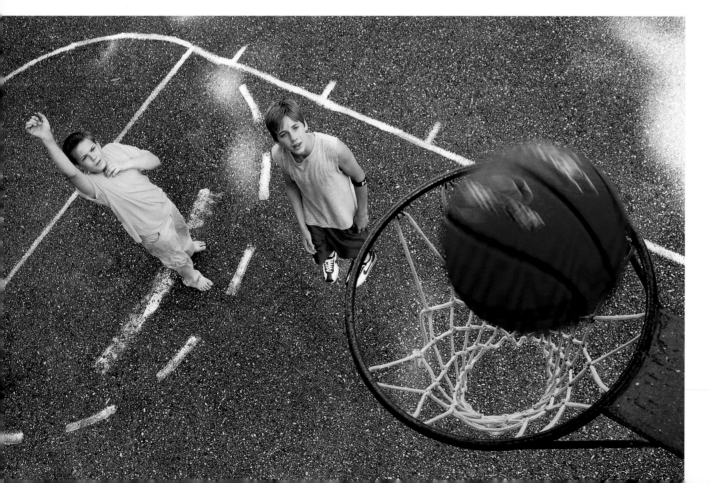

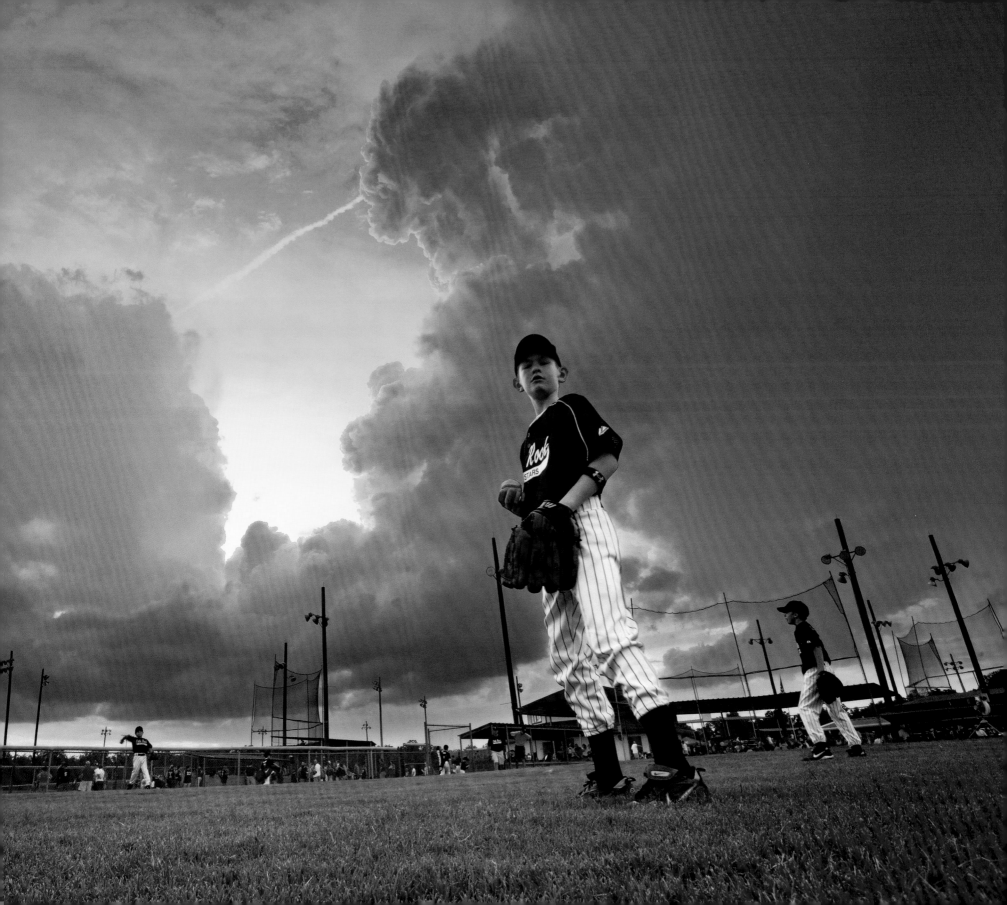

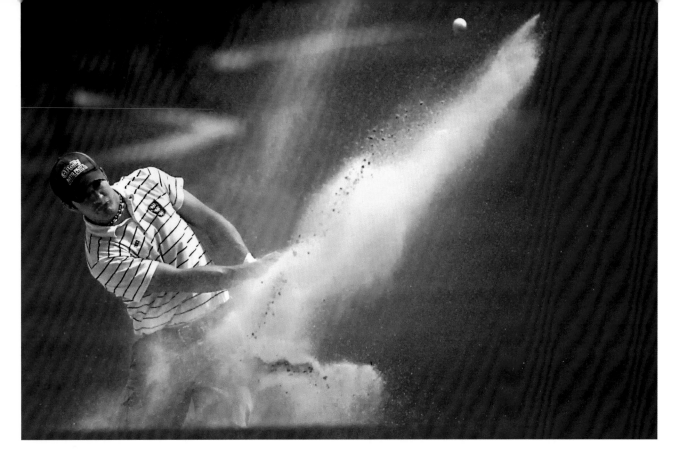

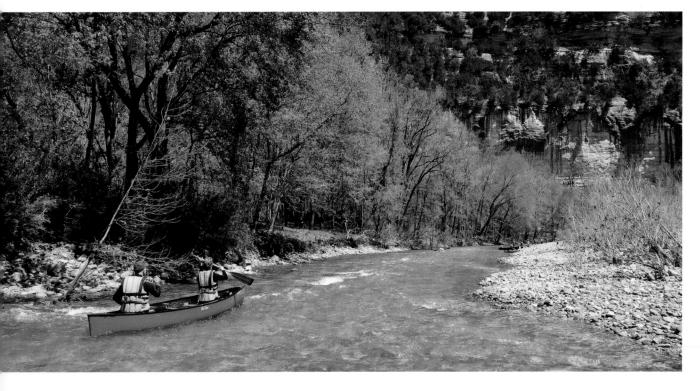

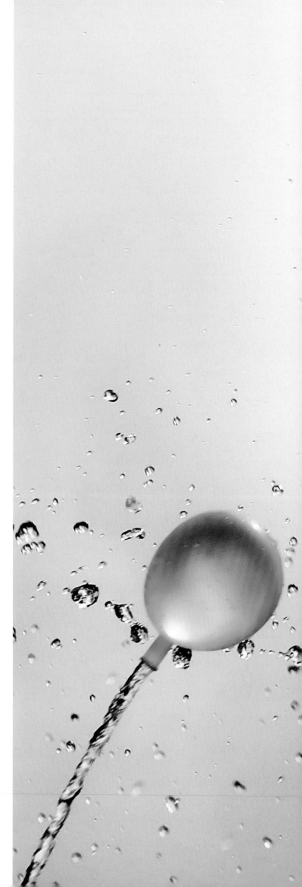

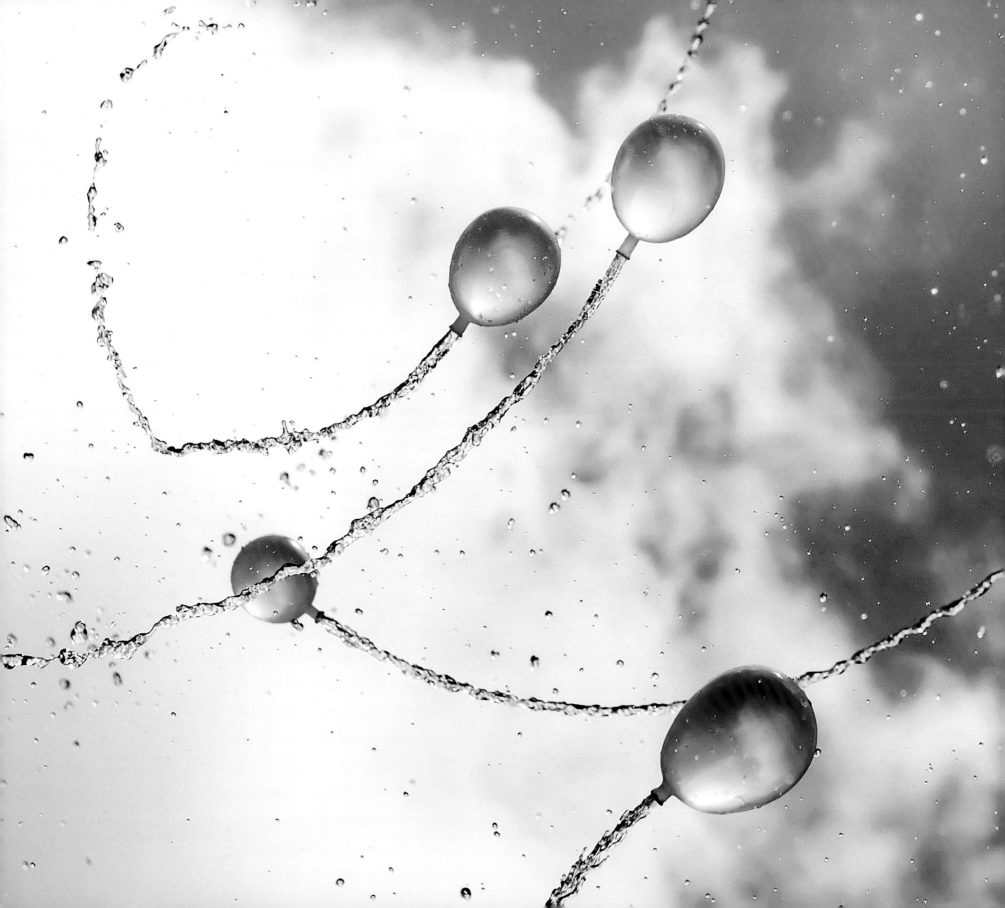

SAVING PAR (*previous left top*): Chris Marshall blasts out of the sand on the Par 5 eighth hole at the Searcy Country Club during the KB Rand Invitational Arkansas State Golf Association event. 📷 GARY MARSHALL

BUFFALO RIVER BLUFFS (*previous left bottom*): Canoeists glide down fast water near Ponca on the Buffalo River in the spring of 2008. 📷 DAVID LEWIS

★ **WATER BALLOONS IN FLIGHT** (*previous right*): On a hot summer day my children were playing in the driveway with water balloons to cool off. As I watched them I wondered what the water balloons would look like in flight without their ends tied. It was after many attempts and a wet lens this image was frozen in time. 📷 DOUG TANNER

RIDING THE BUFFALO RIVER TRAILS (*top*): There are more than 25 established equine trails in Arkansas. One of the most spectacular and diverse is out of Steel Creek landing on the Buffalo National River. The Steel Creek campground for horses is approximately 14 miles west of Jasper, off Arkansas 74. This paradise can be used for canoeing and hiking as well as horseback riding. 📷 PAT GORDON

WORLD CHAMPIONSHIP ROTARY TILLER RACES (*bottom*): A competitor in the annual World Championship Rotary Tiller Races is covered in a cloud of dust as he struggles to keep up with his super-charged racing tiller in Emerson as a part of the annual Purple Hull Pea Festival. 📷 AARON STREET

UNTITLED (*opposite top*): Oaklawn 📷 BILL EVANS

I'VE GOT YA, BRO (*opposite middle*): Brothers Trey and Trevor Foster at the Arkansas High School Rodeo. Trevor is hung up on an 1,800-pound bull. His brother Trey runs in to save him. Thanks, Trey! 📷 TIM FOSTER

HOLD ON! (*opposite bottom*): Chuck-wagon races in Arkansas is a summer pastime. Wheeling around an oval dirt track, a wagon team tries to outrun a trailing horse rider or another wagon team. This particular event was held in Beebe. 📷 GARY MARSHALL

LONE RIDERS IN THE DUST (*opposite right*): These two cowboys off into the sunset at the 2007 National Championship Chuck-wagon Races held in Clinton, at Bar of Ranch. 📷 MARK JACOBS

UNTITLED (*following left*): B-25. 📷 ML BAXLEY

FLYING HIGH 2 (*following right*): Power paraglider flies near Fort Smith just as the sun was setting after a rainstorm. 📷 GREG DISCH

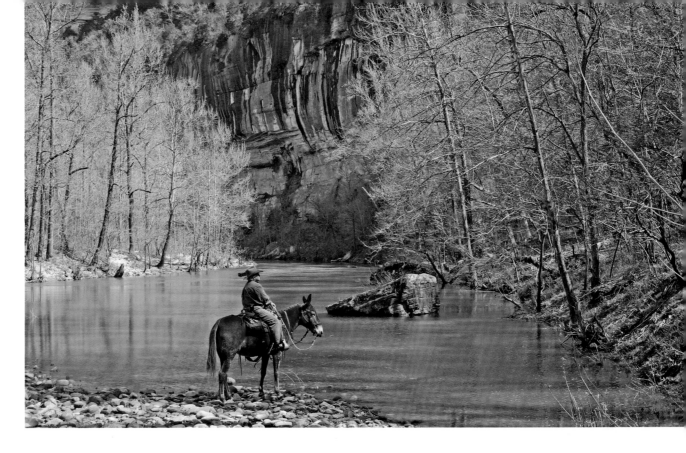

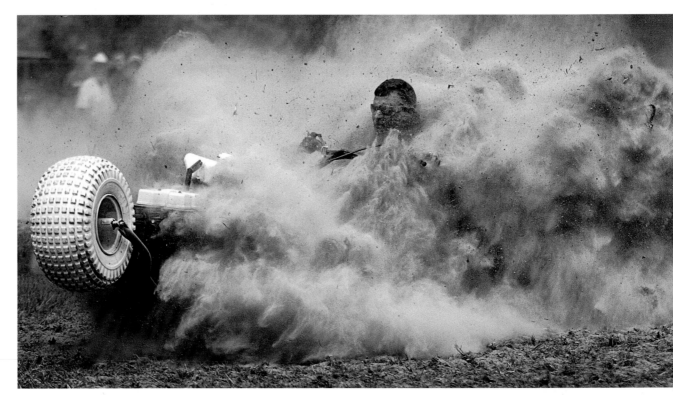

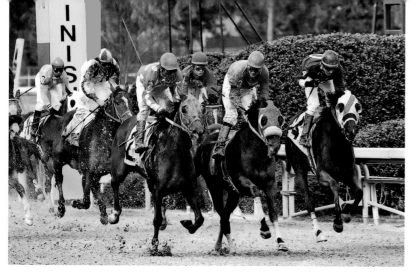

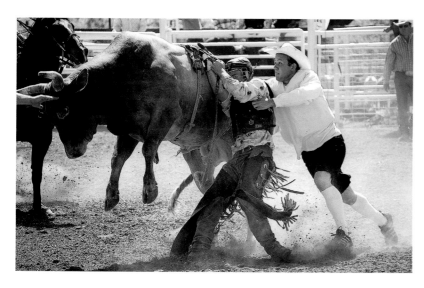

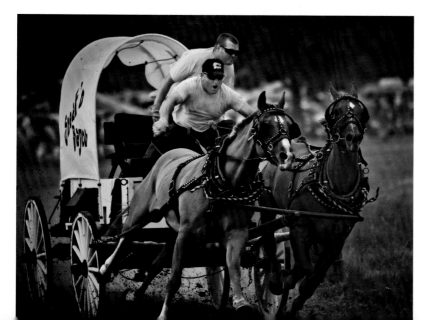

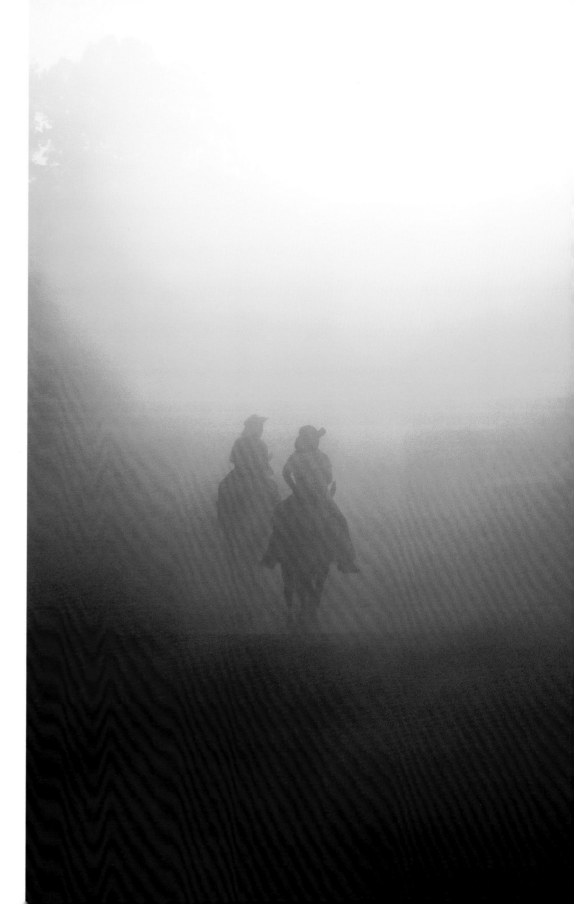

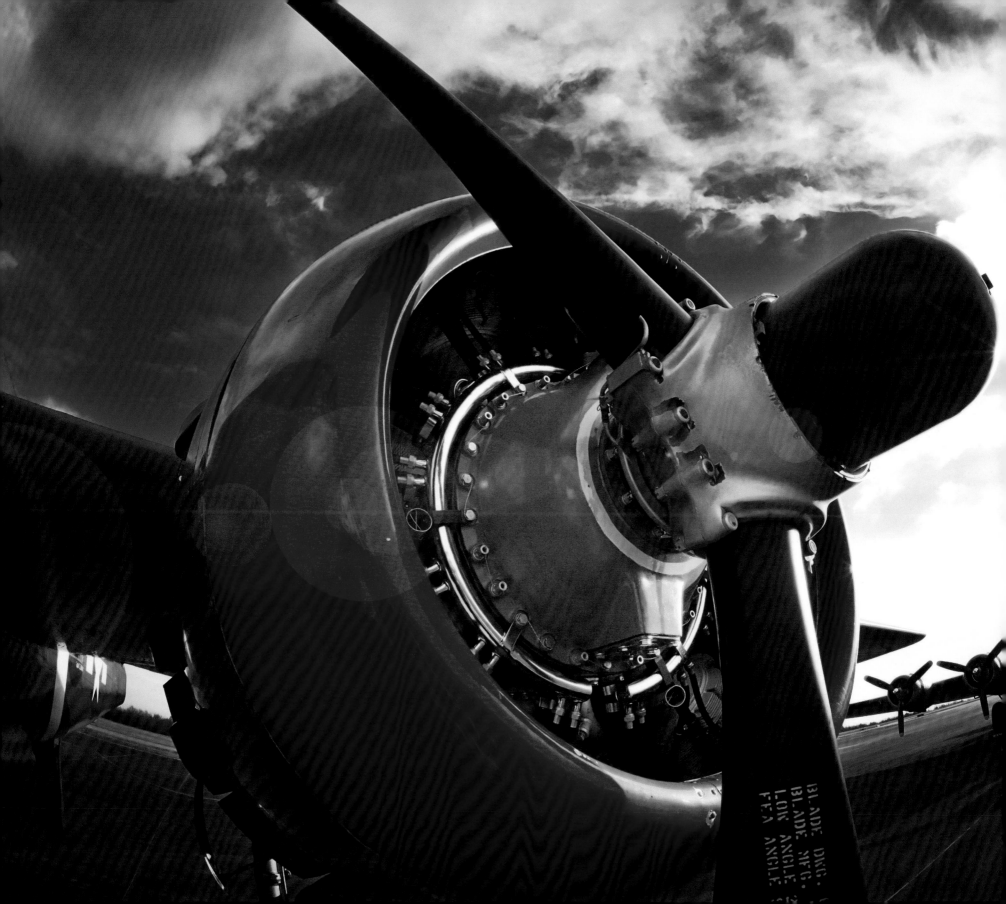

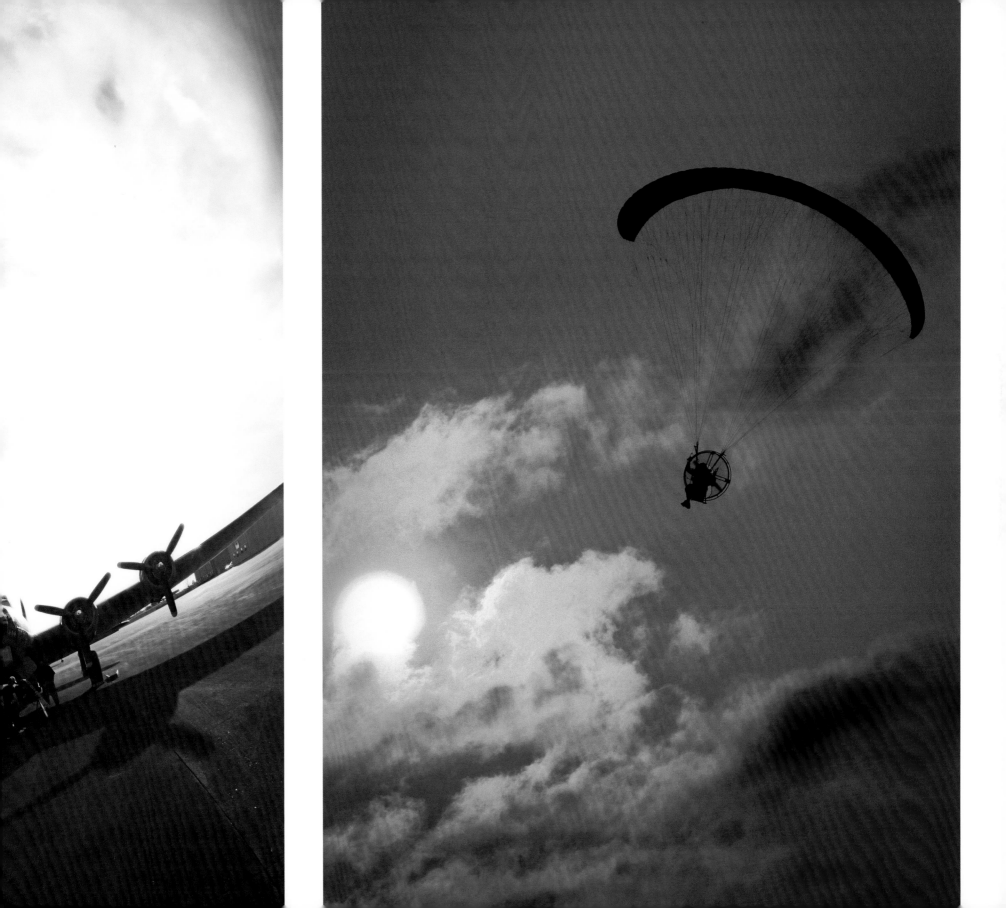

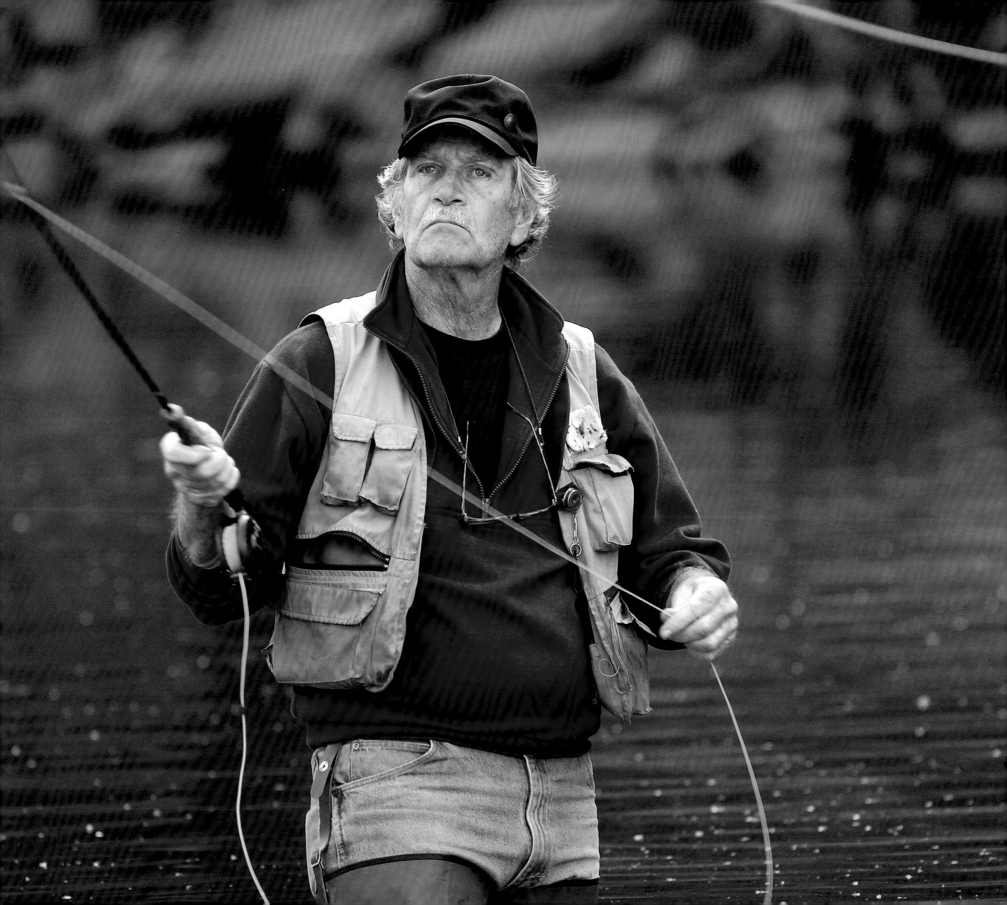

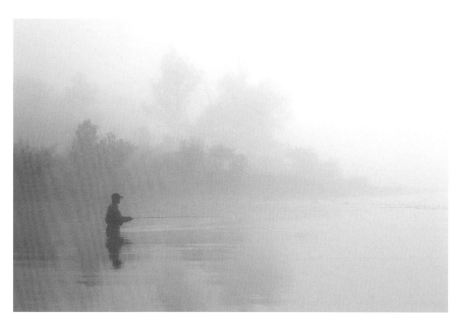

FISHING THE WHITE *(left):* Fishing the White River at Cotter. 📷 PEARL BAKER

FIRST CAST *(far left):* The first cast of the day is always important. The hope of what might bite is what helps get fishermen up at the crack of dawn. 📷 JASON CRADER

FISHIN' IN THE FOG *(below):* Early in the morning at Woolly Hollow State Park. 📷 HOLLY STENE

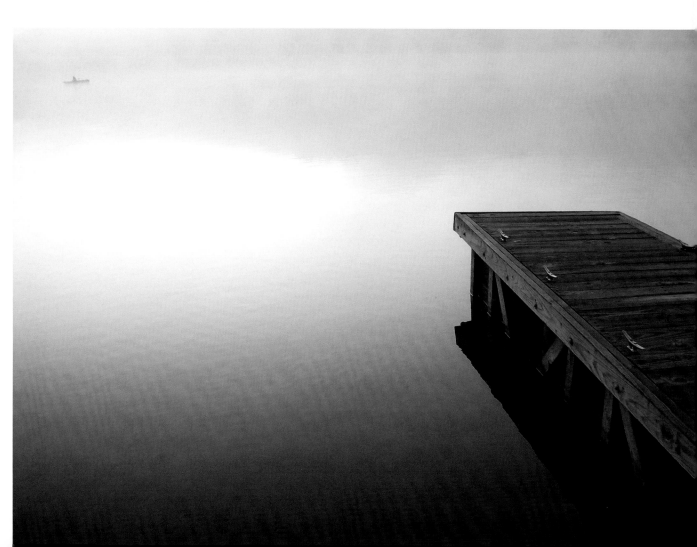

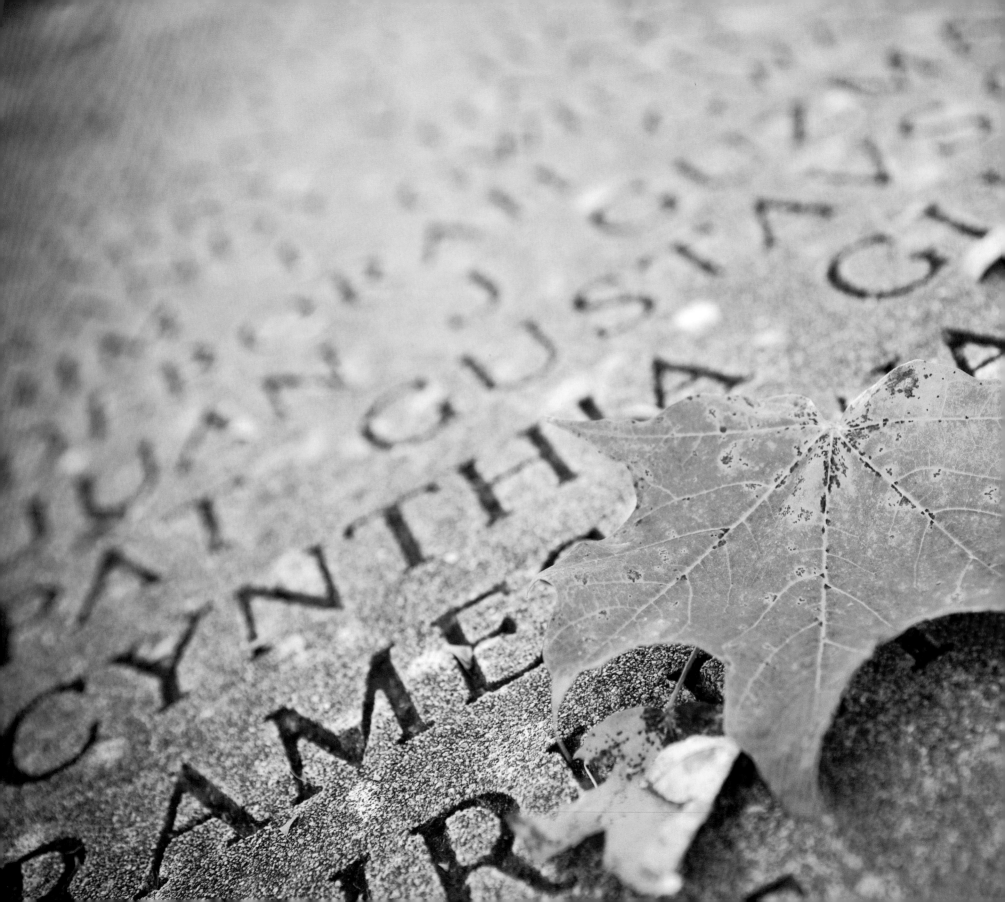

Institutions

SPONSORED BY CENTRAL ARKANSAS LIBRARY SYSTEM

More than lifeless buildings, the photographers of Arkansas showed us how mortar, panels, stones and structures can portray the Natural State's history and culture. Explore the Senior Walk at the University of Arkansas; climb the steps of the majestic Arkansas State Capitol; or meander through graceful churches punctuated by artwork made of shimmering stained glass.

Brick, beams and boulders form cornerstones of these buildings as their design, function and inhabitants form the profile of Arkansas culture.

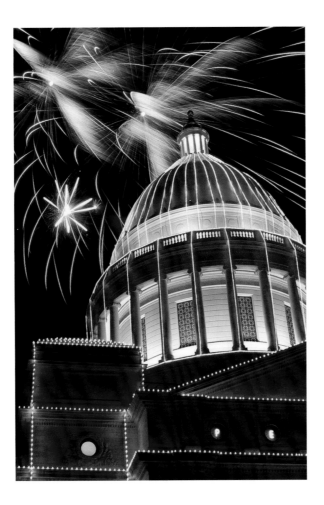

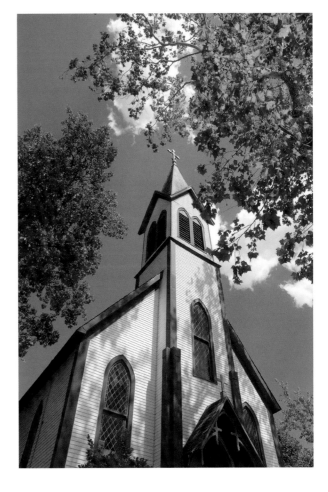

SOLACE *(above):* The picturesque St. Boniface Catholic Church on Arkansas 60 near Bigelow. 📷 TODD OWENS

★ **CHRISTMAS FIREWORKS** *(left):* Fireworks display over the Arkansas State Capitol in Little Rock after the Christmas lights were turned on. 📷 BRIAN CORMACK

SENIOR WALK *(far left):* The Senior Walk is a unique tradition among American colleges and universities. The University of Arkansas at Fayetteville has nearly five miles of paved walks throughout the campus. While the walks were originally stamped by hand, the names are now etched by a machine known as the Senior Sand Hog. 📷 BOB SHULL

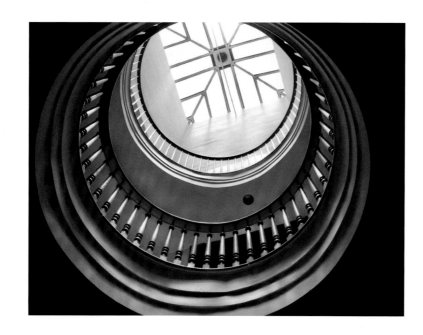

LOOKIN' UP! *(right):* Such beautiful things can be found when you look up! Taken at the Old State House in Little Rock. 📷 DEDE WILSON

ARKANSAS STATE CAPITOL *(far right):* The stairs leading to the Senate. 📷 CURT EUBANKS

902 SALINE COUNTY COURTHOUSE *(below):* The Saline County Courthouse, built in 1902 in historic downtown Benton, also holds the county jail, which is located beneath the building. 📷 DARIN MITCHELL

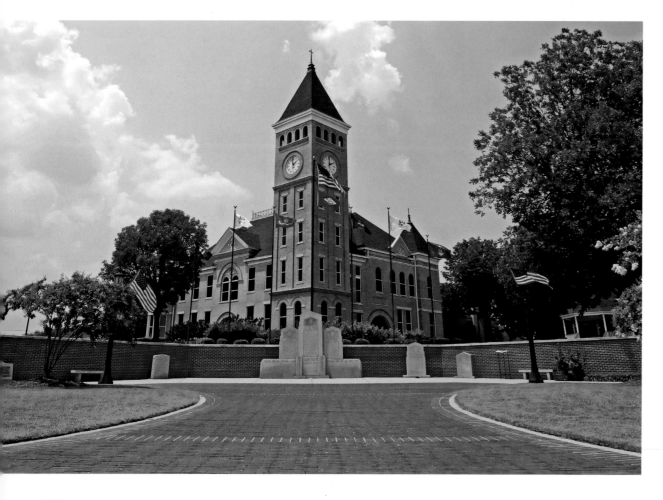

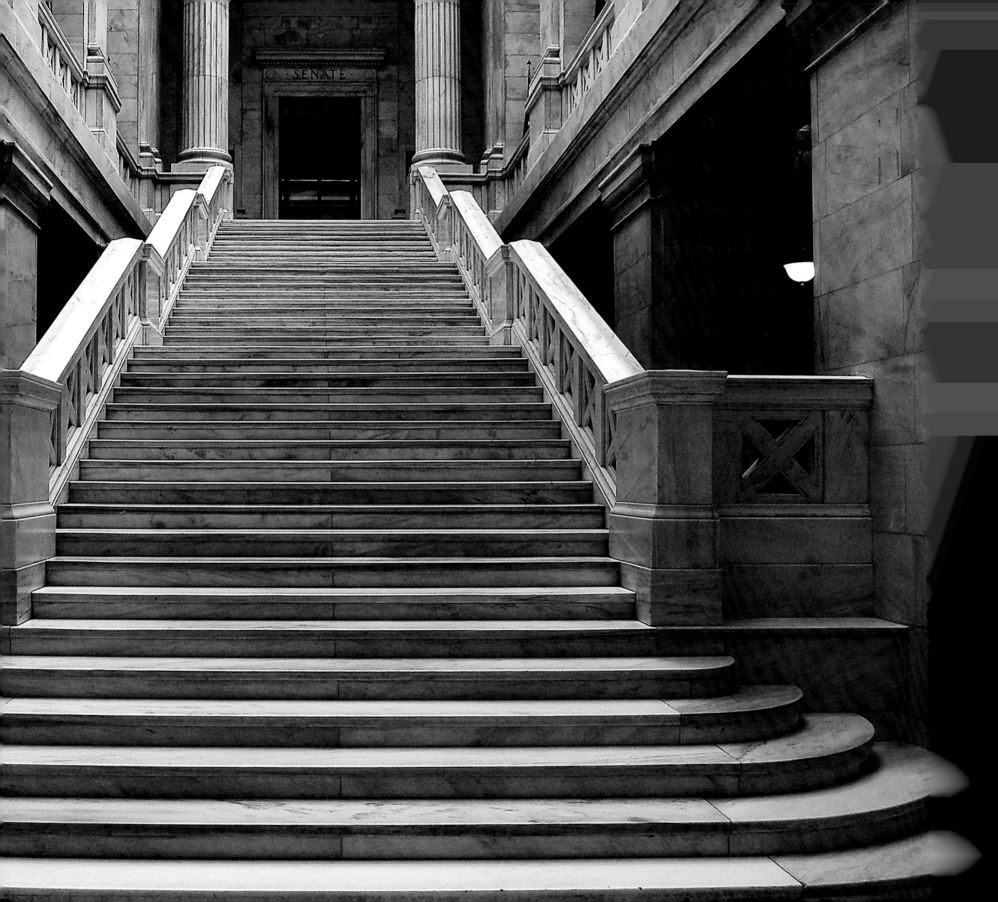

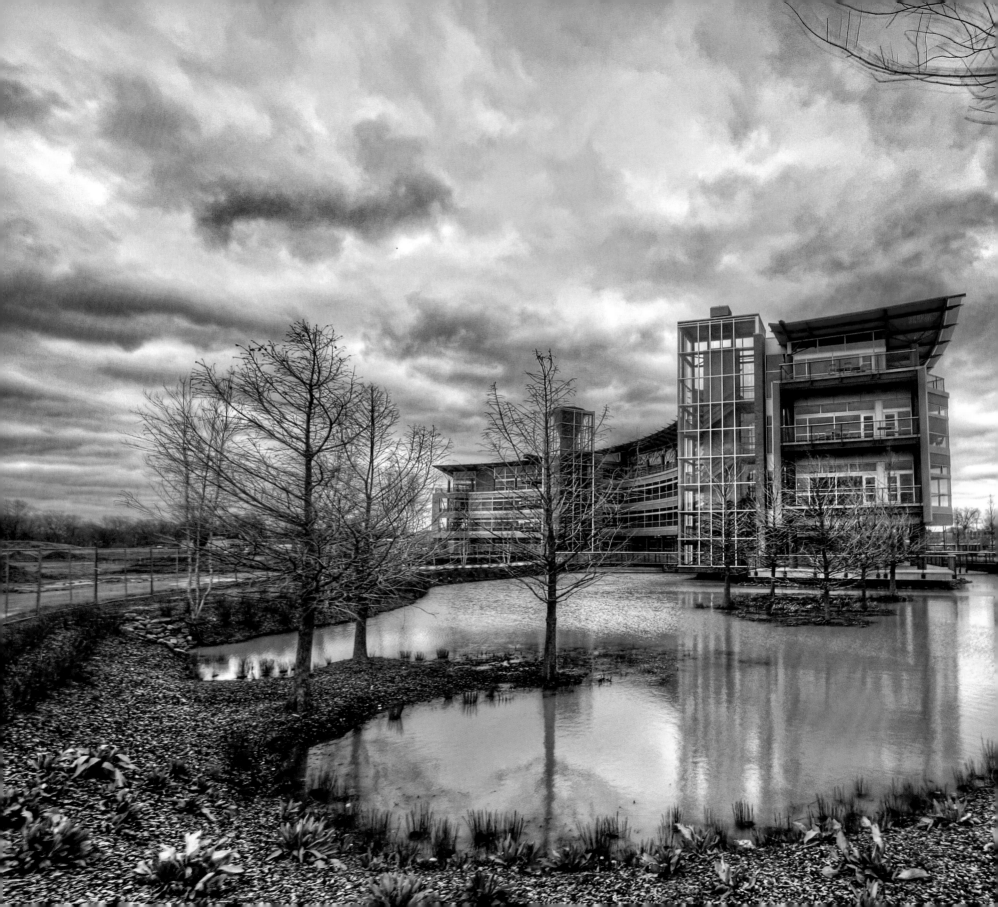

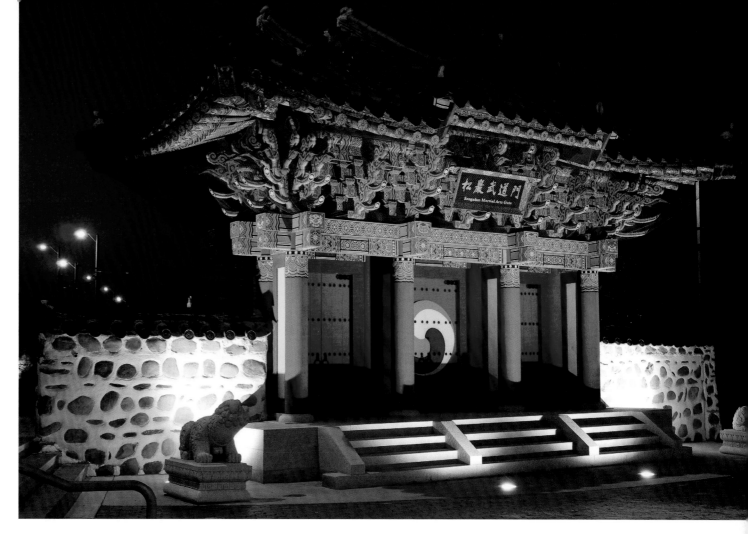
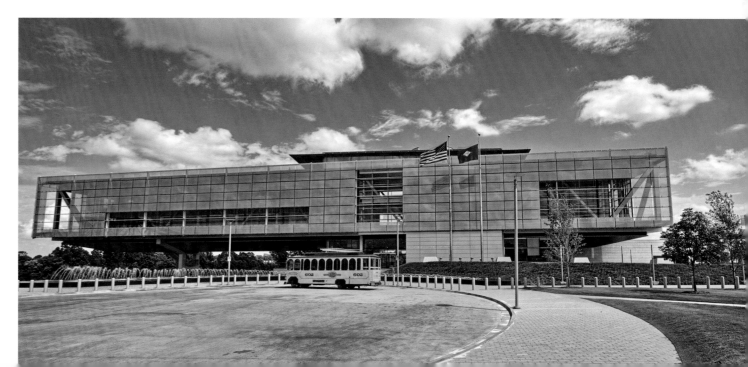

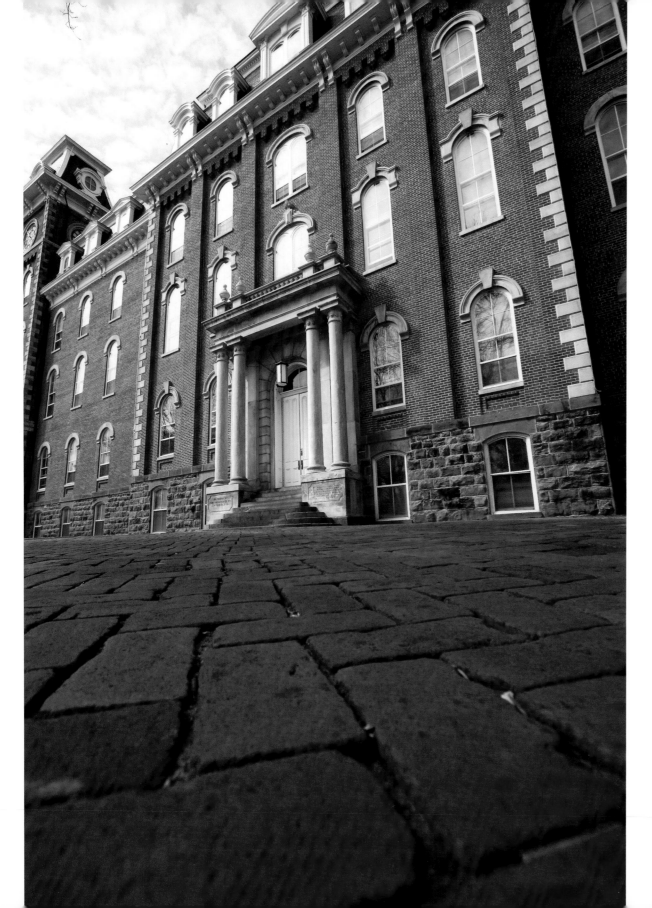
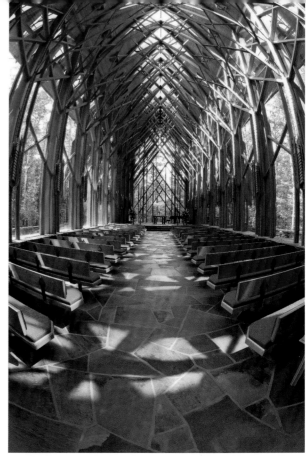

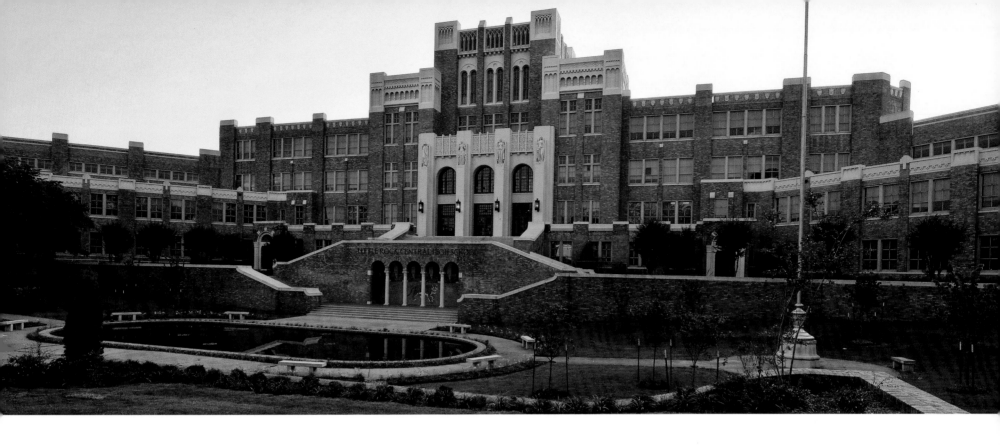

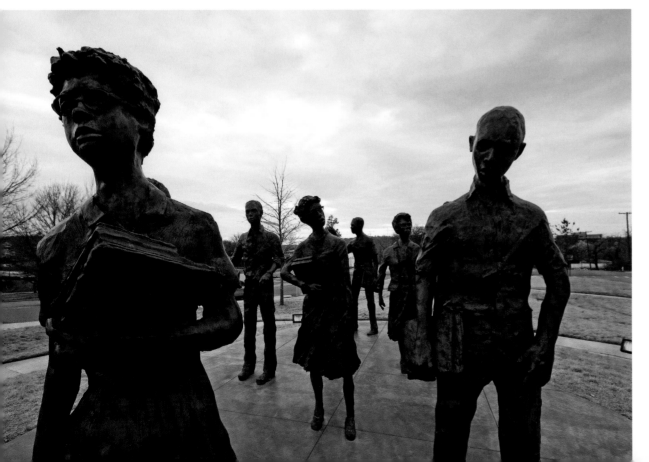

★ **HISTORIC LITTLE ROCK LOCATION** *(above):* Central High School has played a significant part in Little Rock's history. 📷 DICK DUKE

LITTLE ROCK NINE *(left):* The Little Rock Nine statues that sit next to the State Capitol right off Markham Street. 📷 BRYAN THORNHILL/*ARKANSAS DEMOCRAT-GAZETTE*

HEIFER INTERNATIONAL NORTH EXPOSURE *(previous left):* The pond was muddy after a day and night of rain, but the sky was great. 📷 PAUL BARROWS

GARDEN GATE *(previous top):* The entrance leading to the H.U. Lee International Gate and Garden, a memorial honoring Mr. Lee, glows under the night lights. The Gate and Garden is located at the Statehouse Convention Center in Little Rock. 📷 DICK DUKE

CLINTON PRESIDENTIAL CENTER *(previous bottom):* Clinton Presidential Center with a rubber-tired trolley. 📷 PAUL BARROWS

★ **AN ANT'S VIEW** *(opposite left):* Here's an ant's view of Old Main at the University of Arkansas campus at Fayetteville. 📷 ROD JACOBS

ANTHONY CHAPEL *(opposite top):* Anthony Chapel at Garvan Woodland Gardens in Hot Springs. 📷 CHARLES CLOGSTON

ALL GOOD THINGS POINT TO GOD *(opposite bottom):* Majestic view from inside Anthony Chapelat Garvan Woodland Gardens in Hot Springs. 📷 JEANNIE STONE

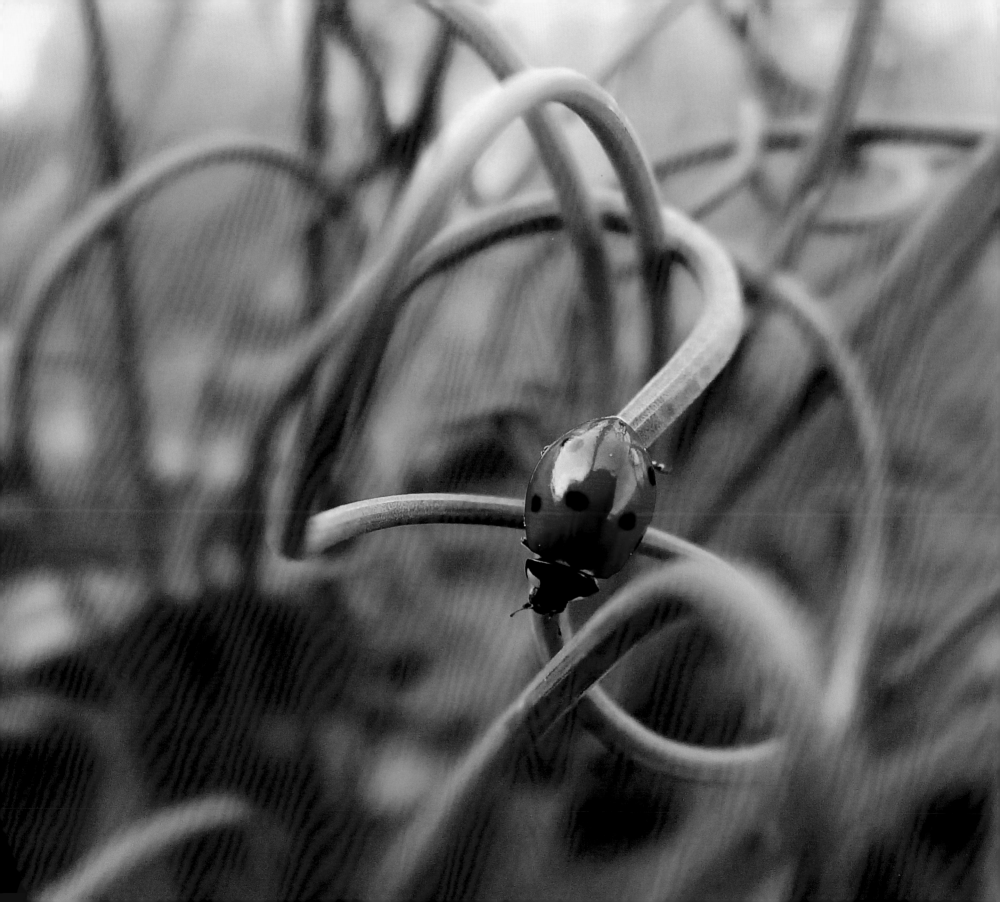

Nature

SPONSORED BY ABRY BROTHERS

There's a reason they call Arkansas "The **Natural** State." Need we say more? Photographers couldn't show us enough. In fact, readers will find that the idea of Arkansas as a home for the great outdoors thoughtfully captured both in the "Nature" chapter and in the Scapes of All Sorts chapter. Arkansas has a lot to show in this regard.

Though we imagine some were stubborn models, we were pleased the photographers took such time and care in photographing life found in nature. Allow yourself to spend some time with the tiny ladybug, the vibrant caterpillar, the curious zebra, the wide-eyed frog and the loving giraffes. Punctuated between photographs of these creatures are plants and flowers of all sizes, shapes and colors.

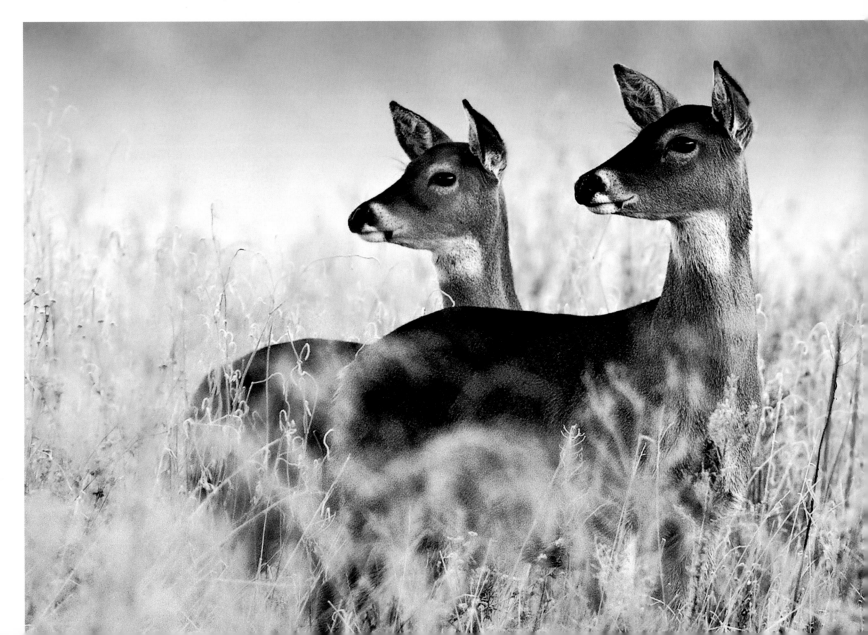

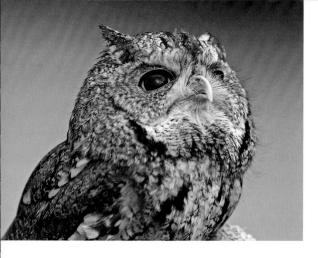

I'M TRYING TO TAKE A NAP (above): Screech Owl looking as if it wants to take a nap. 📷 KEITH DE NOBLE

NATURE'S THEME PARK (previous left): Nature is full of exciting twists and turns. This ladybug enjoys a ride on a green onion rollercoaster. Wheeeee!!! 📷 CHRIS PHILLIPS

FROSTY MORNING WHITETAILS (previous right): Whitetail deer pause to look over their shoulder on the first frosty morning of the year. 📷 MARTY ALLEN

PURPLE WILD FLOWER (right): During their season, these purple flowers line many of the trails at Petit Jean State Park near Morrilton. 📷 RODNEY STEELE

CATERPILLAR (opposite): A caterpillar having lunch. 📷 SAMANTHA SMITH

GETTING A LEG UP (below): A tree frog takes a hike on a canna leaf. 📷 DEBBIE SIKES

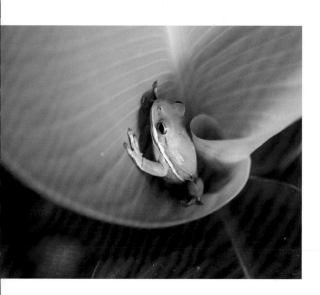

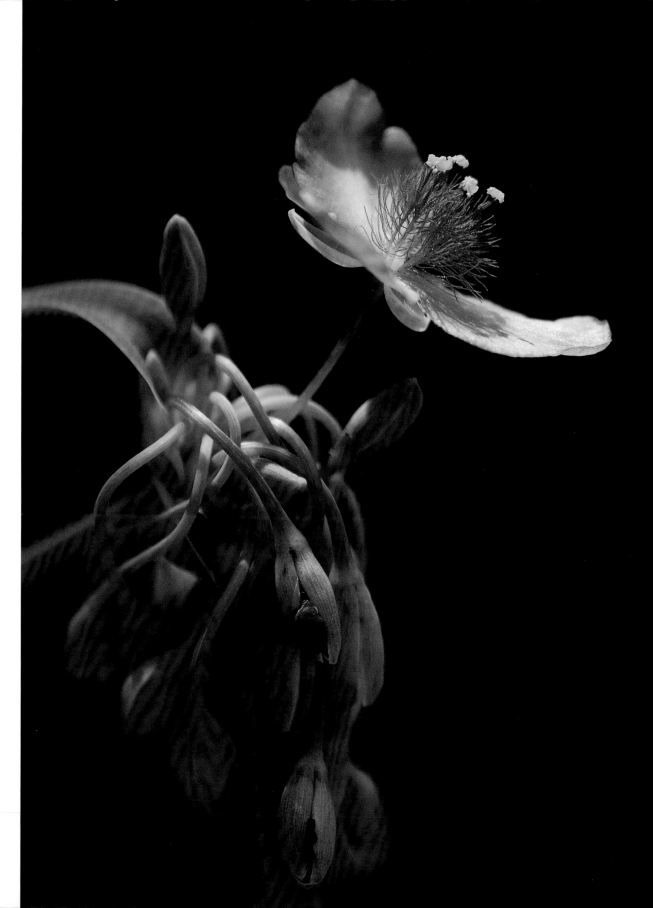

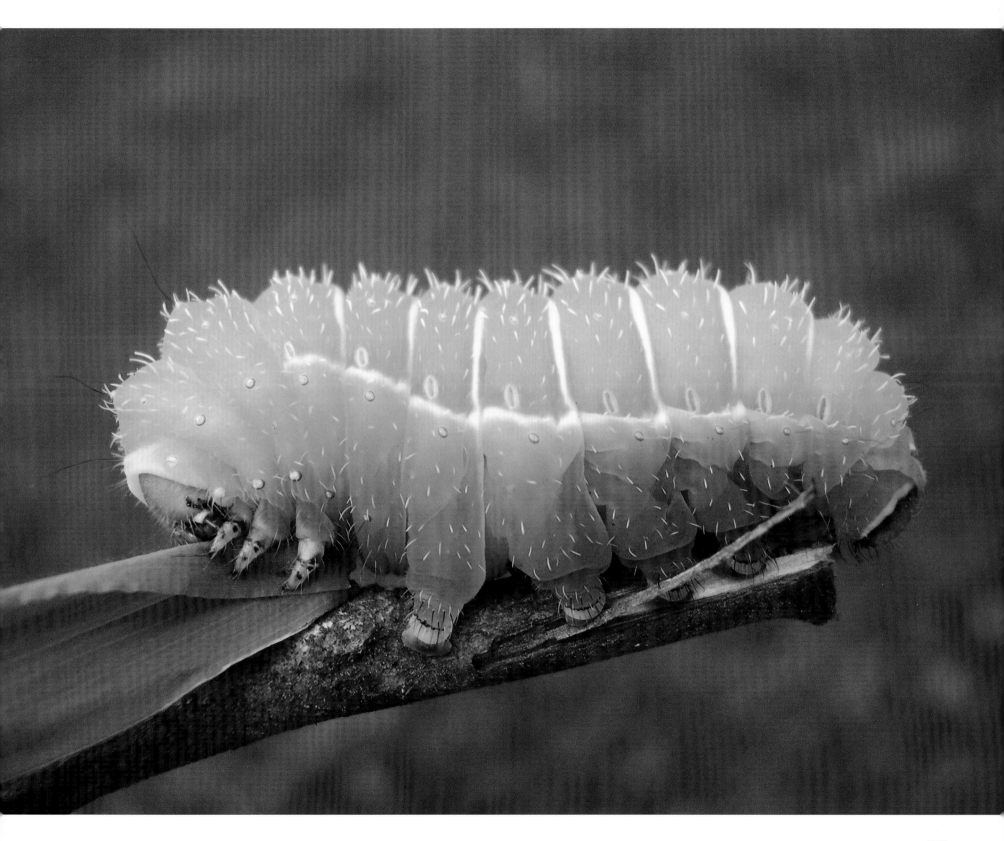

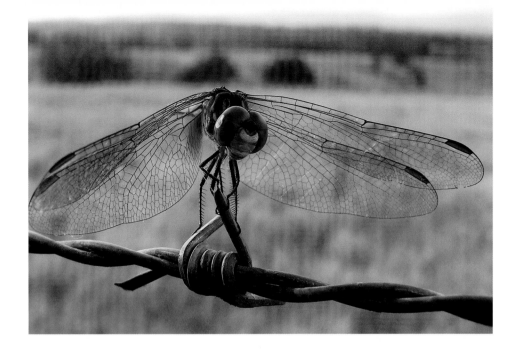

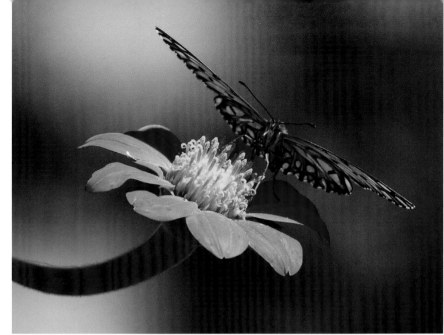

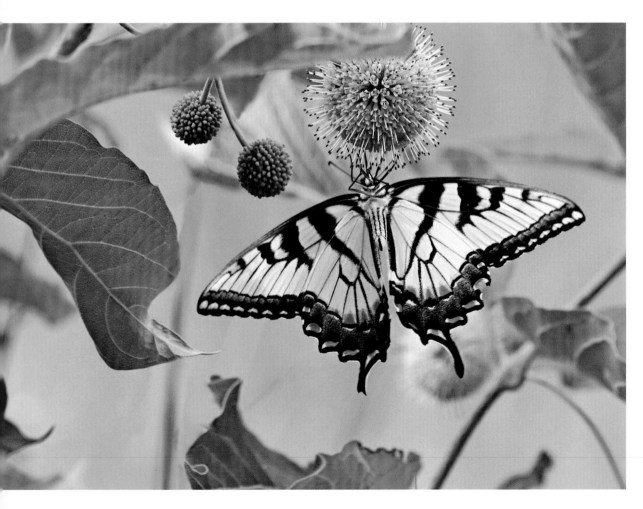

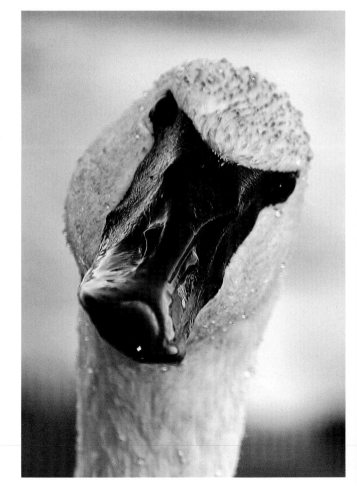

DRAGONFLY (*opposite top left*): Dragonfly on barbed wire. 📷 KATHY SLACH

FLOWER POWER (*opposite top right*): Taken in the Butterfly Garden at Little Rock Zoo. 📷 KAREN GIVENS

ON THE WINGS OF A BUTTERFLY (*opposite bottom left*): I took this picture when we were four-wheeler riding at deer camp. 📷 CAMPBELL DEANN

WILL YOU FEED ME? (*opposite bottom right*): Trumpeter Swan on Magness Lake east of Heber Springs almost asking the photographer as to the whereabouts of the corn. 📷 KEITH DE NOBLE

★ **THE CATCH** (*following left*): The bald eagle was photographed on a very cold morning in January, capturing a shad at this lake. The lake was frozen except for a small area where dozens of eagles continually fed throughout the day. 📷 JASON CRADER

OWL (*following right*): Arkansas River Owl, silently watching 📷 CHARLENE EASON

★ **WHAT?!** (*below*): The nature of curiosity. 📷 NEIL JONES

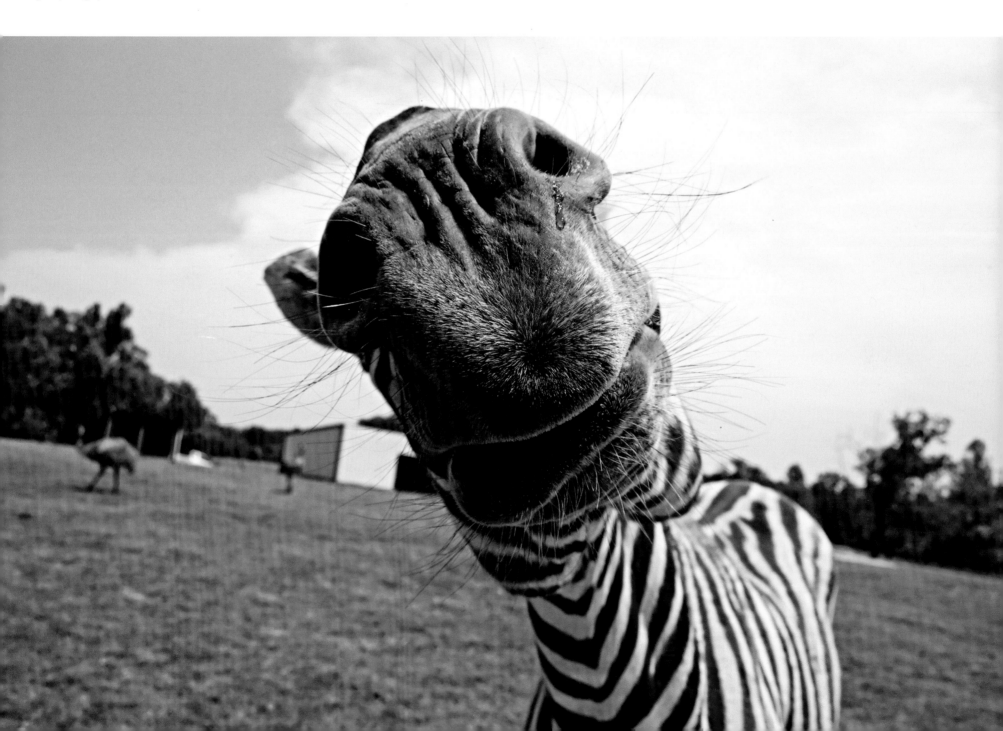

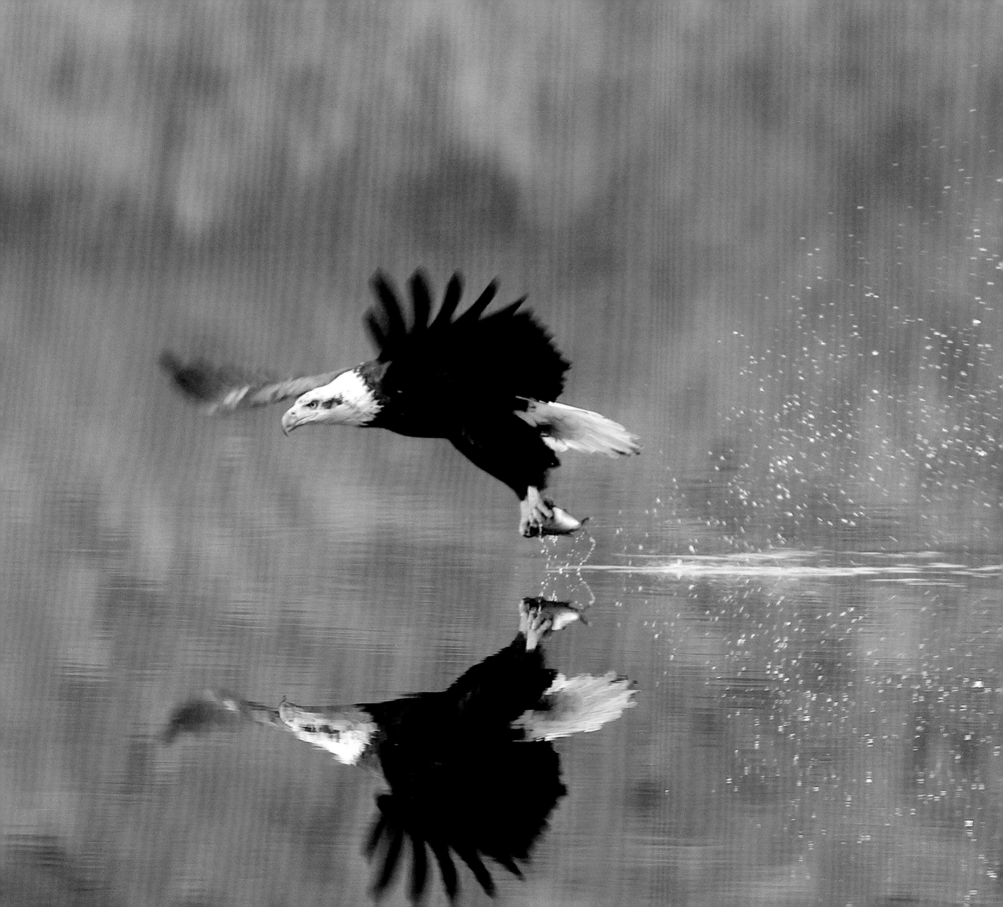

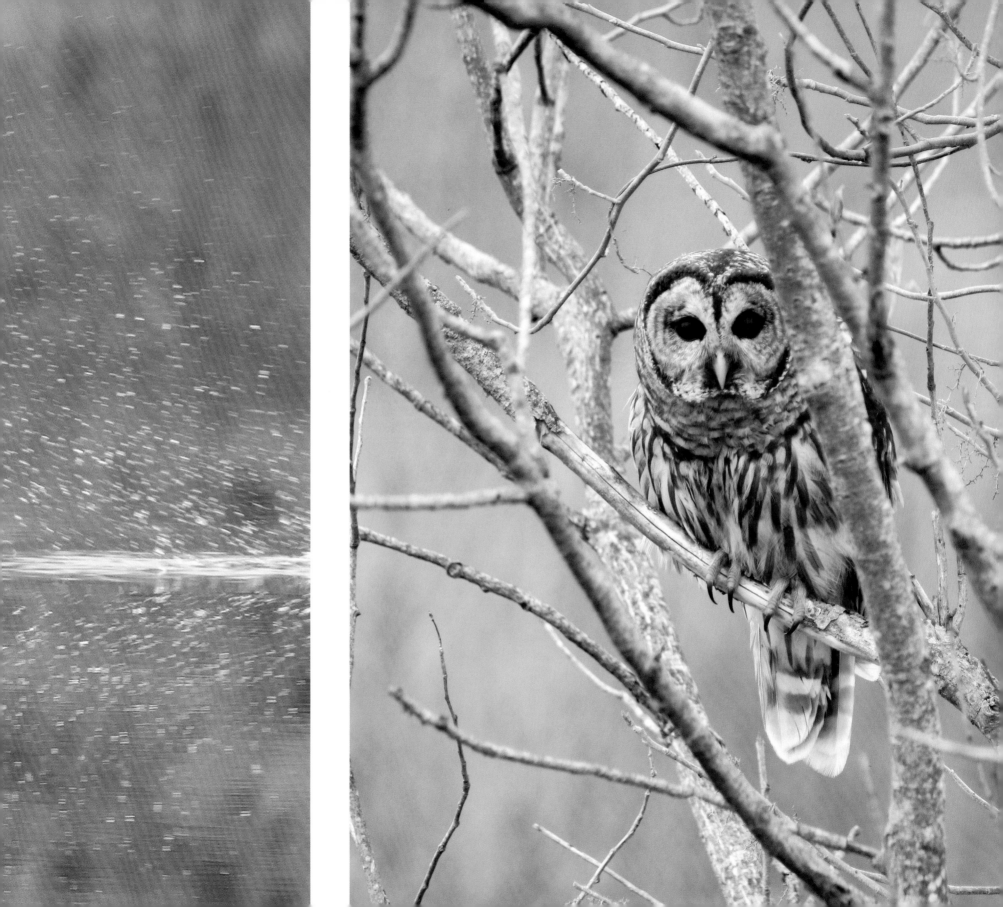

MORNING DEW (*above*): When the sun rises and everything is covered in dew, everything looks great, even the weeds. 📷 MIKE HALL

EASTERN BOX TURTLE (*opposite top*): I found this guy while cutting firewood. I thought he was an especially handsome specimen with so much red when I'm used to seeing more yellow/orange. He was a patient model and let me shoot him for about 30 minutes before he lost interest and left. 📷 DAN MURPHY

SUNFLOWER (*opposite left*): Sunflowers shot on Arkansas 113, just outside Morrilton. 📷 PAUL HAYRE

PEACOCK (*opposite middle*): Trying to impress the girls. 📷 ANITA BIERBAUM

PAINTBRUSH REFLECTIONS (*opposite right*): Dew drops reveal Indian Paintbrush, which is the out-of-focus wash of color in the background 📷 LARRY MILLICAN

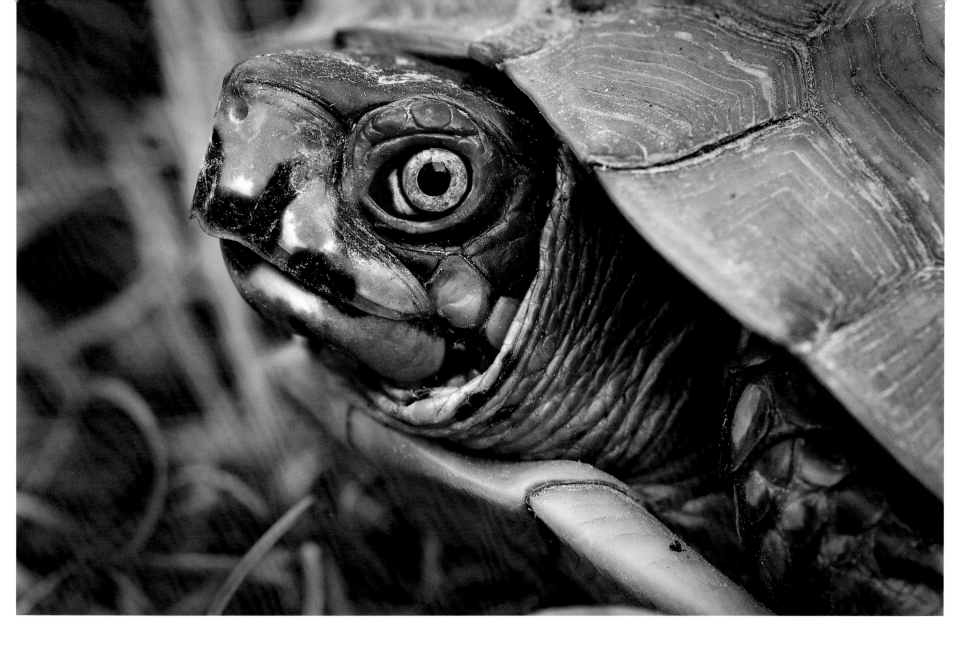

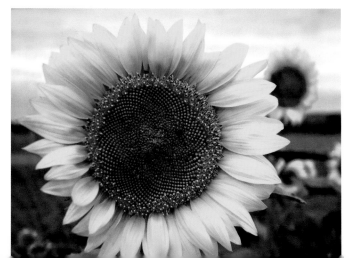

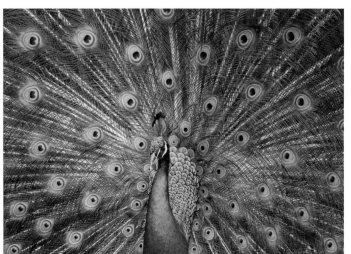

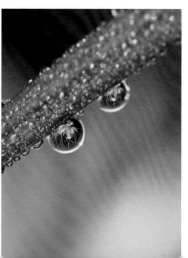

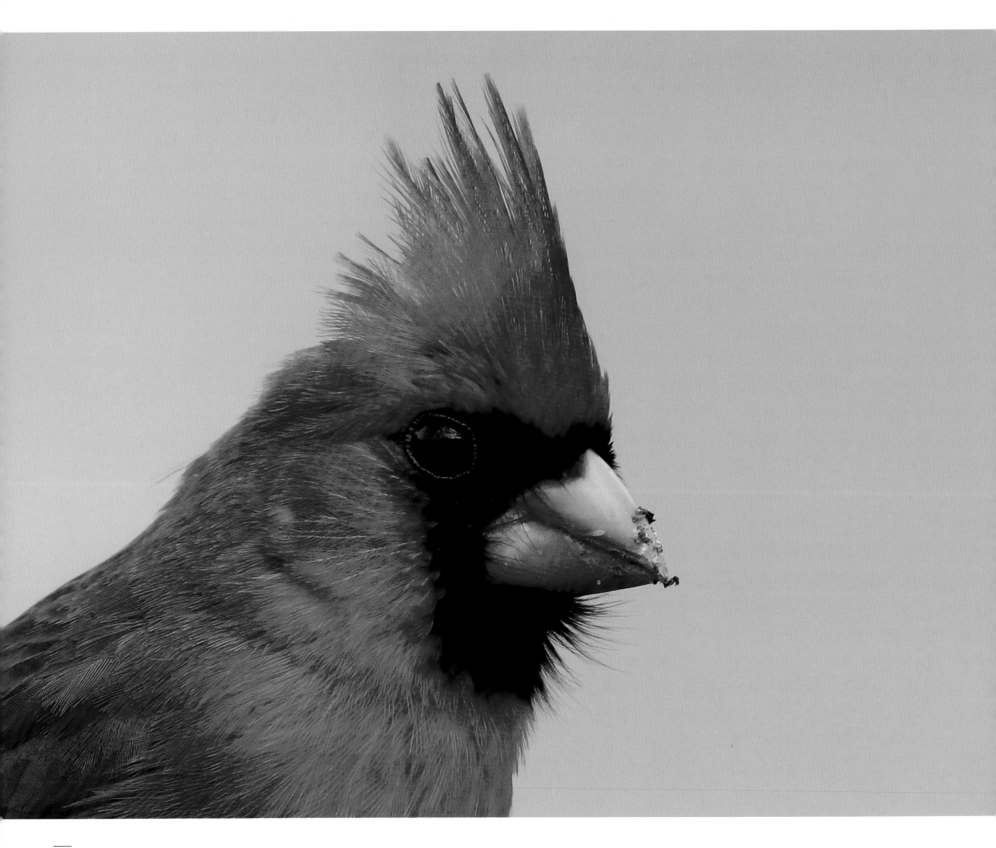

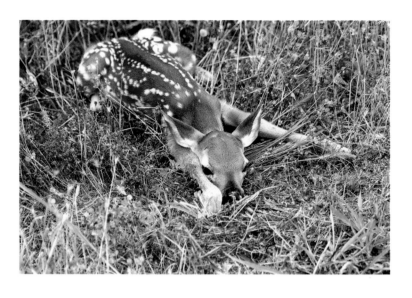

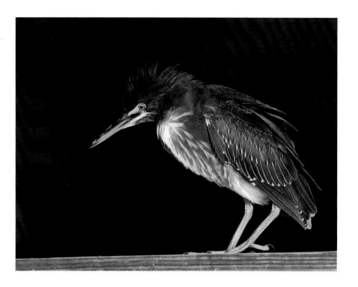

LAKE WOFFORD GREEN HERON (*left*): A Green Heron photographed at sunrise on a boat dock railing on Lake Wofford located one mile south of Bonanza. 📷 JERRY STEWART

WHITETAIL FAWN (*far left*): A newborn whitetail fawn hiding in the grass at Fort Chaffee in Fort Smith. 📷 JERRY STEWART

THE KING (*opposite*): This image of the male northern cardinal was taken at my bird feeders. I used a 400 millimeter lens to get up close. 📷 RUSTY WOOD

ARKANSAS ELK (*below*): Fall elk near Ponca. 📷 DAN MURPHY

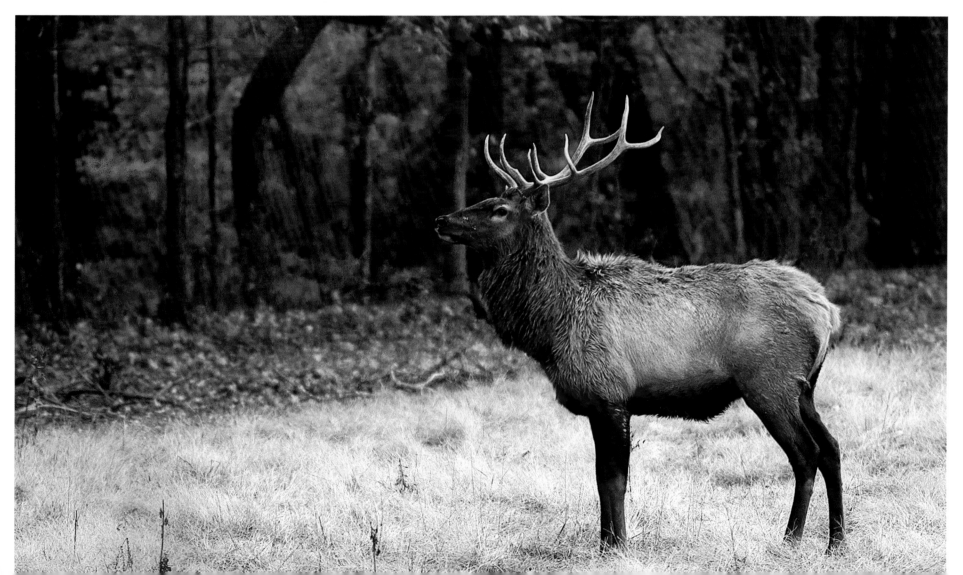

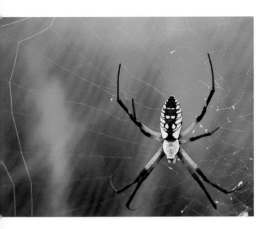

FEMALE YELLOW GARDEN SPIDER (*above*): A female yellow garden spider (Argiope aurantia) that I came across in a wetland in Chicot County. 📷 PHIL TAPPE

ARKANSAS GATOR (*right*): This gator was trying to play possum while it sized us up. 📷 JOHN WILLIAMS

ROUGH GREEN SNAKE (*far right*): Rough green snake in the Ouachita National Forest. 📷 REX LISMAN

LITTLEST BOX TURTLE (*following top*): A baby box turtle posing on an elephant ear. 📷 ANDREA RAZER

RAINDROPS (*following bottom*): Rain drops on the plant looked like it would be a great photo. 📷 RON MURRAY

★ **TUCKED AWAY** (*following right*): Gray tree frog hiding in the leaves. 📷 BOB SHULL

KERMIT THE FROG (*below*): Noticed a cute frog climbing up the tree in my yard one afternoon. Taken in River Oaks near Searcy. 📷 DR. JEFF HENNING

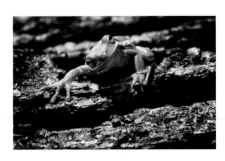

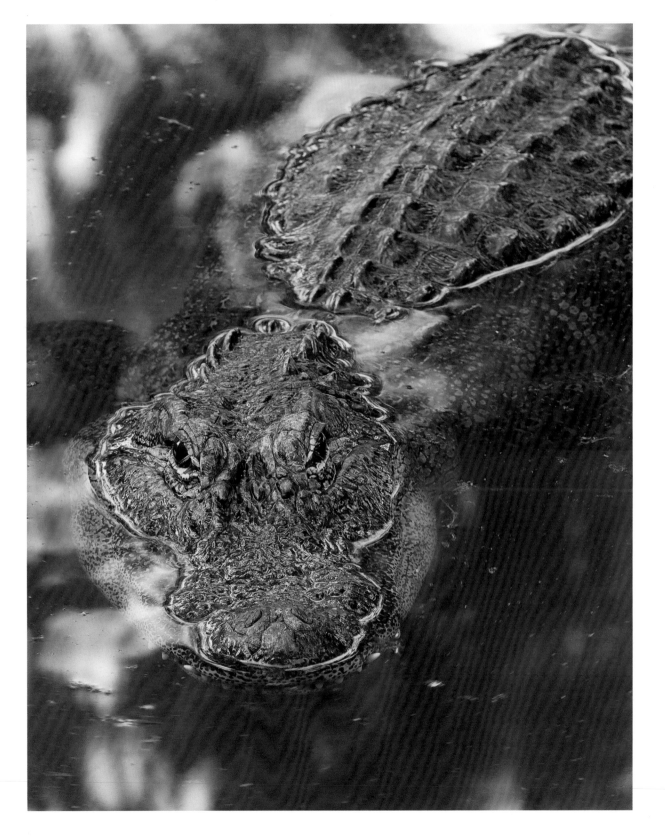

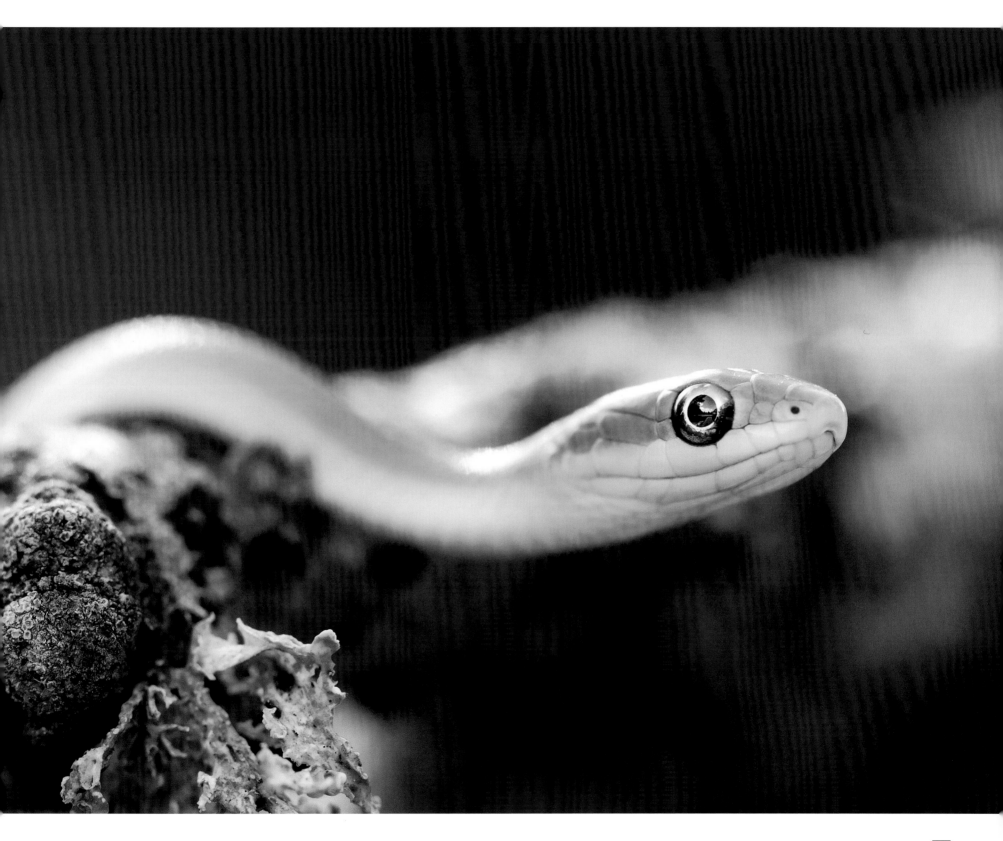

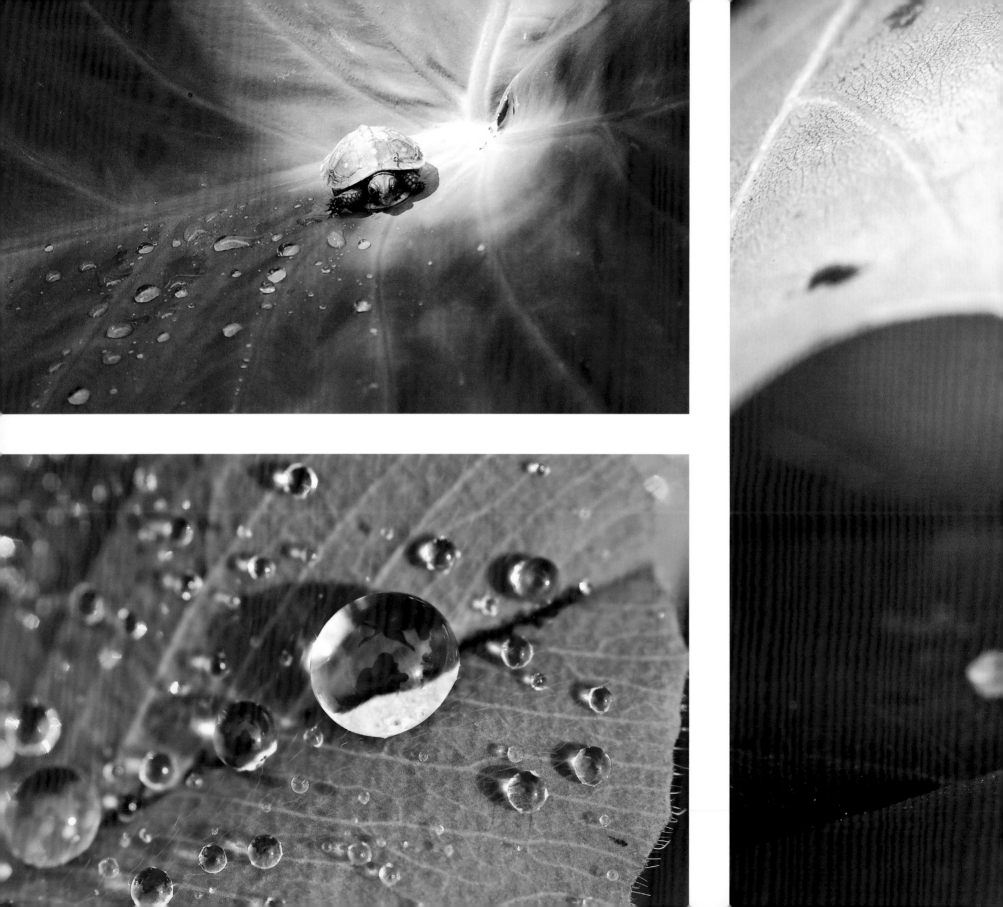

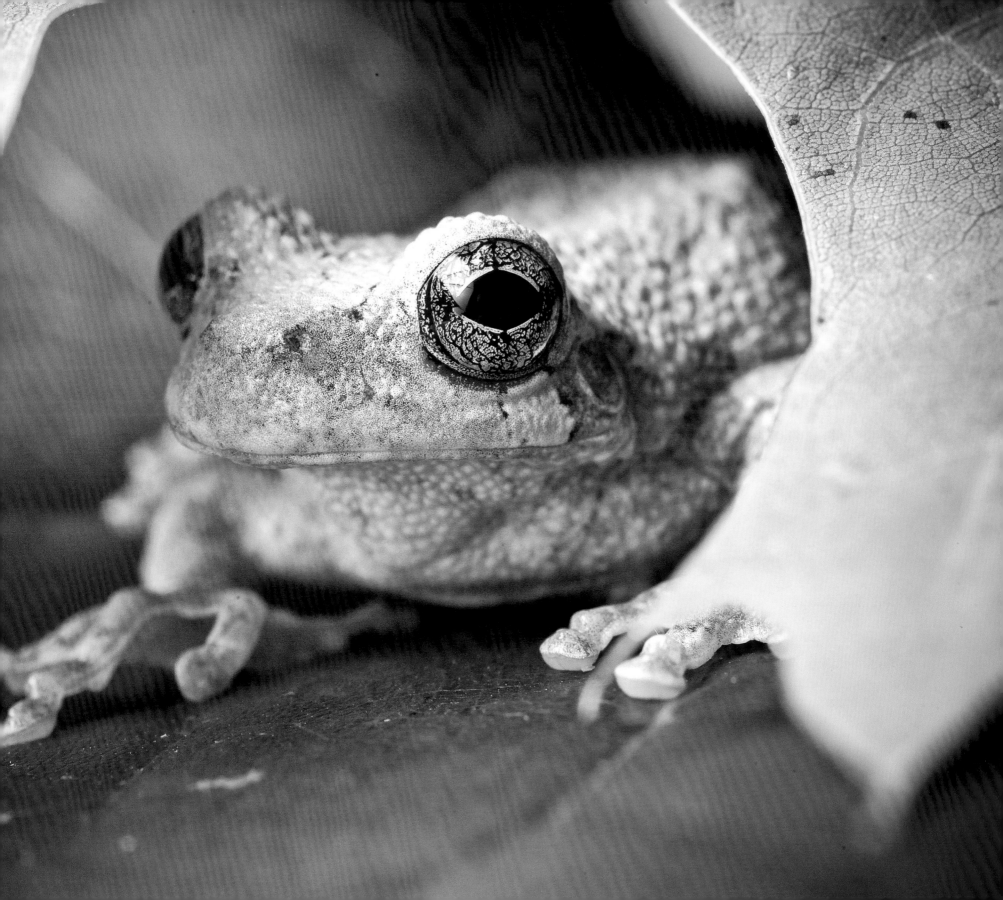

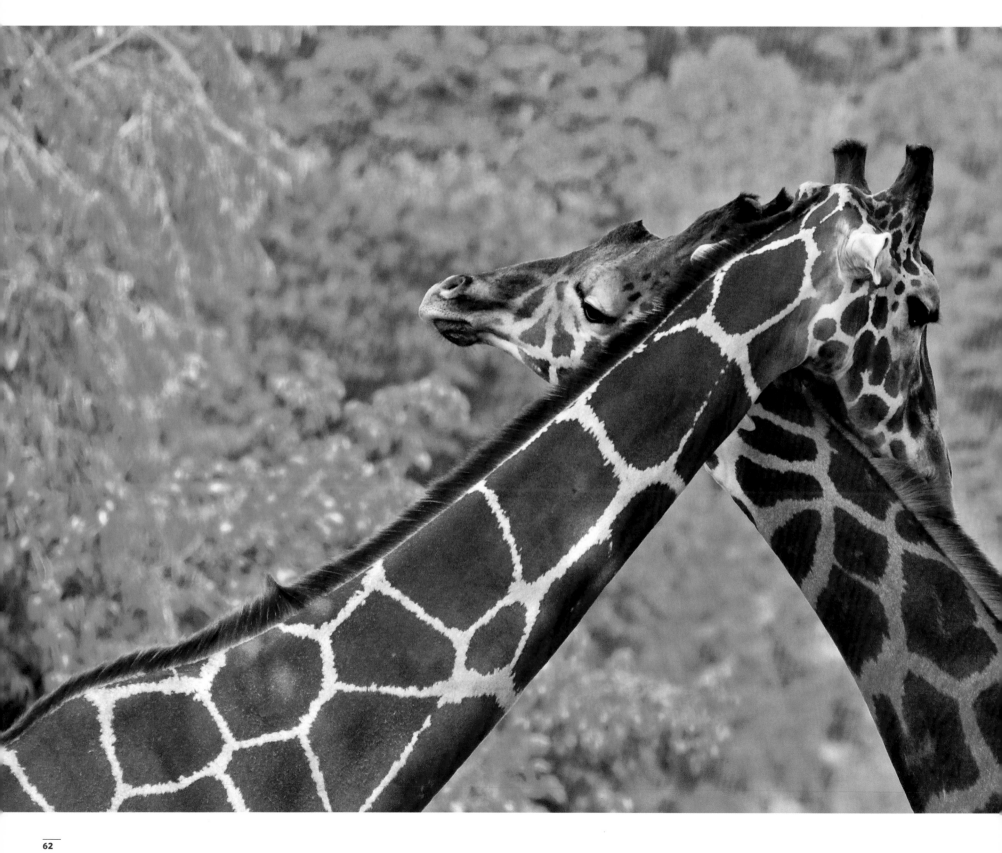

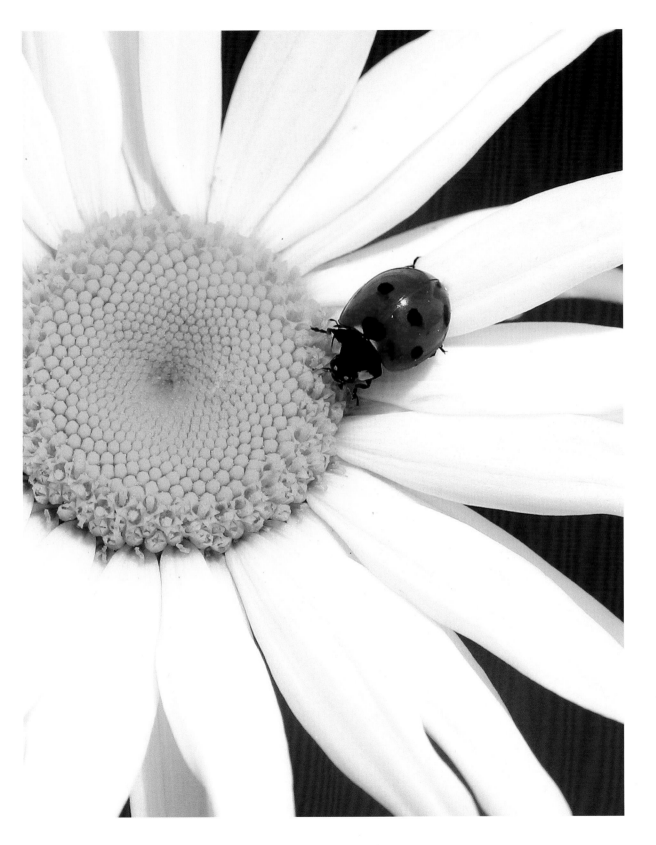

A TENDER MOMENT (opposite): This is a loving moment between what appears to be a mother and child at the Little Rock Zoo.
📷 DICK DUKE

LADYBUG ON A DAISY (left): A flower for the Lady in Red!
📷 SHAWN & JOHN CARRELL

TRUMPETER SWANS (following left): Each November through March, trumpeter swans migrate to a small lake just south of Heber Springs on Arkansas 16. You can tell their age by their color. The younger, the browner the feathers. Most swans grow to about 35 pounds. Here are three preparing to land. 📷 GARY MARSHALL

CURIOUS (following right): Gambel's Quail — Beautiful gamebird found throughout our Natural State. Photograph taken at the Gentry Drive-Through Safari. 📷 CAROLYN WRIGHT

PRAYING (below): God, please help me remember where I put that nut. This one was taken on top of my bird feeders on a rainy day.
📷 RUSTY WOOD

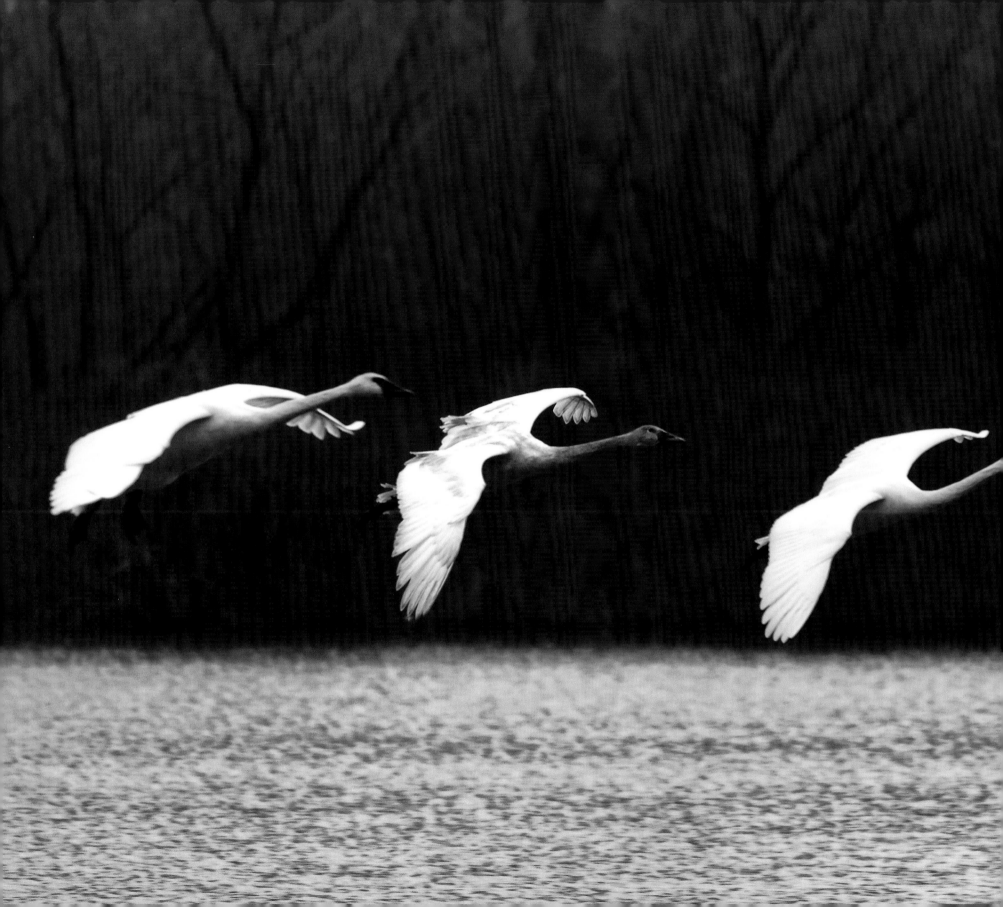

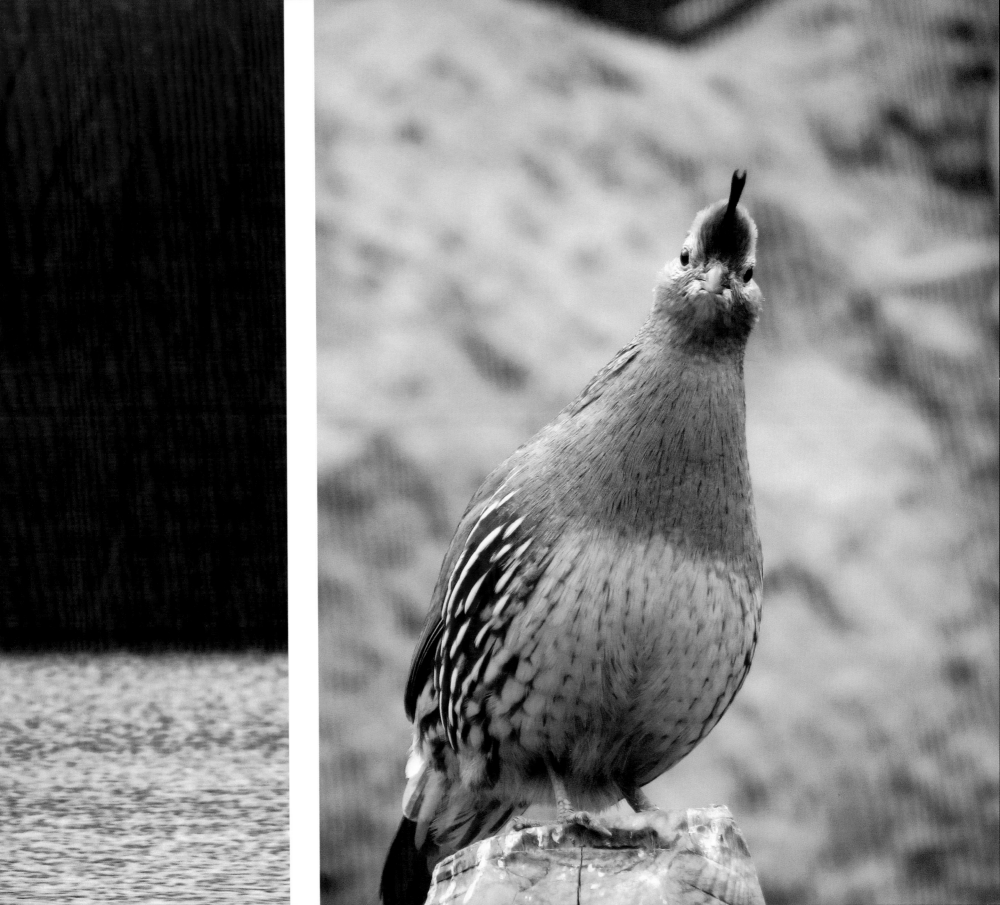

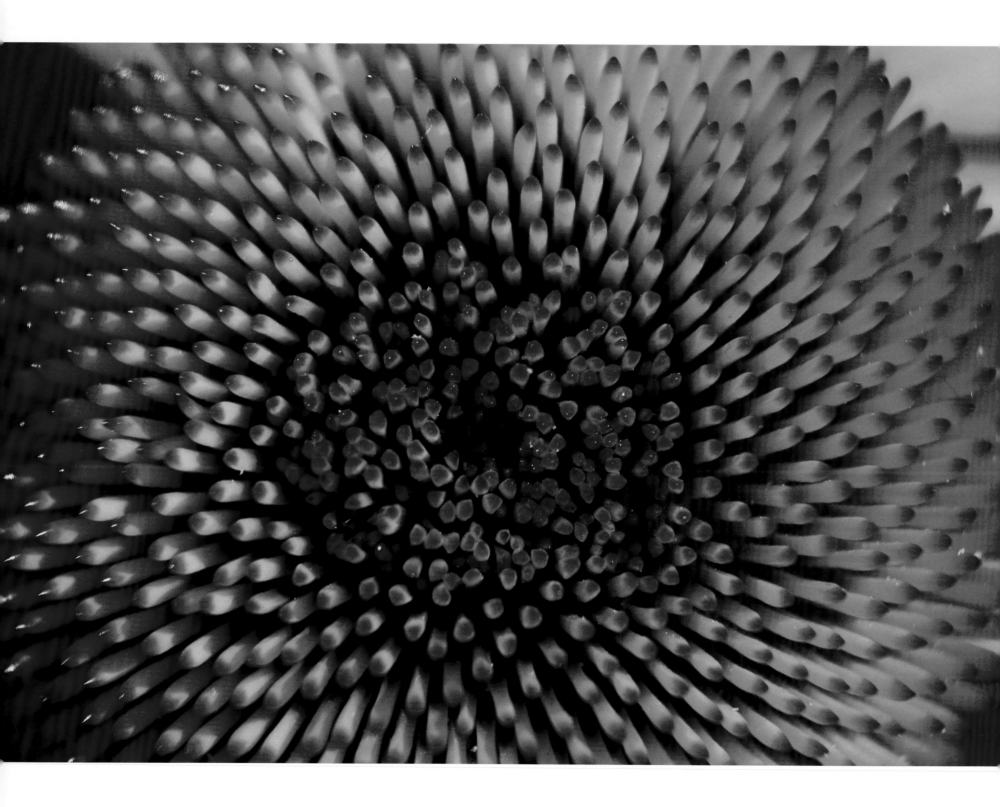

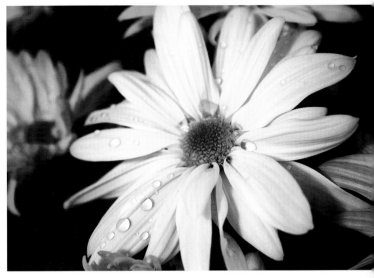

KISSED BY THE RAIN (*above*): After an evening shower in the yard.
📷 DEB CARTER

CLOSE UP (*opposite*): Macro shot of a purple coneflower at the Fayetteville Square gardens. 📷 ROD JACOBS

LILY (*top*): I took this shot in my mom's yard south of Little Rock.
📷 RUSTY WOOD

SPRING MORNING (*bottom*): Wild blue Spiderwort on a hillside near the historic mining town of Rush near the Buffalo River. 📷 JERRY WILCOXEN

SHREK EARS (*following left*): Photographed at Fayetteville's new Botanical Gardens. 📷 JENNIFER SMITH

WOLF SPIDER IN THE BACKYARD (*following right*): This wolf spider made the mistake of walking across my patio when I had my camera out with my macro lens. 📷 MATT MCCLELLAN

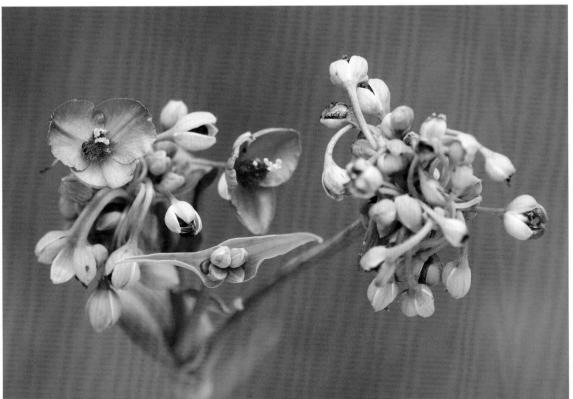

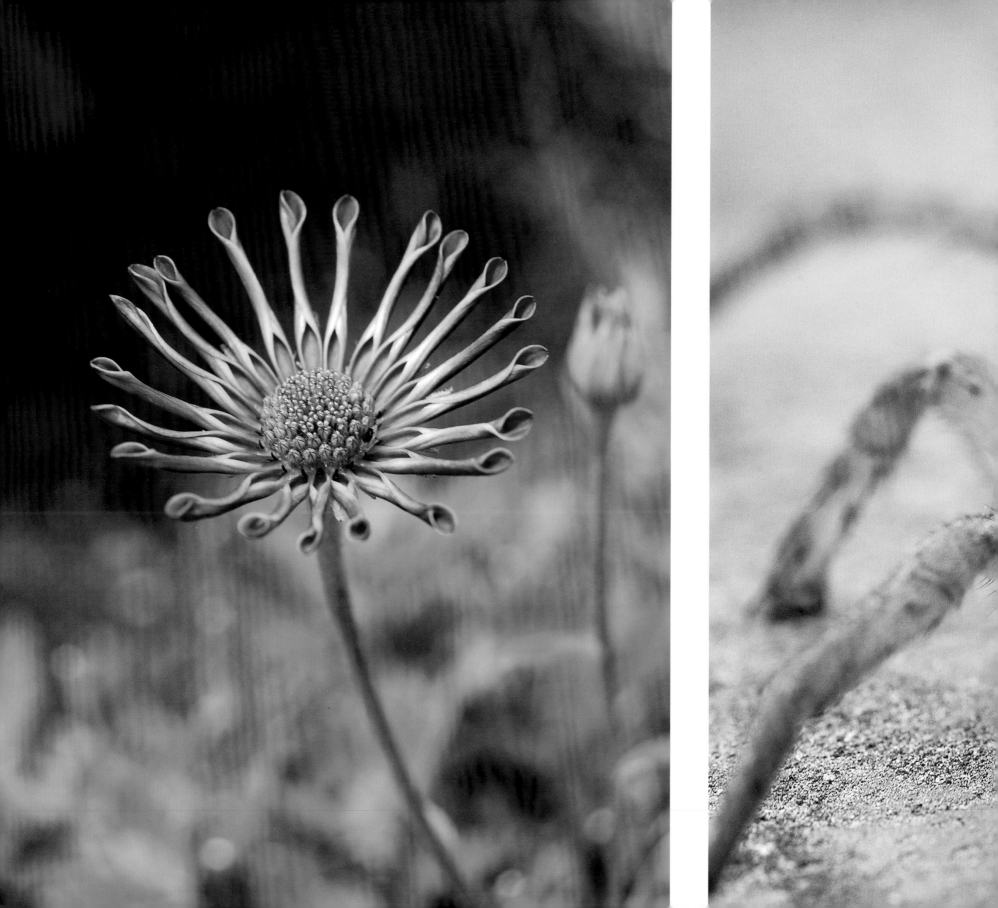

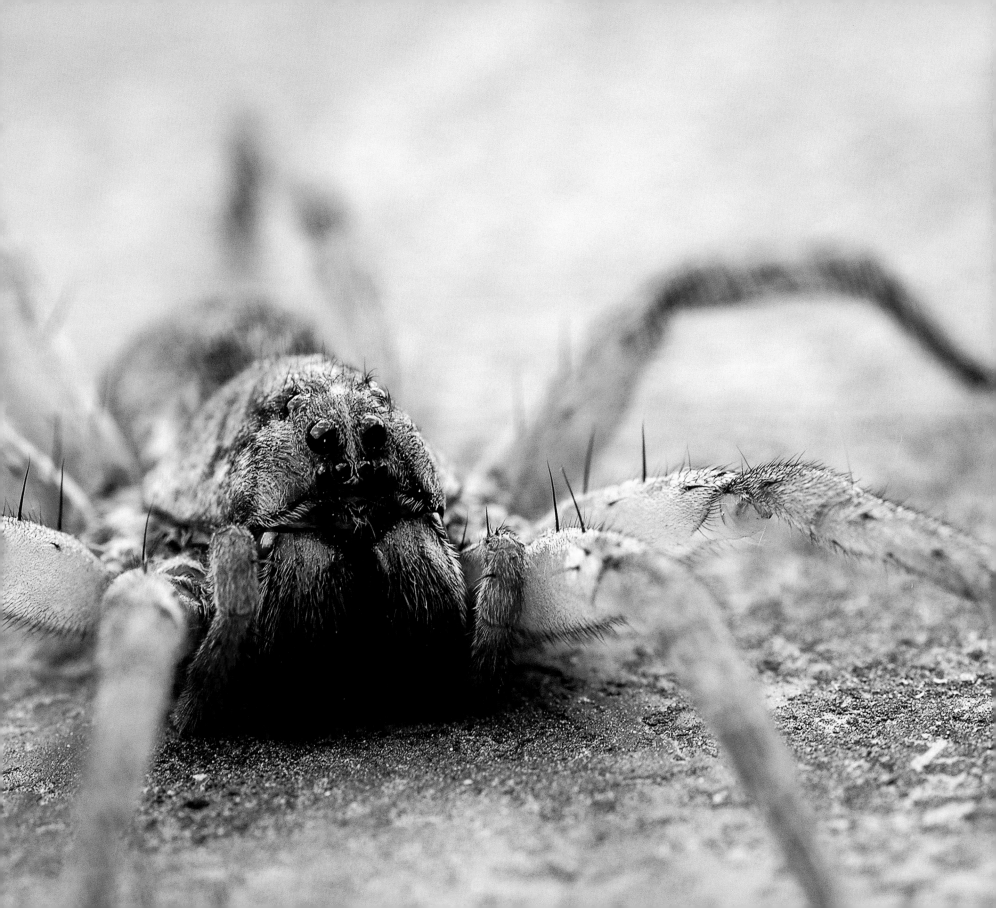

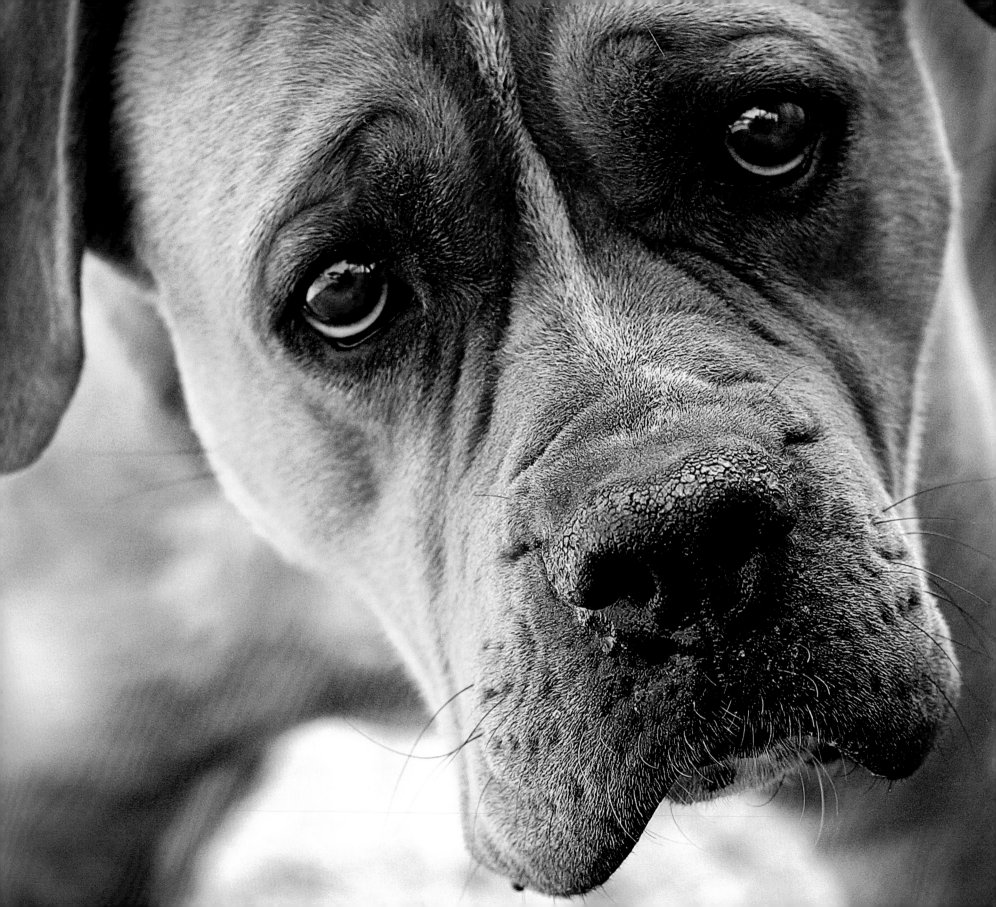

Pets

Oh how we adore our sweet pets. We bathe them, feed them and sometimes clothe them. We care for them as our children and photograph them just as much.

One can't go wrong publishing a book that shows cute puppies, furry kittens and graceful horses. So snuggle into a comfy lounge chair and enjoy with ease the kitten snuggled underneath his yellow blanket, the basset hound snuggled between the arms of a young boy and the cow "snuggled" between the broken fence rail. You can't help but feel all warm and fuzzy inside.

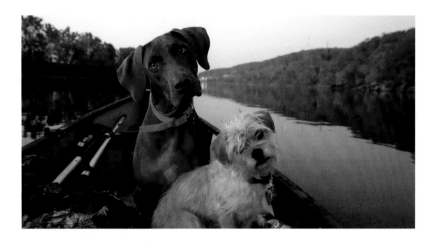

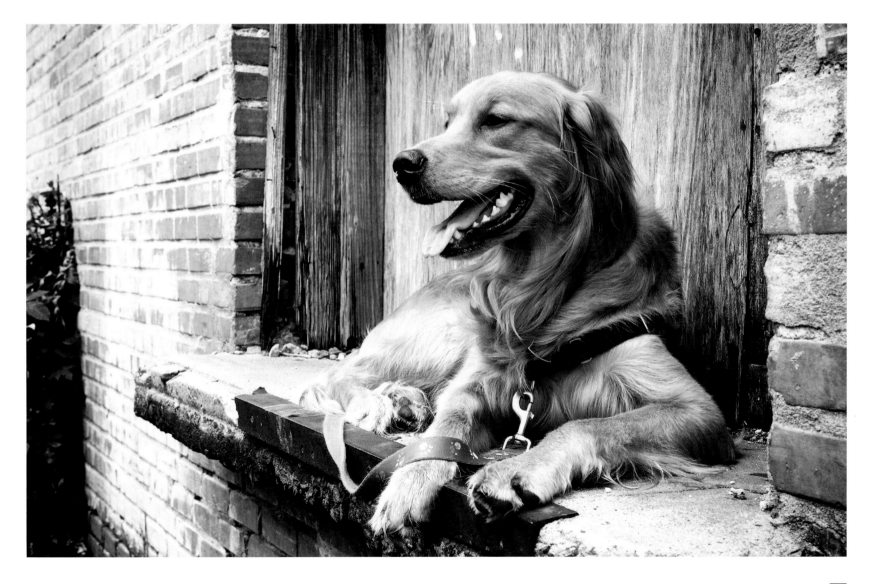

INQUISITIVE *(previous left):* Ever feel like you're being watched? 📷 BOB SHULL

★ **FISHIN' BUDDIES** *(previous top):* Sadie and Peanut. 📷 MARK MUSGRAVE

COOPER *(previous bottom):* A happy dude on a gray day. 📷 RICHARD RYERSON

DOG SWIM *(right):* Zeke, a golden poodle, shakes after emerging from the pool during the annual Dog Swim at Jim Daily Aquatic Center at War Memorial Fitness Center in Little Rock. 📷 RUSSELL POWELL/ *ARKANSAS DEMOCRAT-GAZETTE*

THE SPRINKLER *(opposite):* Dogs and sprinklers equal hours of entertainment. 📷 RICHARD RYERSON

RAZORBACK BAGGO *(below):* My cat, Sophie, overlooking a game of Razorback Baggo. 📷 JULIA NOBLE

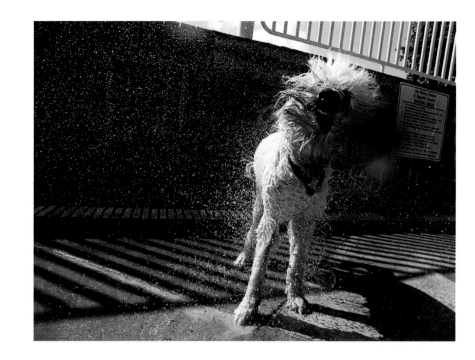

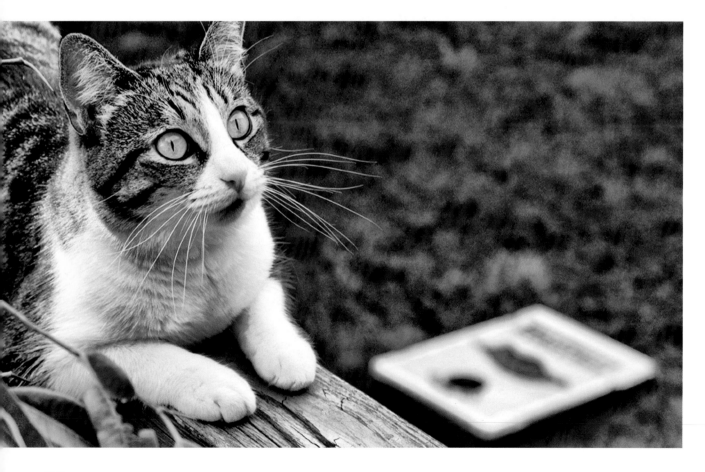

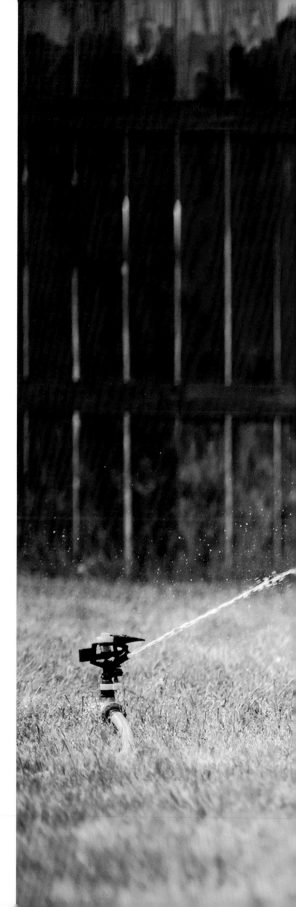

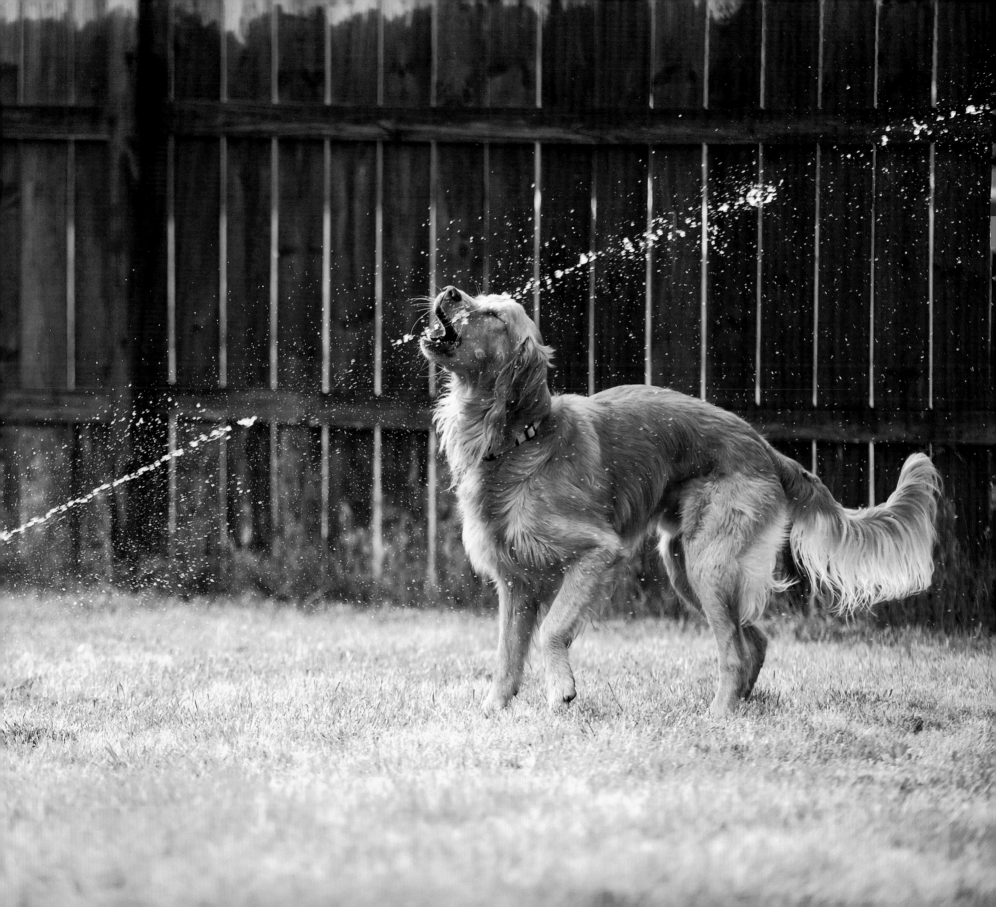

FOREST'S STICK *(right):* Forest loves his stick.
📷 BRYAN CLIFTON

FRAMED! *(below):* Our cat at the end of a tube — it made a cute frame. 📷 KELLY ROSTAGNO

DINNER BELL *(bottom):* Bird dog litter of nine each getting its share of the grub. 📷 PAUL HAYRE

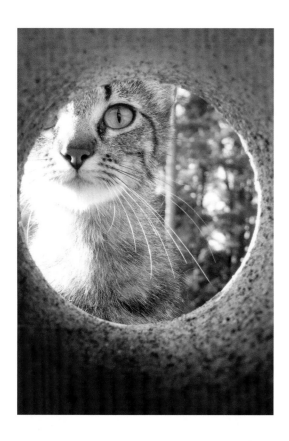

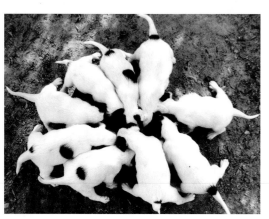

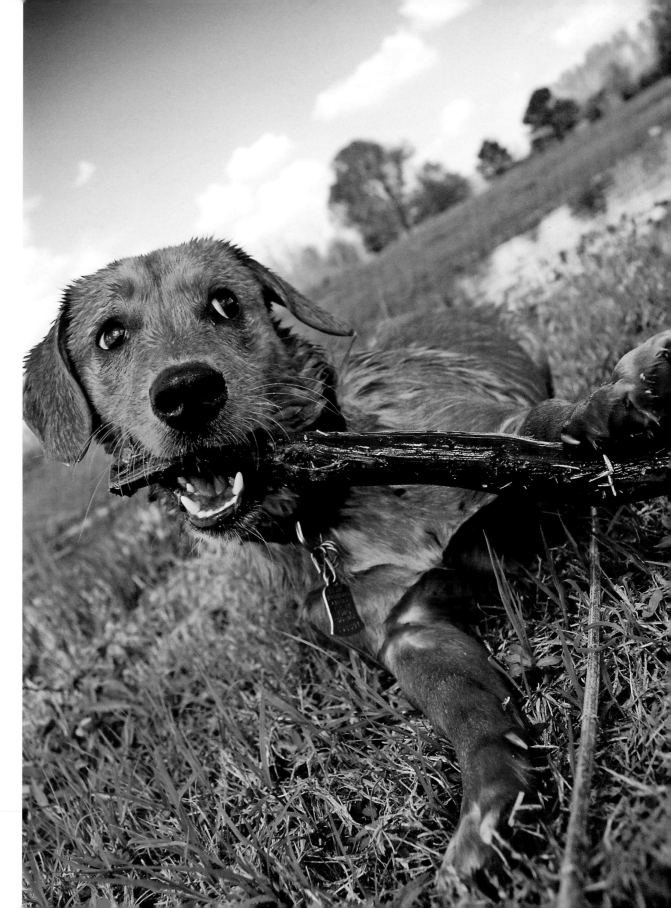

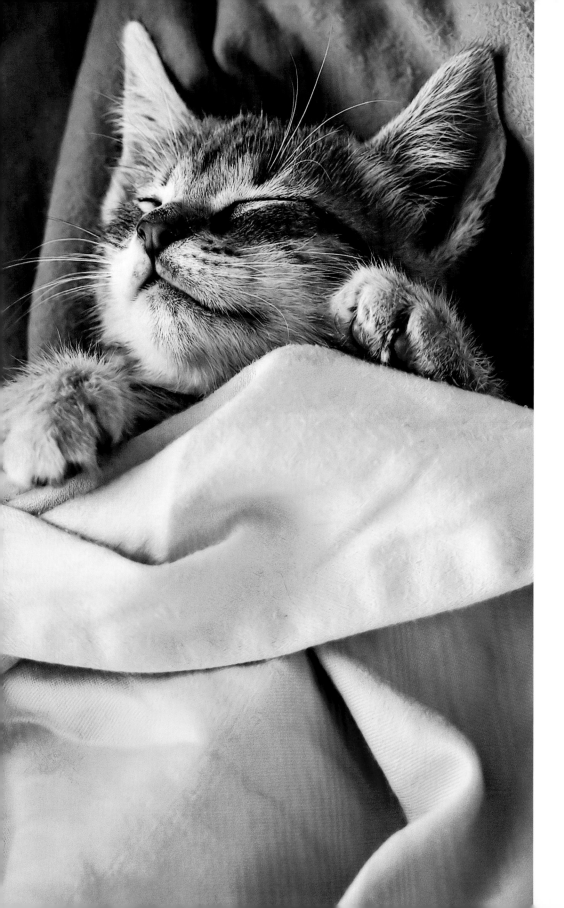

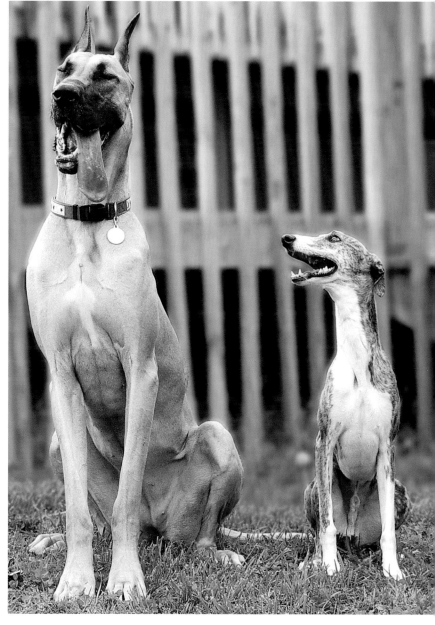

★ **THE NEXT BIG THING** (*above*): Sit tall, sit proud... but no matter how big you think you are, there's always someone bigger! Kelsey (Great Dane) and Salvador (whippet).
📷 CHRIS PHILLIPS

SLEEPING KITKAT (*left*): KitKat fell asleep underneath the sheets, giving me a perfect chance for some really cute photos. 📷 CHRIS BURNS

★ **BLOSSOM** *(right):* My neighbor Rusty Smith holding Blossom, my bloodhound puppy. 📷 ZACK JENNINGS

ACT ONE, SCENE TWO *(opposite):* My dog, Argos, prepares for another take in his dogumentary. In reality, he just wanted another treat. 📷 MARK MONDIER

HEADACHE *(following left):* You see some interesting things when you live on a farm. This cow got stuck being a bit too greedy in its search for hay in an old barn. 📷 JASON CRADER

THAT'S THE SPOT *(following middle):* Arabian stallion rubbing the back of a cat. 📷 SHARON MORRIS

FIRST MEETING *(following top right):* Taken last summer when our Arabian colt met a filly for the first time. 📷 KAREN GIVENS

READY TO GREET THE WORLD *(following bottom right):* This little fellow has a lot of growing up to do but he seems really happy. 📷 ROBERT BURAZIN

DACHSHUND PUPPY *(below):* Wiener puppy. 📷 DIXIE KNIGHT

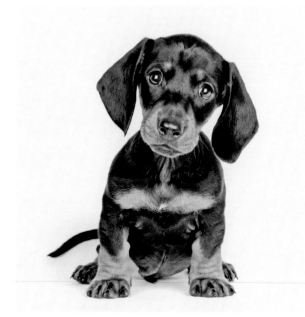

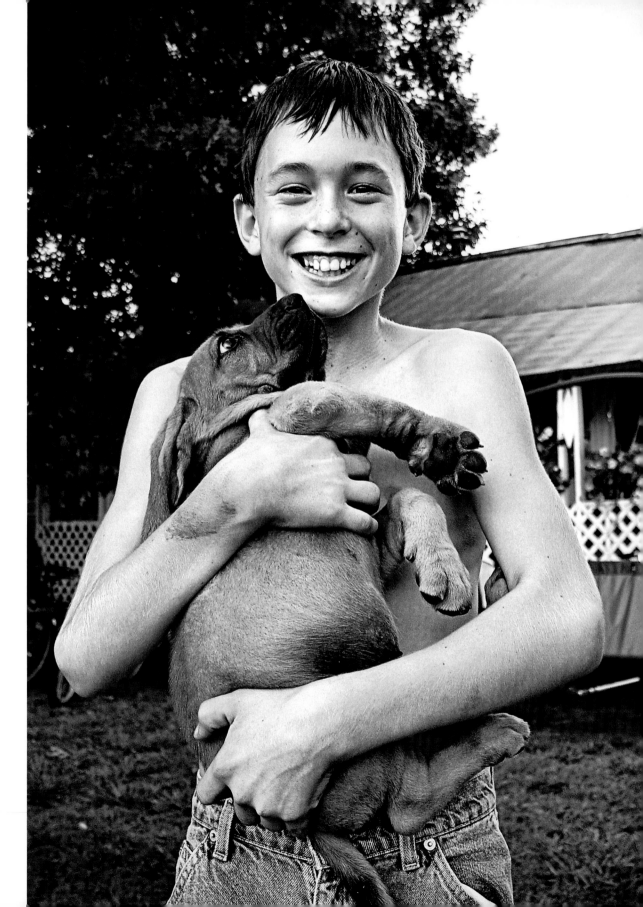

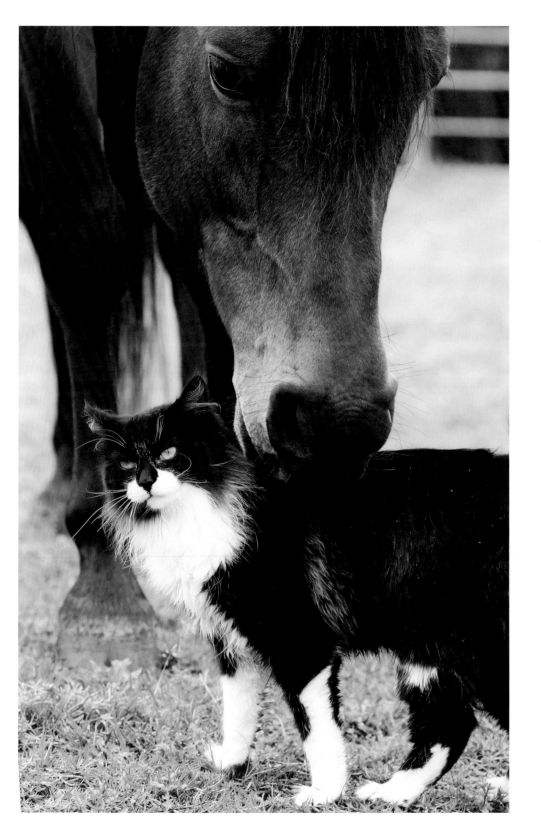

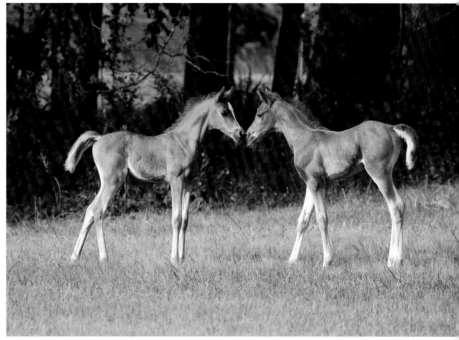

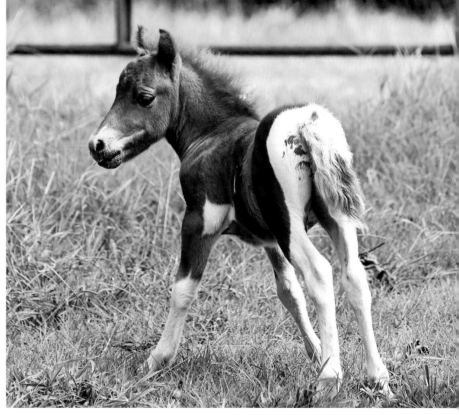

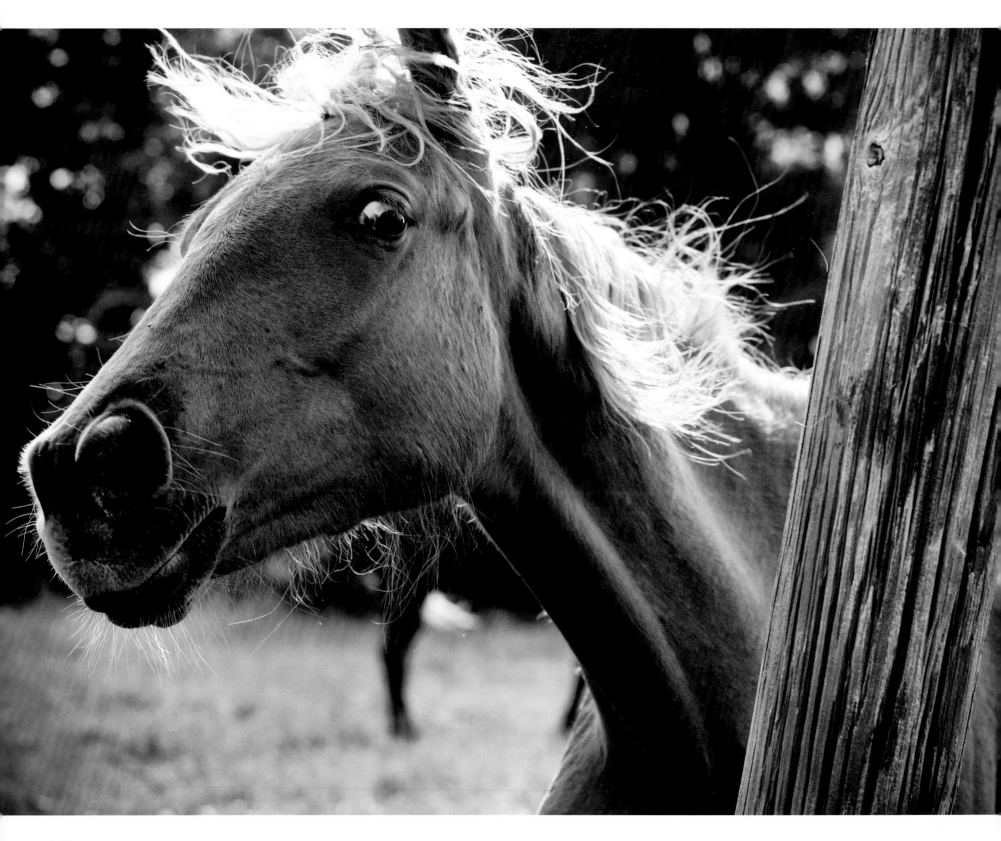

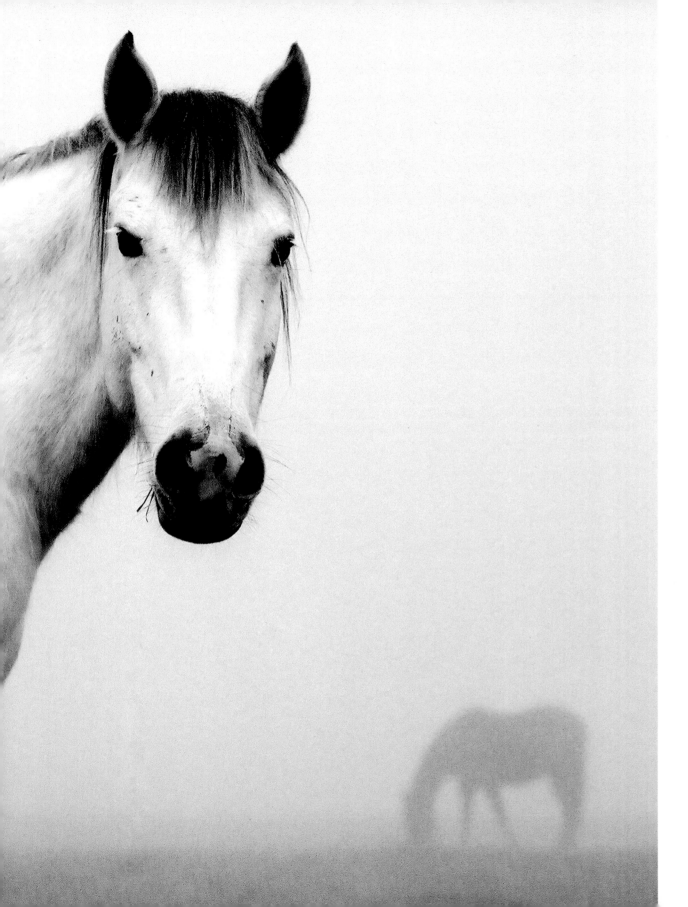

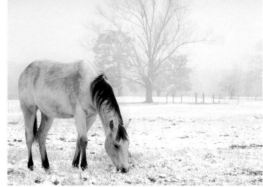

WINTER GRAZING *(above):* A friend of mine owns this horse on a farm in Genoa, and I happened to be driving by about 7 a.m. on the only day we had snow instead of ice. 📷 ROZANA PAGE

FOGGY MORNING HORSES *(left):* Horses enjoy a quiet, foggy morning on the Southern Arkansas University farm in Magnolia. 📷 AARON STREET

HORSE VS. POLE *(opposite):* A horse gazes intensely at a fence post in Little Rock. (No fence posts were harmed in the making of this image.) 📷 MARK MONDIER

KING OF THE SNOW *(below):* Arabian stallion King running through the snow 📷 STACEY BATES

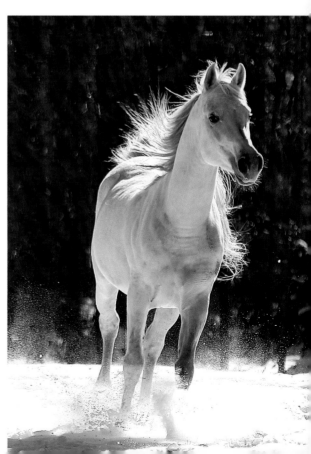

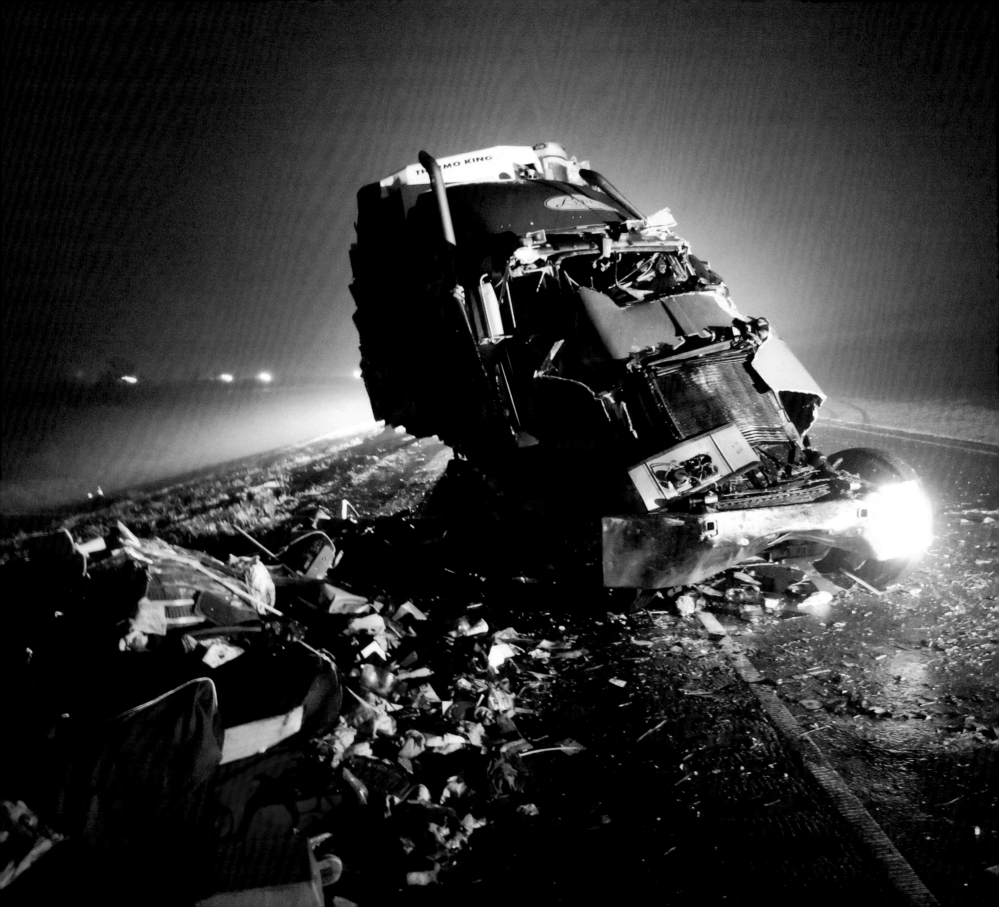

Newsworthy

News is defined in many ways, but we define it in one: An event that happened. Period. We kept it pretty simple. Of course, to make it into the book, the photo had to tell us something and mark a significant moment in time that might allow the opportunity to remember and reflect. Whether the photographer captured tragedy, heroism or ceremony, these moments define our history.

Many of the photos show life-changing occurrences. The impact of Mother Nature is illustrated through the aftermath of a tornado that ripped apart a community, rains that flooded city streets and parks and snow that blanketed the countryside. These photos also portray resolve to continue on and fight back, as well as reverence and honor for those no longer with us.

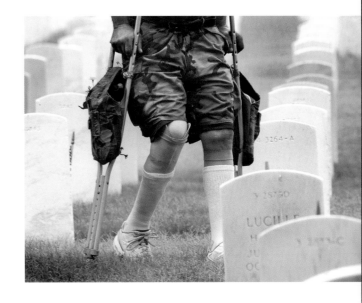

A VETERAN REMEMBERS (*top*): Veterans Day 2006. A Veteran Remembers … and so should we. 📷 KIRK JORDAN

SPRING FURY. (*below*): Spring did a number all over Arkansas. The Bull Shoals dam had to be opened for the first time in some 30 years. 📷 ROBERT BURAZIN

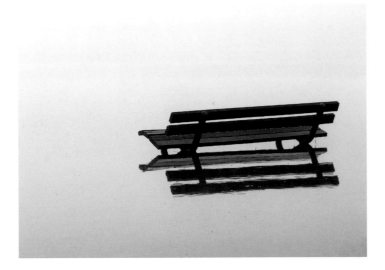

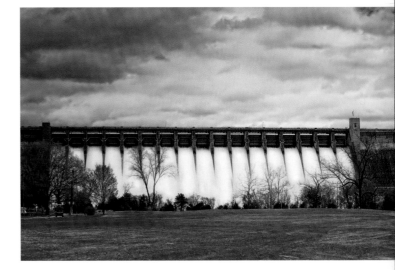

SOLITARY BENCH (*above*): A bench at Beaverfork Lake during extremely high water and thick fog. 📷 MATTHEW KENNEDY

UNTITLED (*left*): A demolished tractor-trailer sits on Interstate 40 near the 252 mile marker in St. Francis County as crews work to clear a multiple-fatality accident. Several vehicles, including a bus, a tractor-trailer and a pickup, were involved in the accident. 📷 STATON BREIDENTHAL/*ARKANSAS DEMOCRAT-GAZETTE*

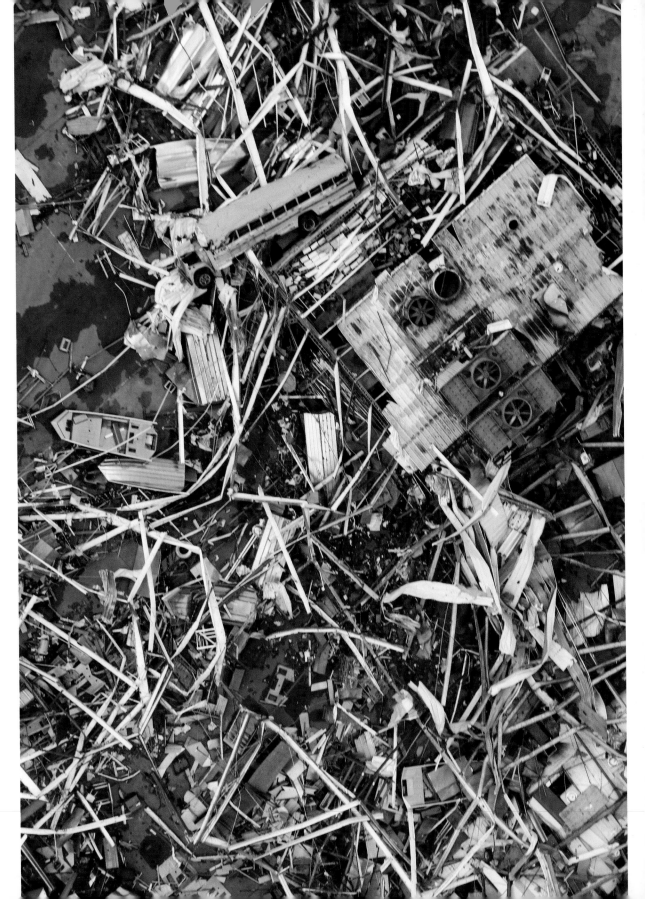

TORNADO AERIAL *(right)*: A school bus sits in the wreckage of RiverTrail Inc. boat factory in Clinton. The tornado traveled more than 100 miles across Arkansas without leaving the ground and killed 13 people. 📷 BENJAMIN KRAIN/*ARKANSAS DEMOCRAT-GAZETTE*

★ **NOW THAT THE DAY IS DONE** *(opposite top)*: Military men in crisp attire retire Old Glory following Veterans Day ceremonies at Camp Robinson in North Little Rock. 📷 KIRK JORDAN

READY, AIM, FIRE *(opposite left)*: Confederate Flag and Heritage Day on the State Capitol grounds. 📷 JOHN DAVIDSON

REGAL *(opposite right)*: In full regalia, an American Indian dances at Pinnacle Rendezvous at Pinnacle Mountain State Park in Little Rock. The 'encampment,' which includes costumed mountain men and women, is held each fall. 📷 DEBBIE SIKES

★ **ALL IN A DAY'S WORK** *(below)*: Liberty and Hwy 286 volunteer fire departments battle a house fire on U.S. 64 in Conway. 📷 MICHELLE HAYGOOD

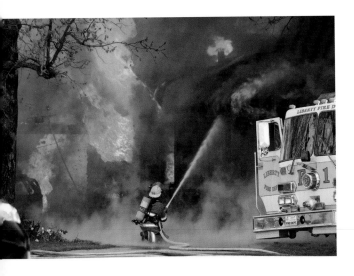

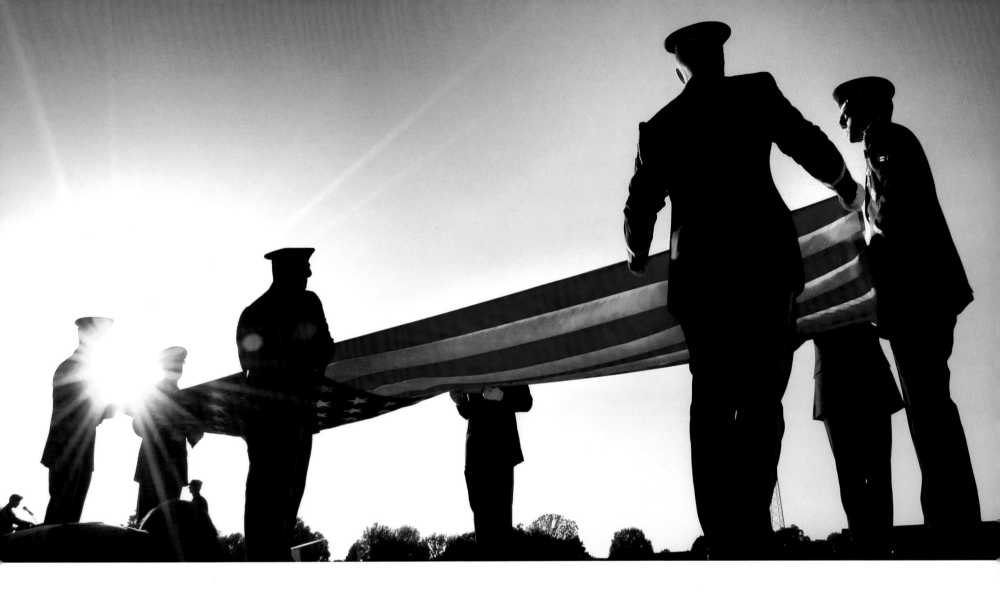

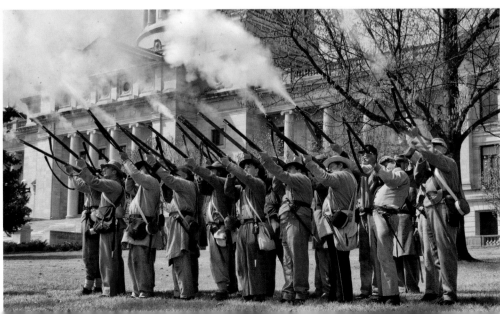

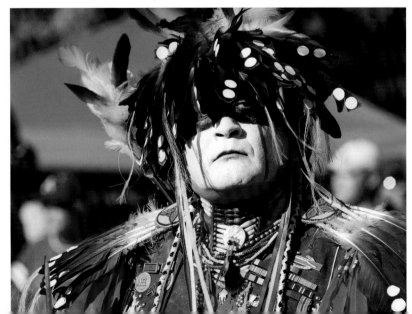

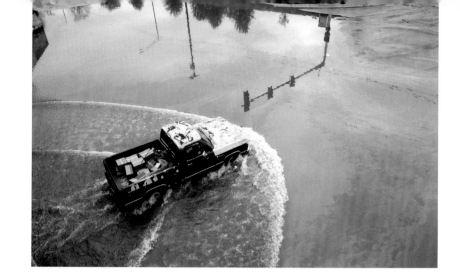

UNTITLED *(right):* A truck drives through floodwaters eastbound on Pershing Boulevard toward the intersection of Percy Machin Drive in North Little Rock. Heavy rainfall flooded the intersection, and barricades were put up to deter drivers, but this one chose to drive through.
☞ KAREN E. SEGRAVE/*ARKANSAS DEMOCRAT-GAZETTE*

COLD AND WET *(opposite left):* Cows gather on a small island made by flooding from the White River in Oil Trough, where most of the town was left submerged after heavy rain flooded waterways across the state. ☞ BENJAMIN KRAIN/*ARKANSAS DEMOCRAT-GAZETTE*

★ **SNOW STORM** *(opposite right):* Late spring snowstorm blankets Arkansas in March. ☞ REX LISMAN

RISING WATERS *(below):* After torrential rains hit Arkansas early this spring, many rivers flooded at near record levels. This shot reveals how the rising waters inhibited normal travel for many Arkansans. Here, the flooded Ouachita River forces the Highway Department to close a section of Arkansas 7 just outside Arkadelphia. ☞ STEPHEN CARTER

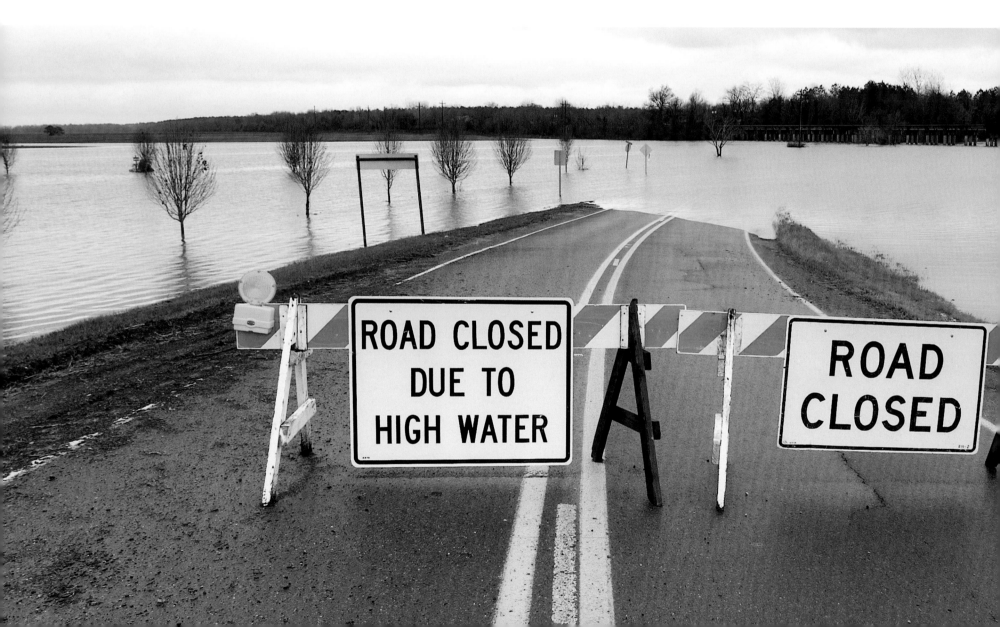

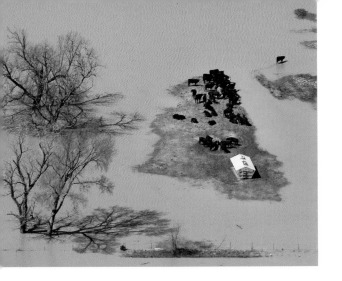

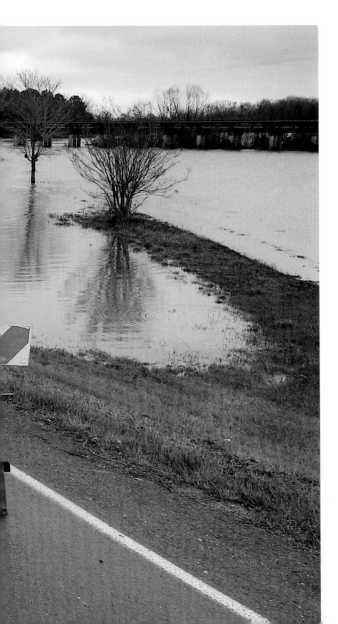

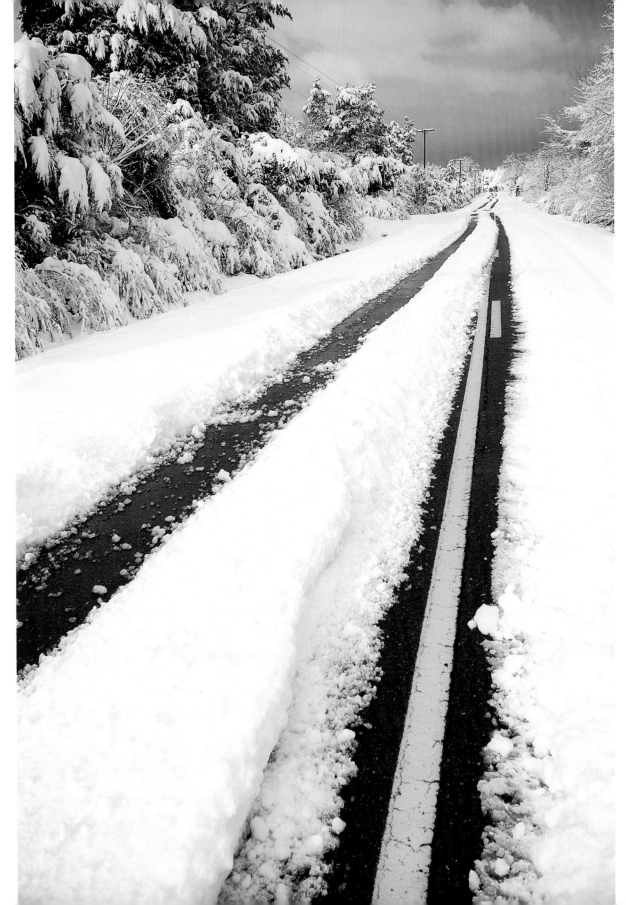

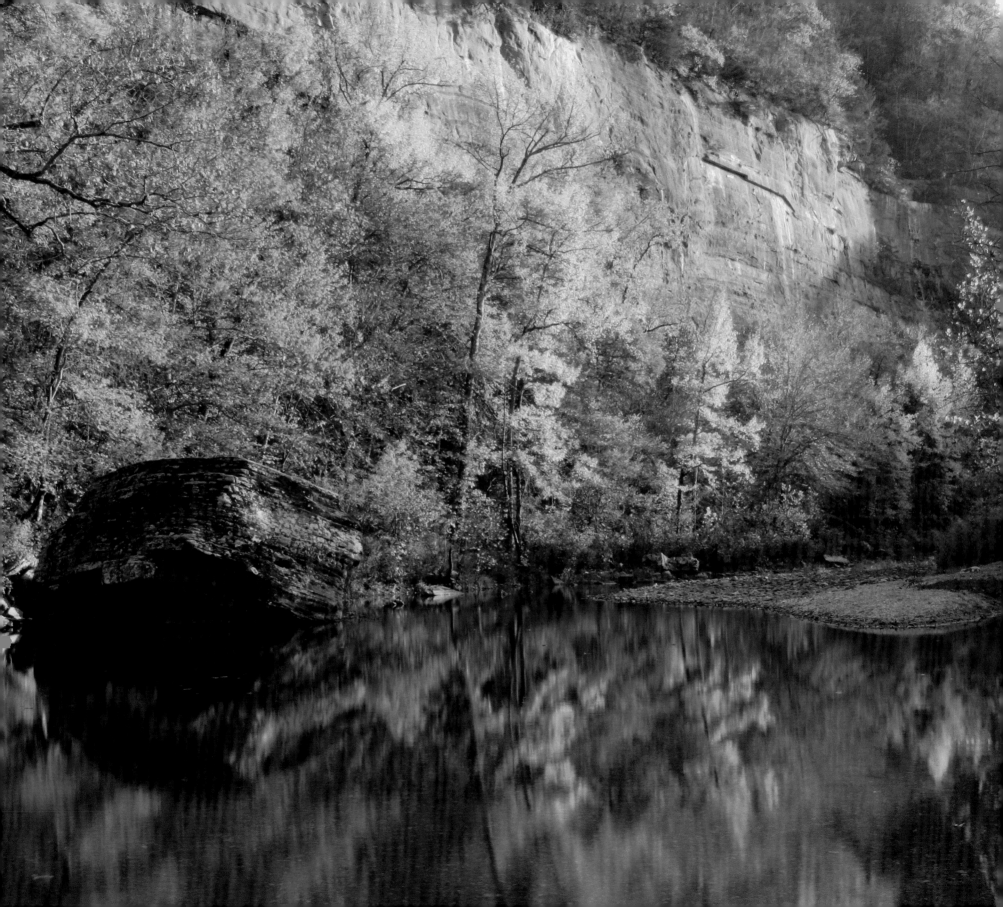

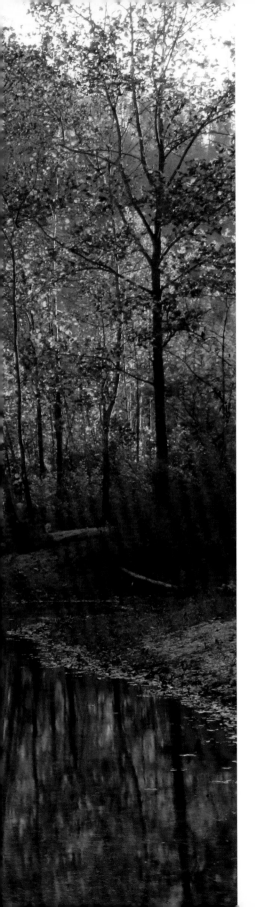

Scapes of All Sorts

Arkansas as The Natural State, Part II.
Photographers throughout the state defined this chapter by submitting thousands of photos depicting mountain ranges, river valleys, countrysides, swampy forests and miles and miles of skies. You'll find photos with tall trees, rugged mountains, beautiful waterfalls and serene pastures.

We expect you'll see skies as you have never seen them before (we hadn't). Beautiful rich reds and vibrant blues fill the heavens and light up the land. They more resemble a painting than a photograph, and that is why we love them.

We are not all natural, of course.

Photographers also showed us new ways to look at man-made scapes. Portraits of new and old bridges, downtown city streets and city skylines that light up the night also provide insight to the makeup of the state.

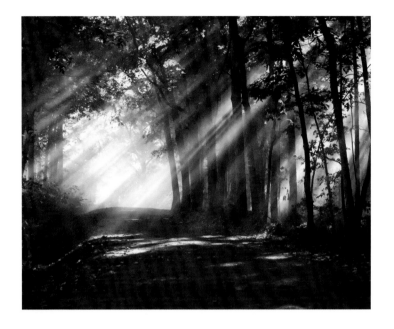

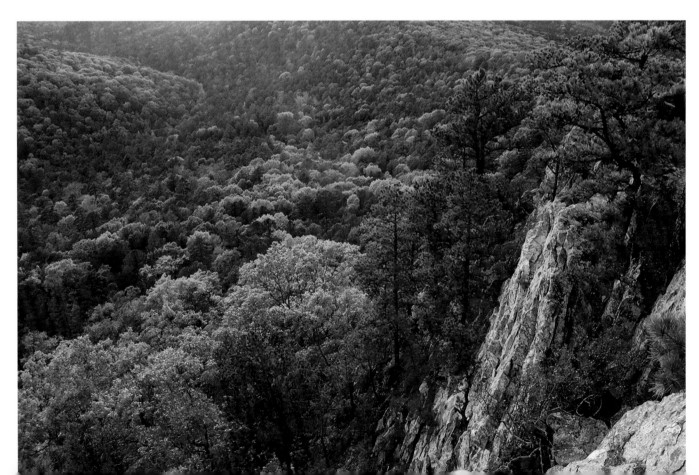

BUFFALO RIVER REFLECTIONS (*previous left*): As I came around the bend of the river late in the evening one fall day it just took my breath away. This scene is the perfect example of the Ozarks in the fall. 📷 KEN ROBINETTE

CAVE MOUNTAIN ROAD (*previous top*): This is Cave Mountain Road in Newton County. The picture was taken at about 7:30 in the morning as the fog floated through the trees, catching the sun. 📷 CHRIS DAVIDSON

FLATSIDE PINNACLE (*previous bottom*): Sunset from Flatside Pinnacle in the Flatside Wilderness of the Ouachita National Forest. 📷 BRIAN CORMACK

FALLING ANGLES (*right*): A perfect overcast morning after a fall shower. The light and colors were amazing. 📷 ALEX KENT

BUFFALO RAINBOW (*opposite*): Rainbow in the colorful Buffalo River valley. 📷 MARTY ALLEN

MISTY MORNING (*following left*): This is a fishing pier on Lake Conway covered in a fine mist. 📷 CHRIS BURNS

UNTITLED (*following right*): Mount Magazine. 📷 ML BAXLEY

AUTUMN GLORY (*below*): Late afternoon sunshine on a sweeping panorama near Eureka Springs. 📷 MICHAEL BUFFINGTON

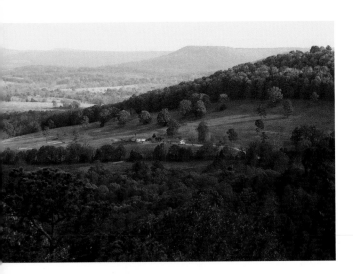

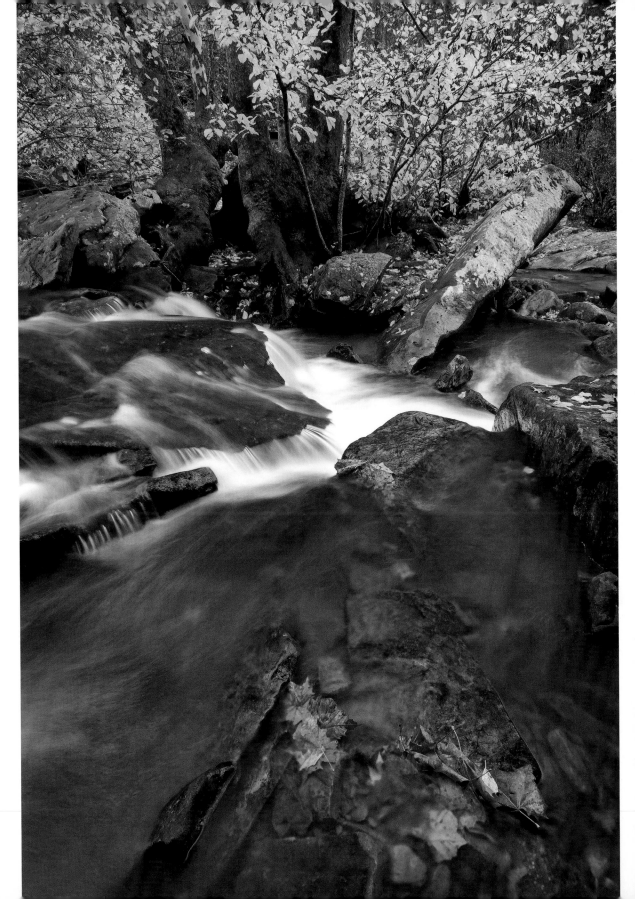

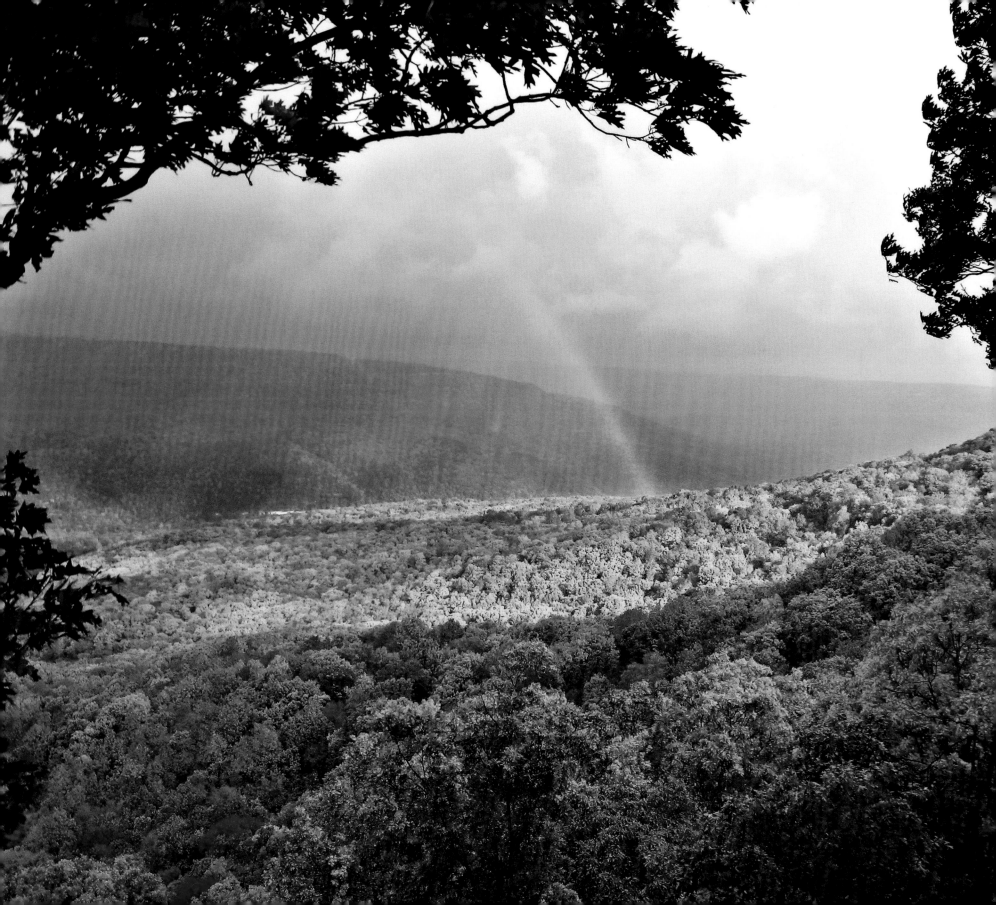

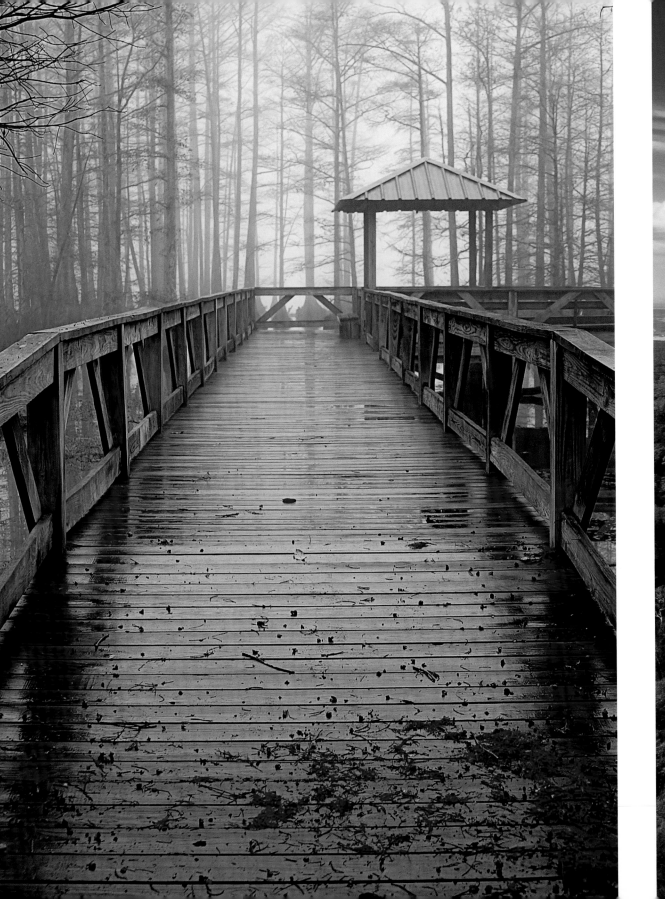

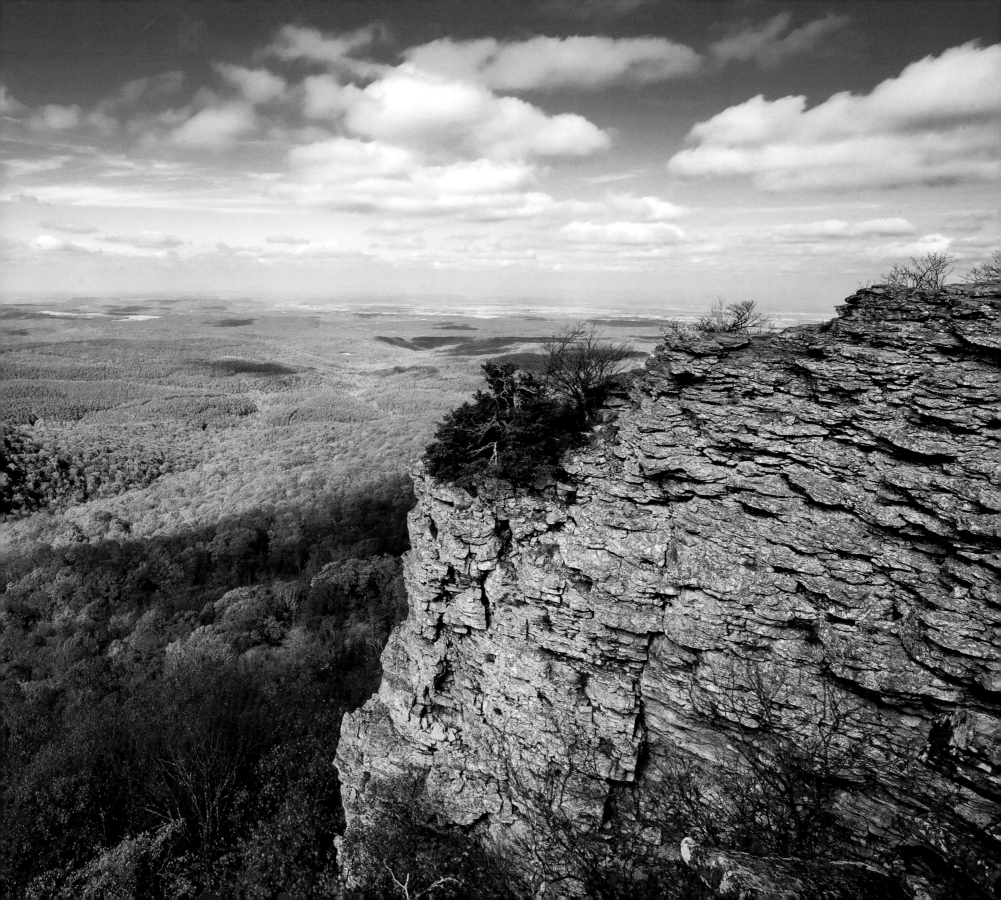

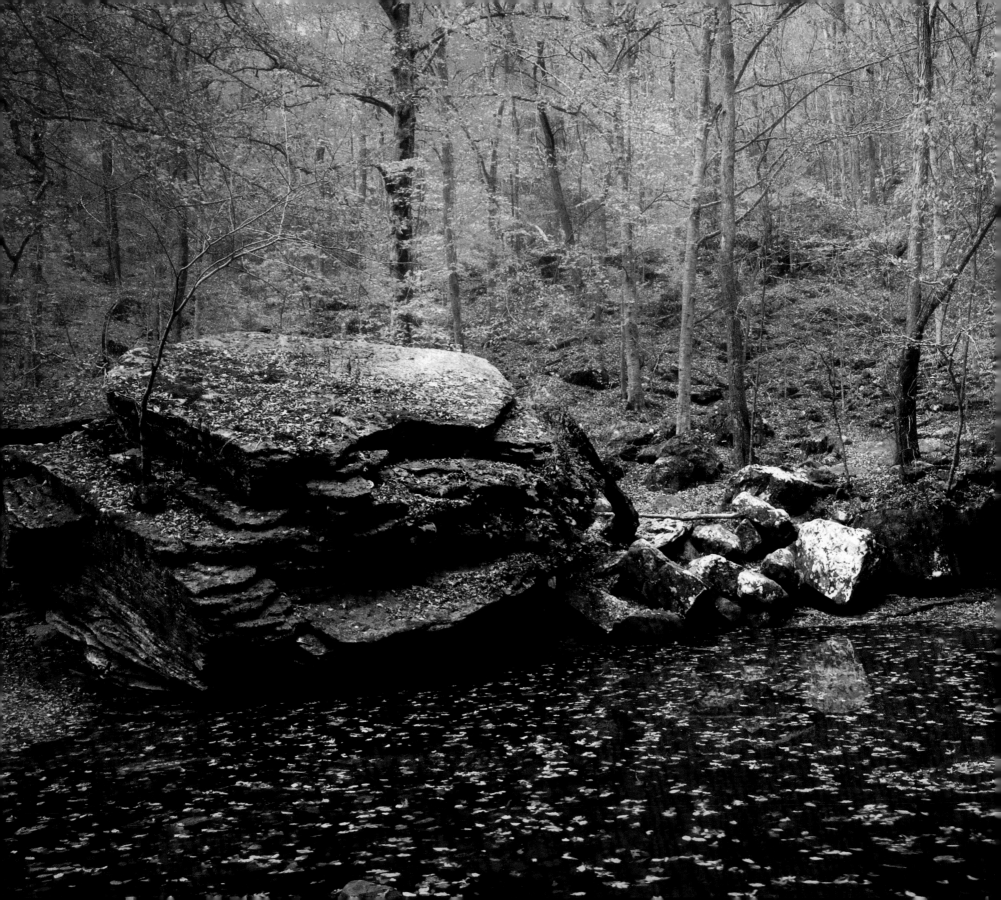

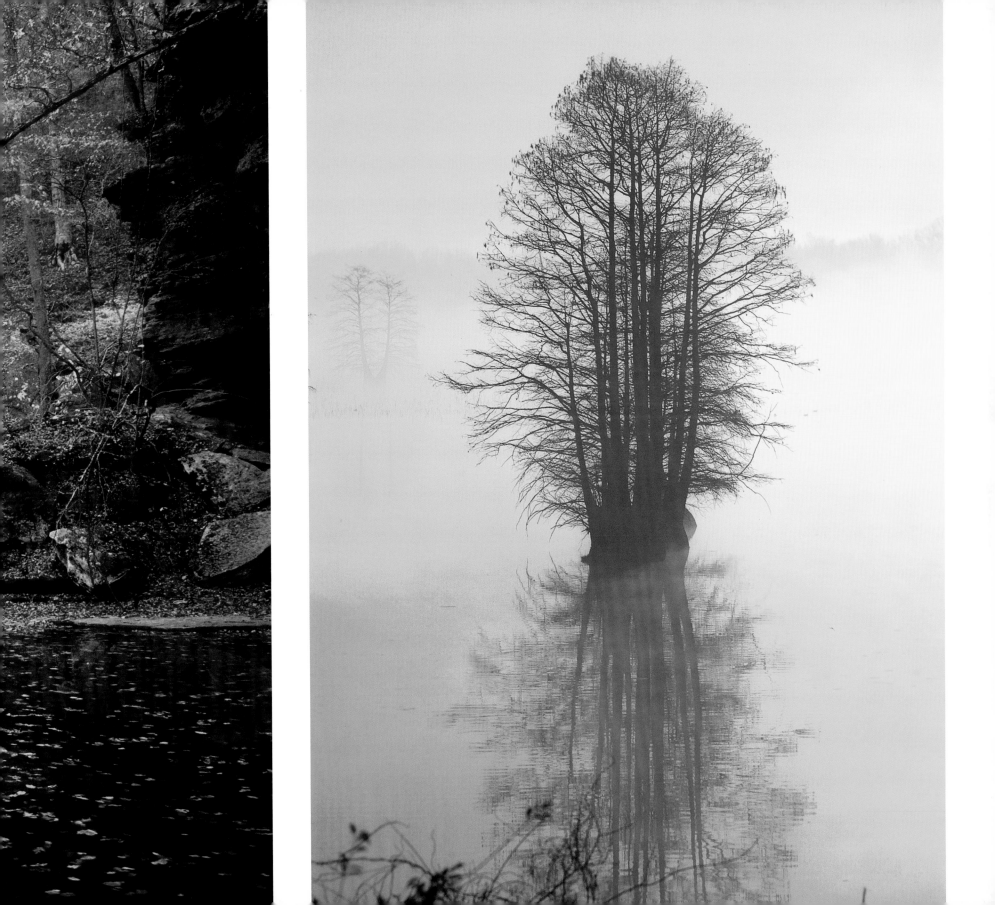

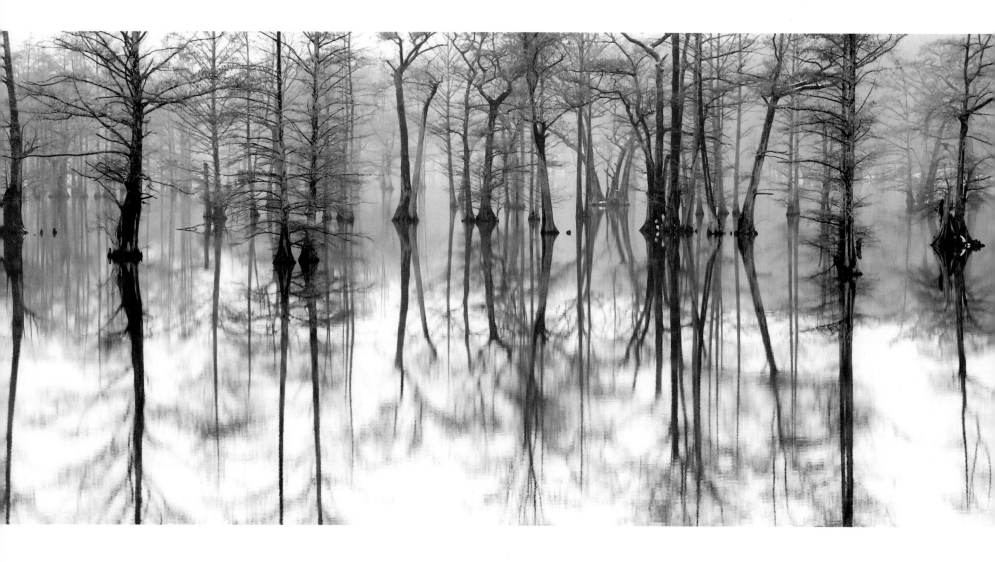

WOOD BETWEEN THE WORLDS (*above*): Motorists in a hurry are apt to speed by this tranquil overflow pool brimming with cypress trees, just off of Interstate 430 and the Maumelle entry ramp. 📷 KIRK JORDAN

PONCA'S POOL (*previous left*): Sill waters in the morning at Ponca. 📷 DAN MURPHY

HONEY LIGHT (*previous right*): A "water-walking" tree hovers in the honey light of early morning on Lake Conway. 📷 KIRK JORDAN

JUST THIS SIDE OF HEAVEN (*opposite left*): Walking through Murray Park in Little Rock as the fog started to burn off the river. 📷 PATRICK MCATEE

LAKE BAILEY (*opposite top*): Lake Bailey at Petit Jean Mountain State Park near Morrilton. 📷 BRIAN CORMACK

HARRIS BRAKE SUNRISE (*opposite bottom*): Sunrise over Harris Brake Lake near Perryville in late October. 📷 DAVID BOWDEN

★ **EARLY MORNING TRAIN** (*following*): Early morning train passes through Calico Rock along the White River. 📷 MARTY ALLEN

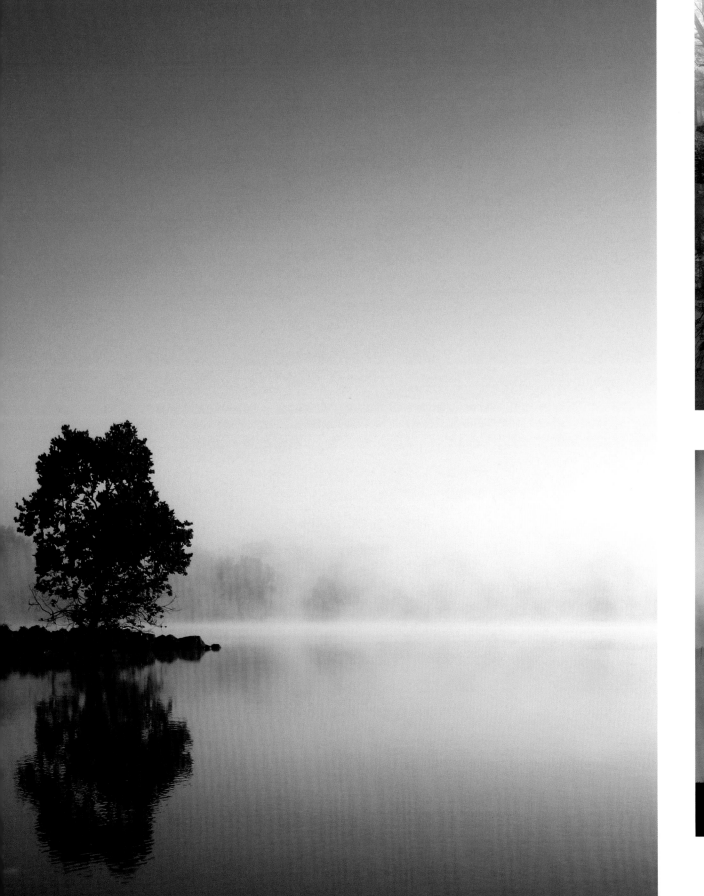

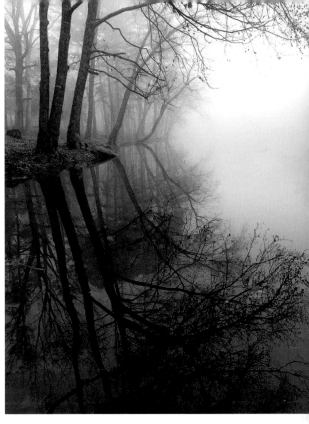

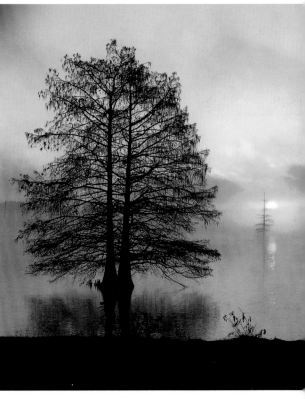

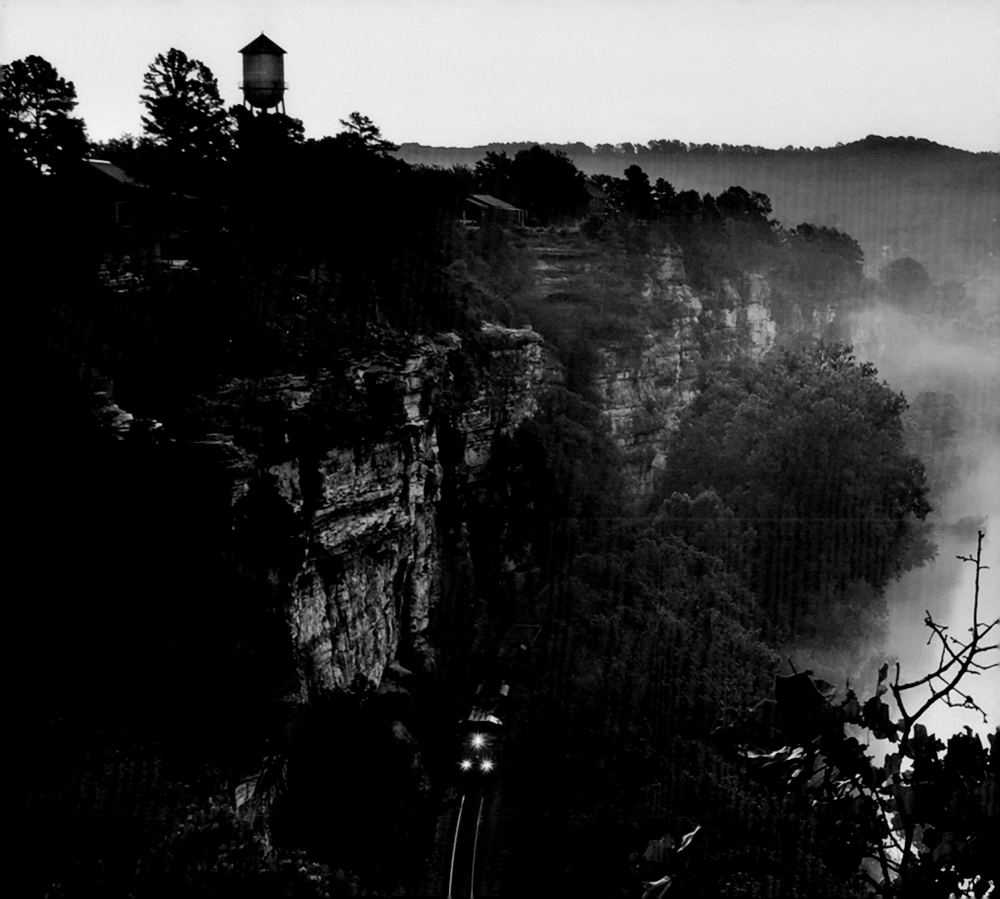

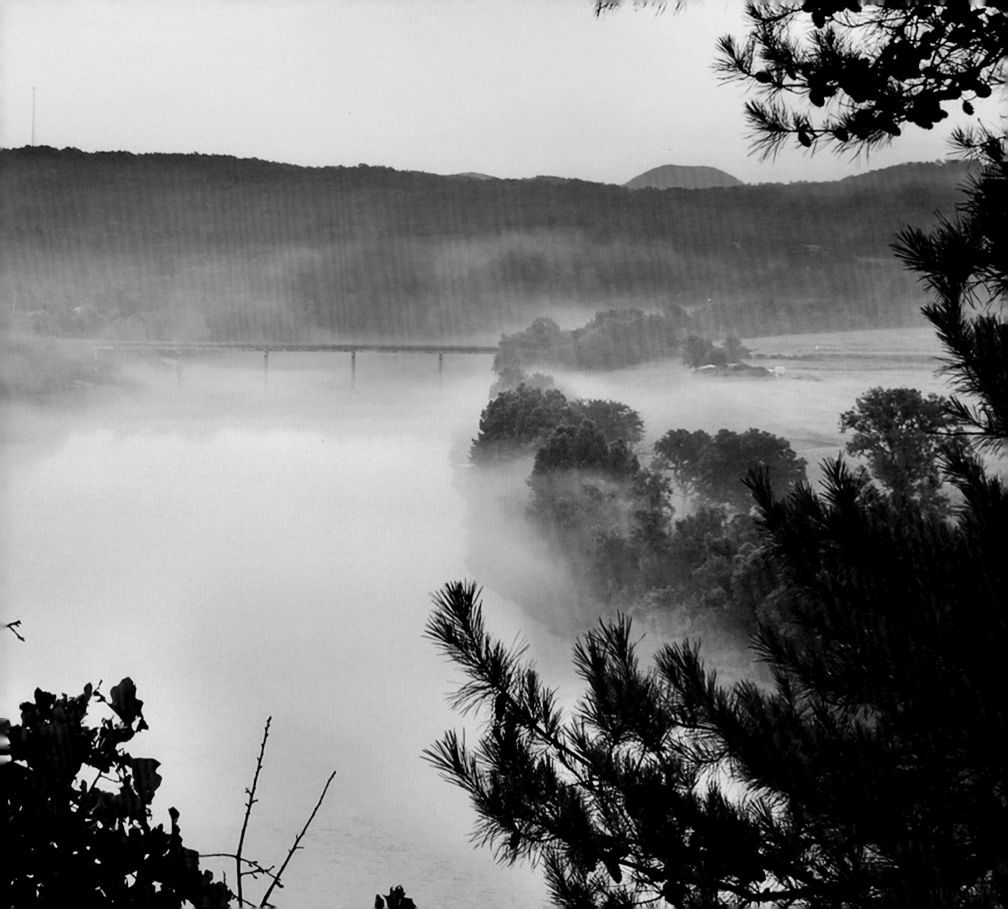

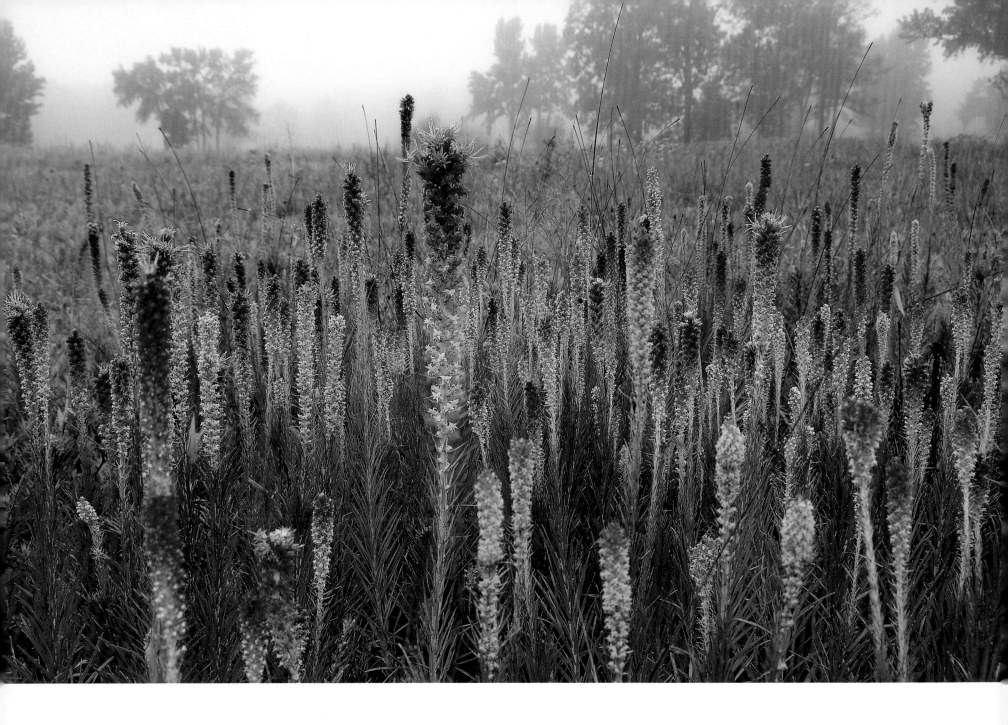

AWESOME WILDFLOWERS (*above*): Small patch of blazing star just starting to bloom. 📷 MIKE HALL

WATER'S EDGE (*opposite left*): The water's edge is carpeted with green moss, only seen when the dam on Greers Ferry is not generating. It seems to be pointing the way to a great fishing spot. 📷 KARLA HALL

FOGGY DAWN ON THE NORFORK RIVER (*opposite right*): Foggy dawn on Norfork River 📷 BARRY HAMILTON

EARLY MORNING MAUMELLE RIVER (*opposite bottom*): Early morning Maumelle River. 📷 MICHAEL ROBERSON

BEFORE THE FOG BURNED OFF (*following left*): I was heading down to the Arkansas River near Murray Park in Little Rock and came upon this field where the morning sun's light seemed to lie on top of the fog. 📷 PATRICK MCATEE

FOGGY TRAIL (*following right*): I took this shot on May 24, 2008, on the Signal Hill Trail in Mount Magazine State Park off scenic Arkansas 309. The fog was so thick that I could barely see 10 feet in front of me. 📷 CHRIS BURNS

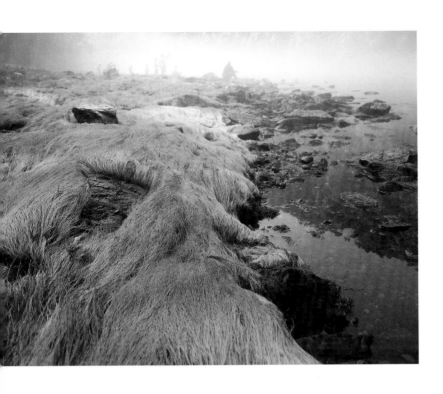
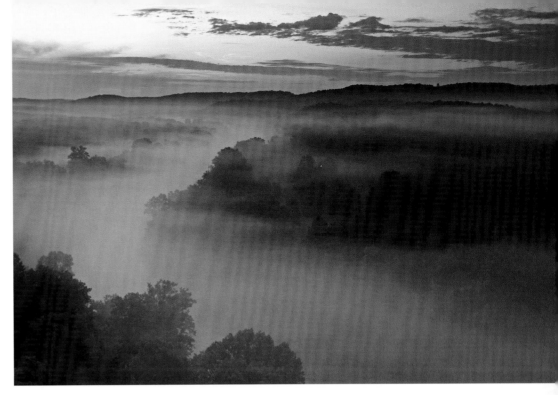
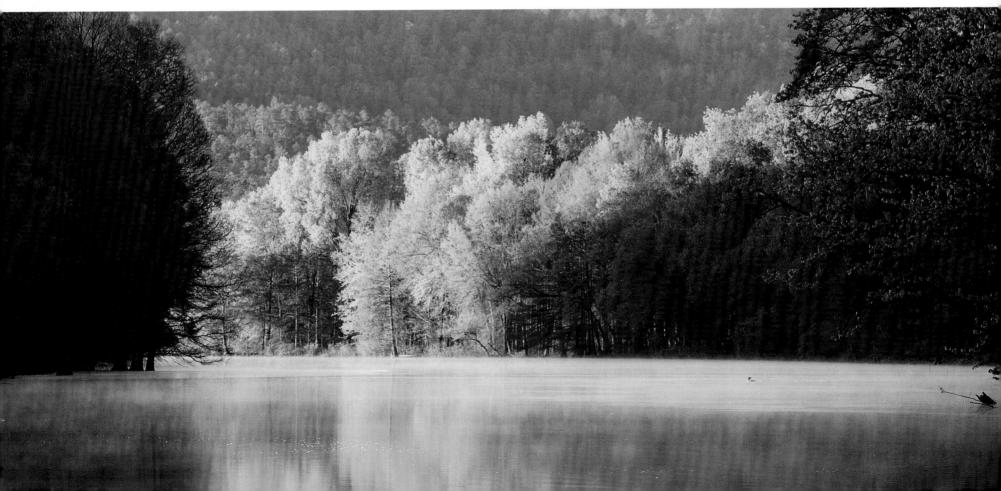

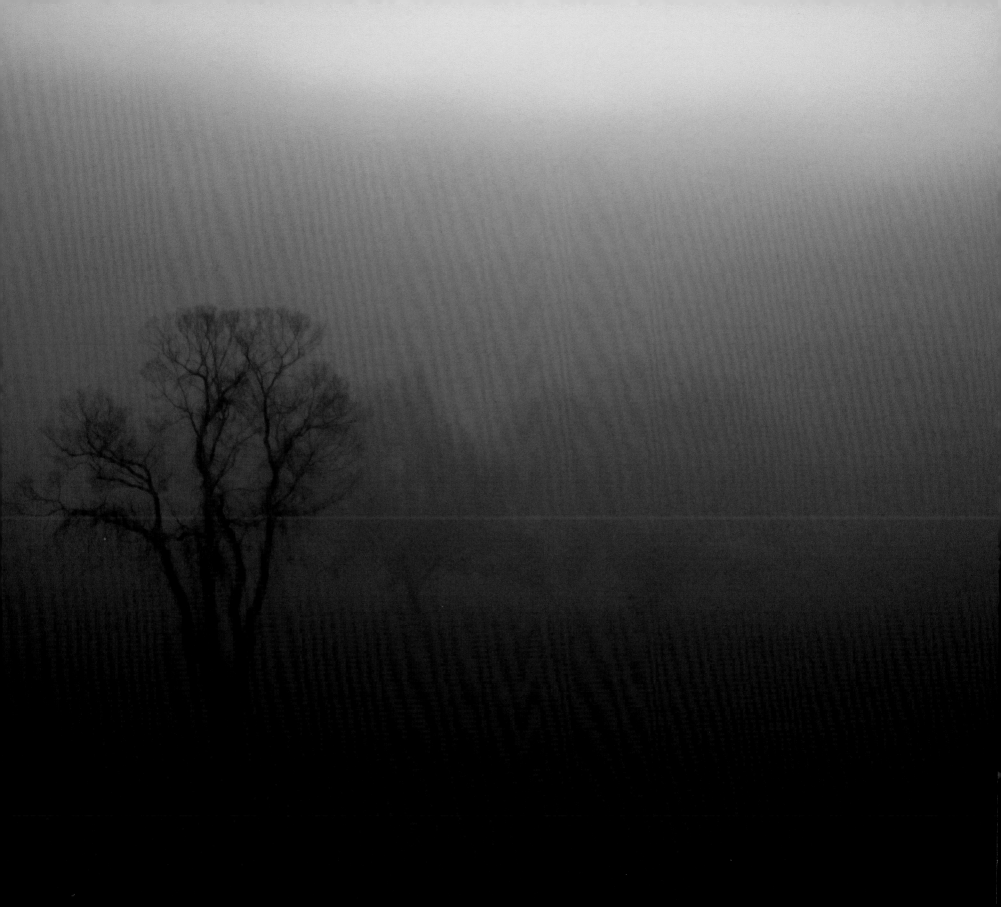

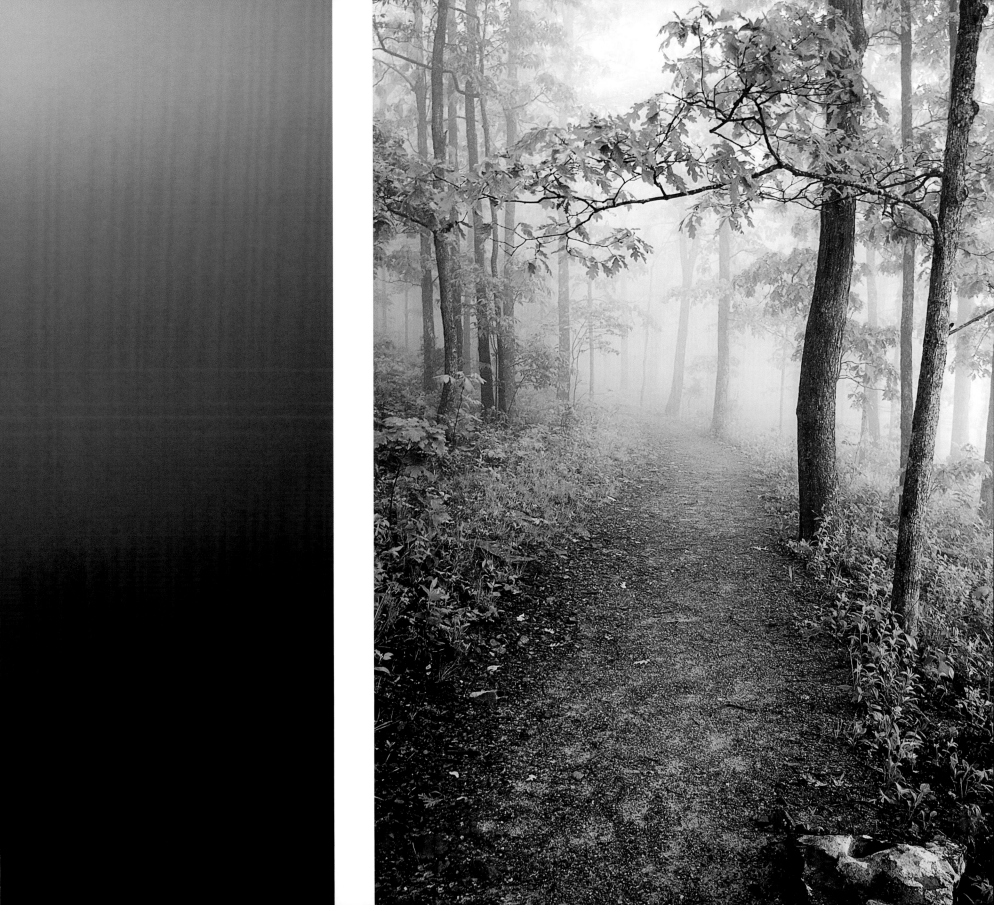

PETIT JEAN VALLEY FROM STOUT'S POINT (*right*): A storm front was bringing breaking clouds and sunlight on the valley below Stout's Point at Petit Jean State Park near Morrilton.
📷 RODNEY STEELE

HAW CREEK FALLS (*below*): A lone sweetgum leaf rests above the creek as Haw Creek Falls roars in the background. Fall is here, and the landscape once again comes alive with color.
📷 DOMINIC ROSSETTI

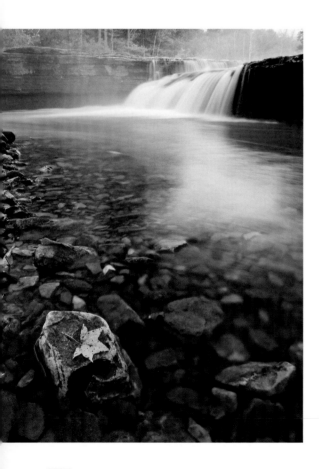

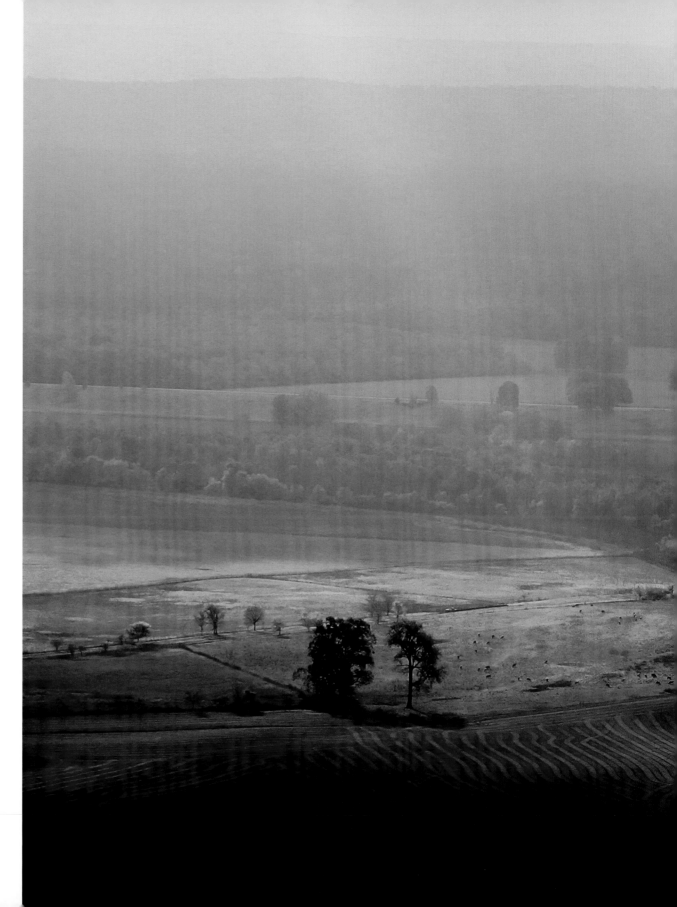

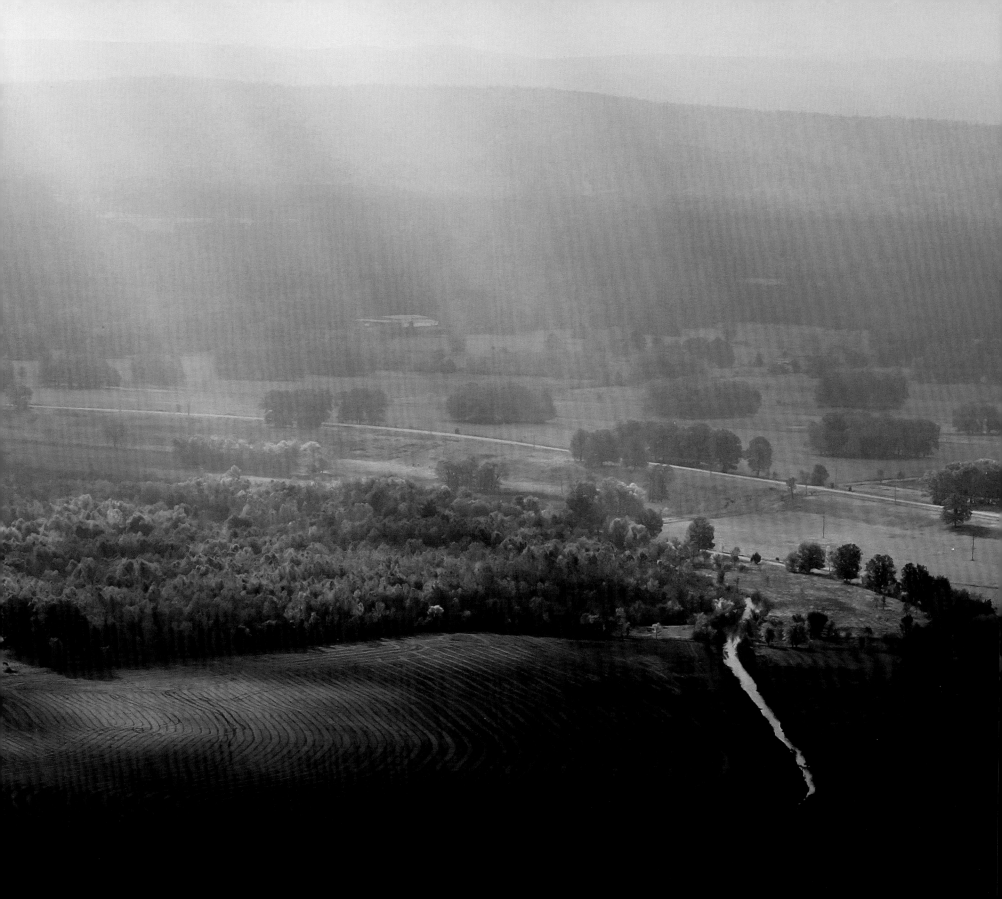

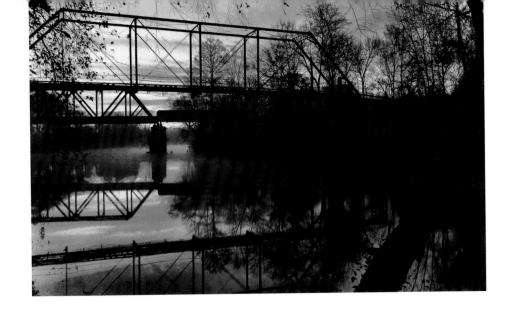

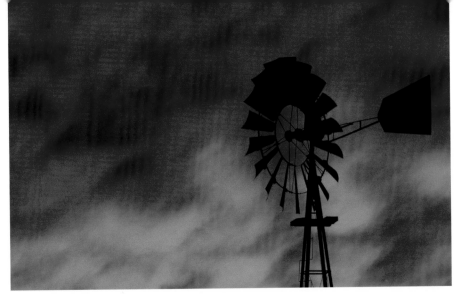

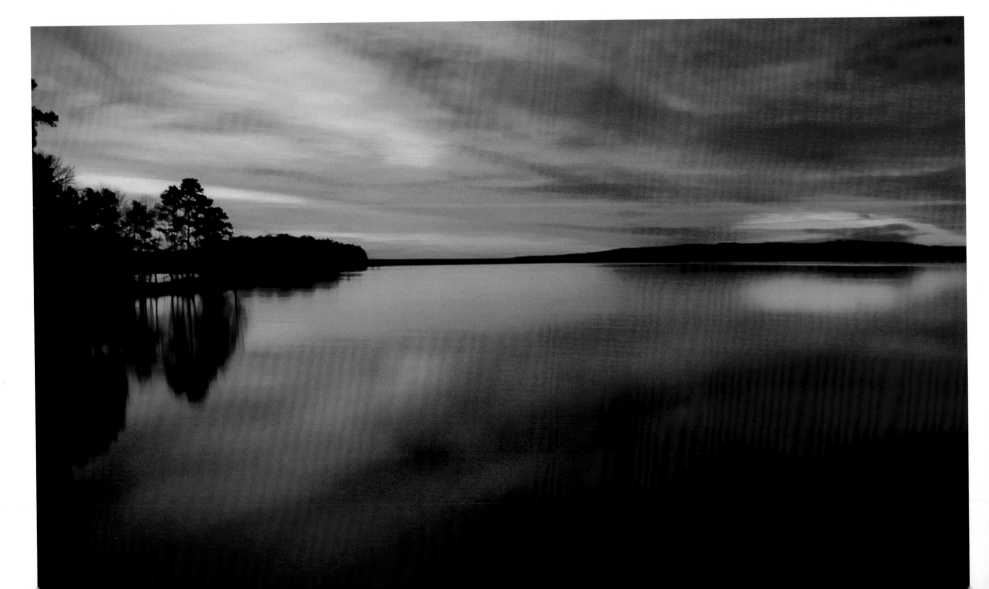

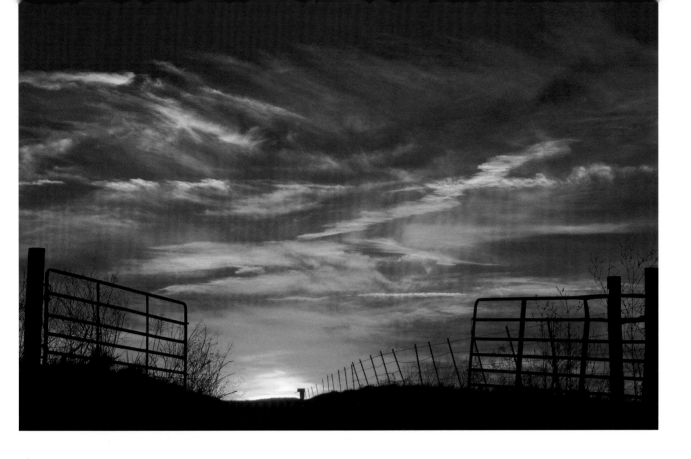

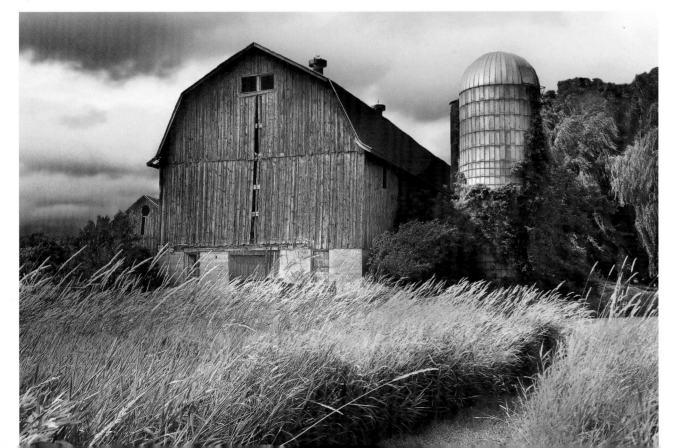

OLD SALINE RIVER BRIDGE *(opposite left):* Dawn at Old Saline River Bridge. 📷 DR. JEFF HENNING

SUNSET *(opposite right):* Clouds burst with color behind a windmill located off Puppy Creek Road during the sunset on a Saturday night near Lowell.
📷 DAN HALE/*ARKANSAS DEMOCRAT-GAZETTE*

WINTER SUNRISE AT DEGRAY LAKE *(opposite bottom):* Winter Sunrise at DeGray Lake. While at the lodge for a conference, there were several days of spectacular sunrises with rich, fire-like colors. 📷 RODNEY STEELE

★ **GATEWAY SUNSET** *(top):* This sunset was taken in the Brush Creek area of Tonitown in February 2008.
📷 TODD WHETSTINE

A NEW DAY IN ARKANSAS *(bottom):* Rural living at its finest.
📷 KAYE BURAZIN

★ **GLORY HOLE** *(following top):* I captured this shot of "Glory Hole" in the Arkansas Ozarks on a late February afternoon. The sun to my back allowed perfect timing for the rainbows to contrast against the silky water flowing from above. It was a beautiful moment where preparation met opportunity and all the right elements fit perfectly together.
📷 STEPHEN CARTER

SUNSET SYMMETRY *(following middle):* One grand evening at the Ward Nail park in Lowell. If you look closely you might see the moon peeking out through the clouds.
📷 JOE SPARKS

UNTITLED *(following bottom):* Arkansas River. 📷 ML BAXLEY

KINGS RIVER FALLS *(following right):* Kings River Falls is a popular destination for the casual hiker. The trail is short, easy to negotiate, and the waterfall is inspiring.
📷 HAROLD HULL

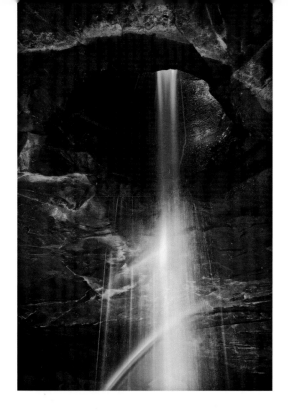

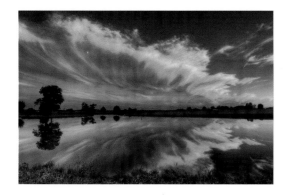

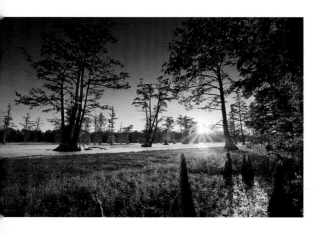

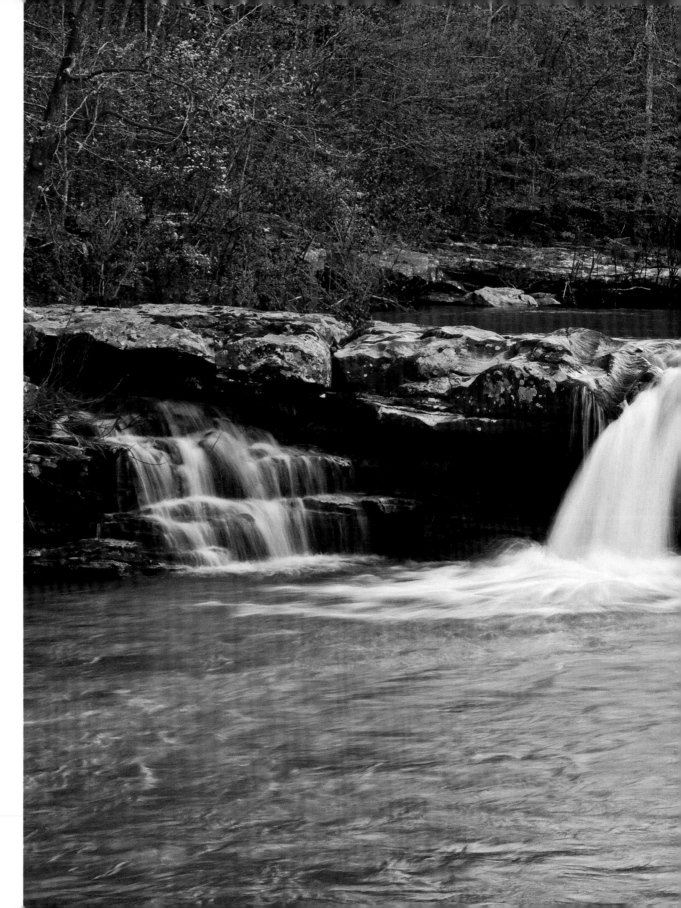

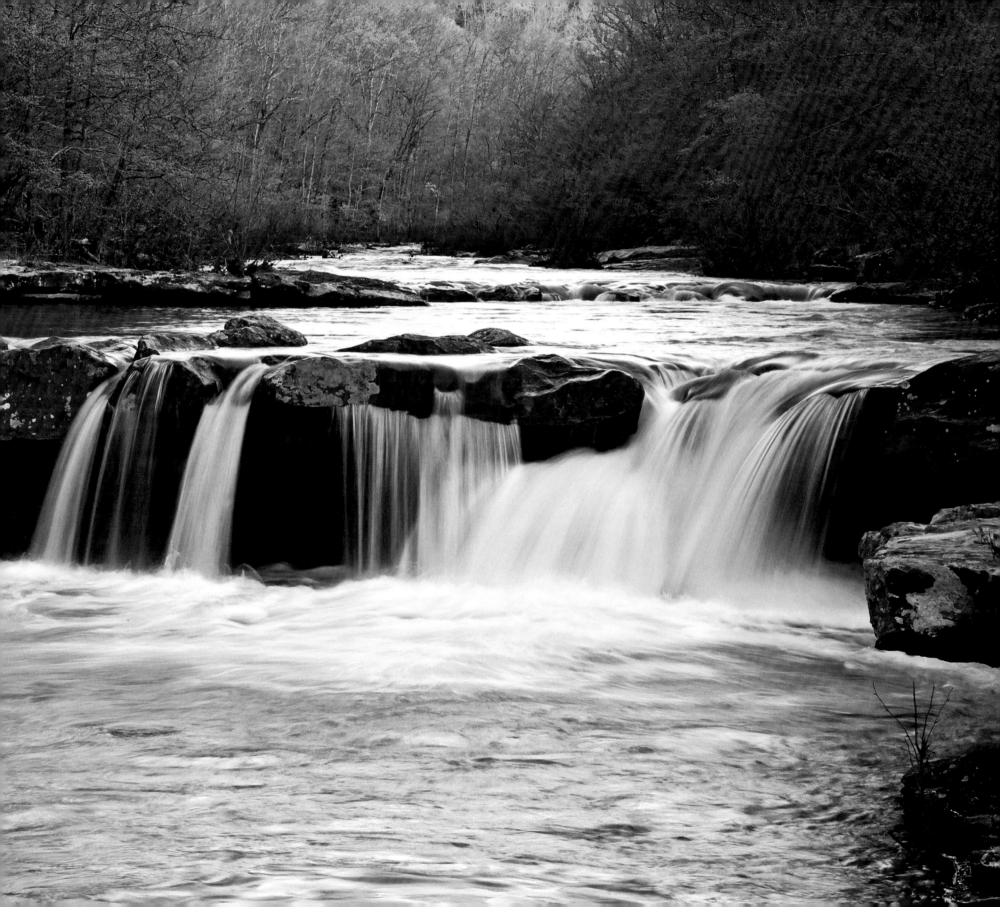

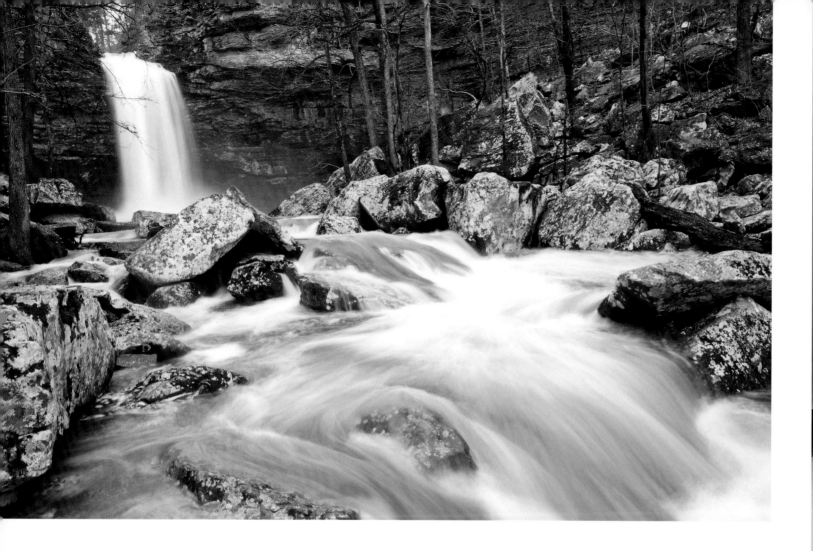

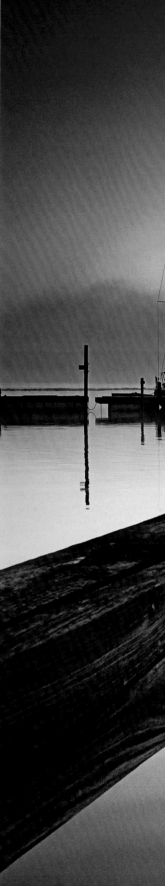

CEDAR FALLS AT FULL BLAST (*above*): After the big rains we had this spring (2008), Cedar Falls at Petit Jean State Park near Morrilton was running full blast. You couldn't even get across the creek it was so high. 📷 MATT MCCLELLAN

EARLY MORNING SAIL (*right*): Sunrise at the Lake Maumelle Marina. 📷 TODD SMITH

PECAN TREES LINE A ROAD (*following left*): This is the center of a photo that was stitched together from 15 vertical shots. The final print is about 10 feet wide by 17 inches tall. 📷 JONNY MEYER

JUNGLE RUN (*following right*): Slowly boating up a small shoot off of the White River toward lower Crooked Lake, just south of Prestons Ferry, this tunnel leads to the heart of what some have called the North American Amazon. 📷 CLINT HERRINGTON

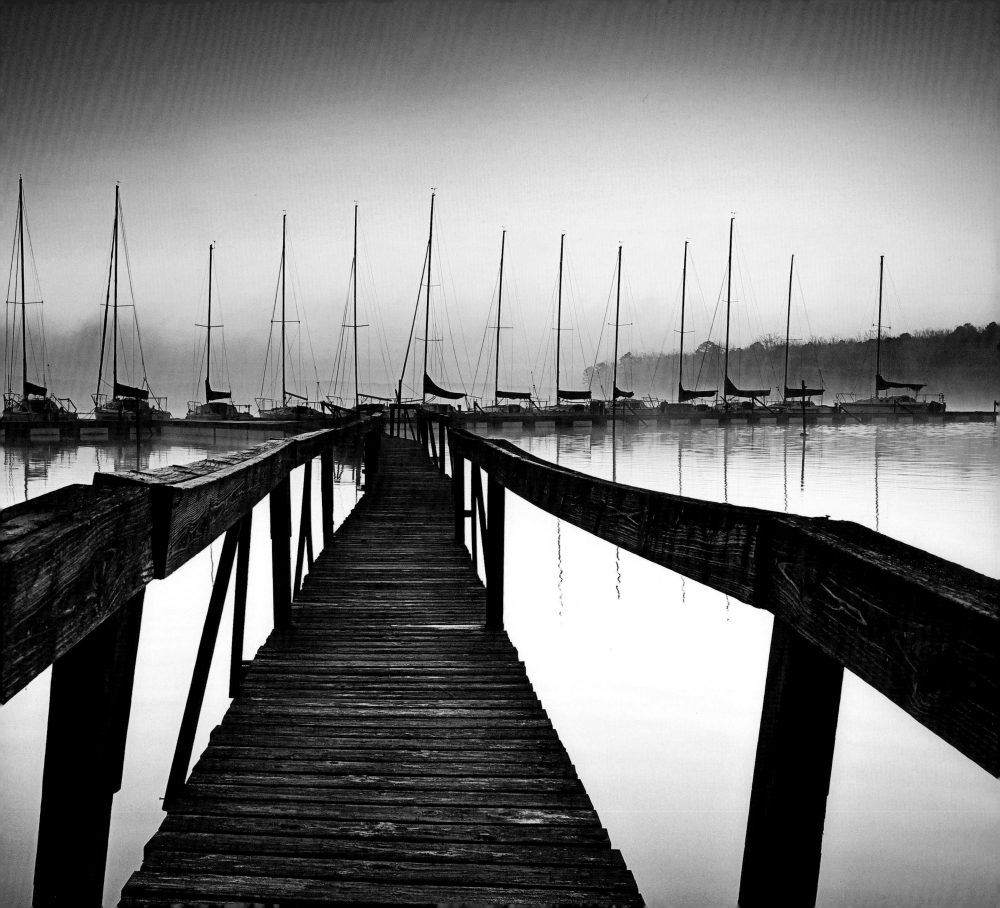

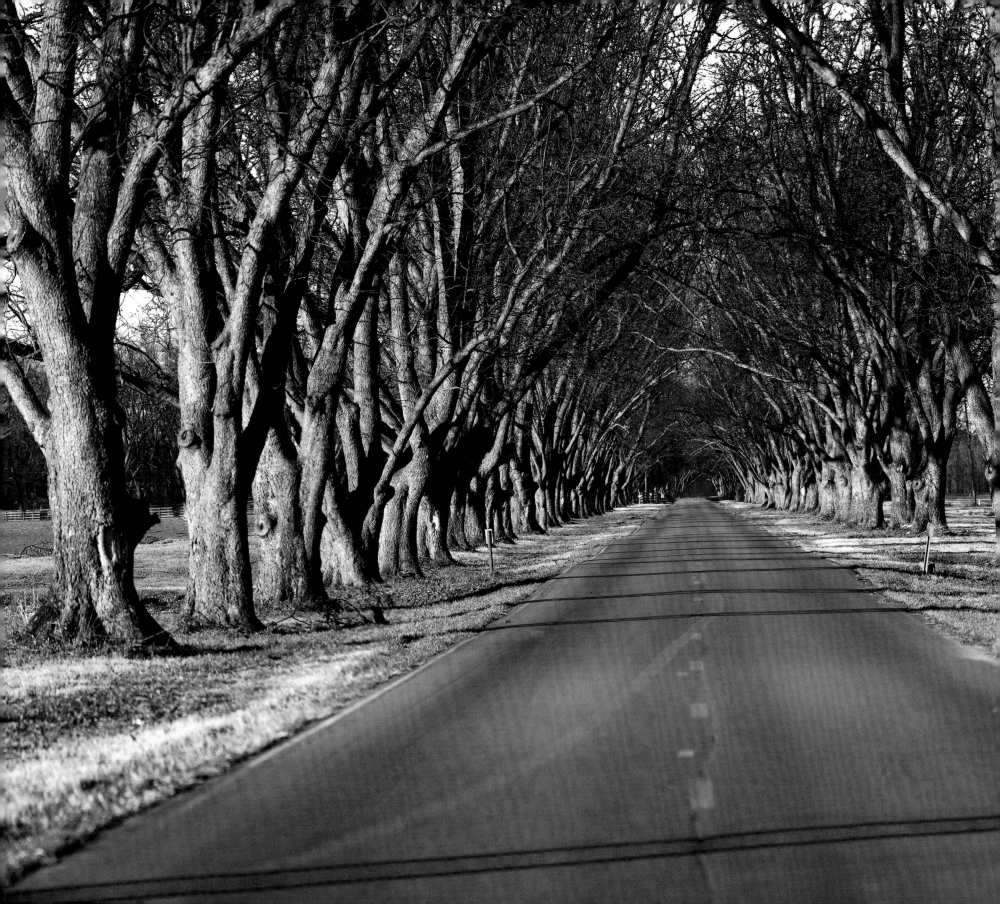

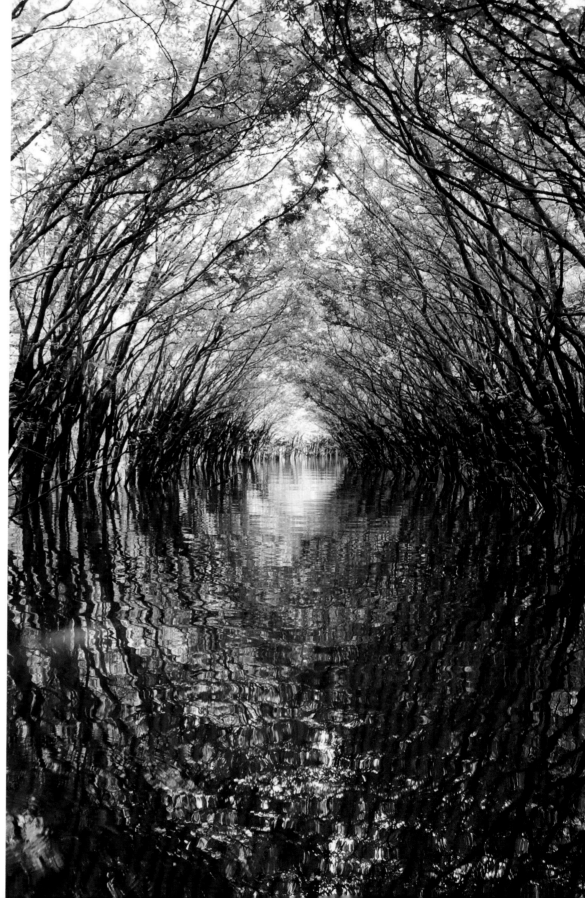

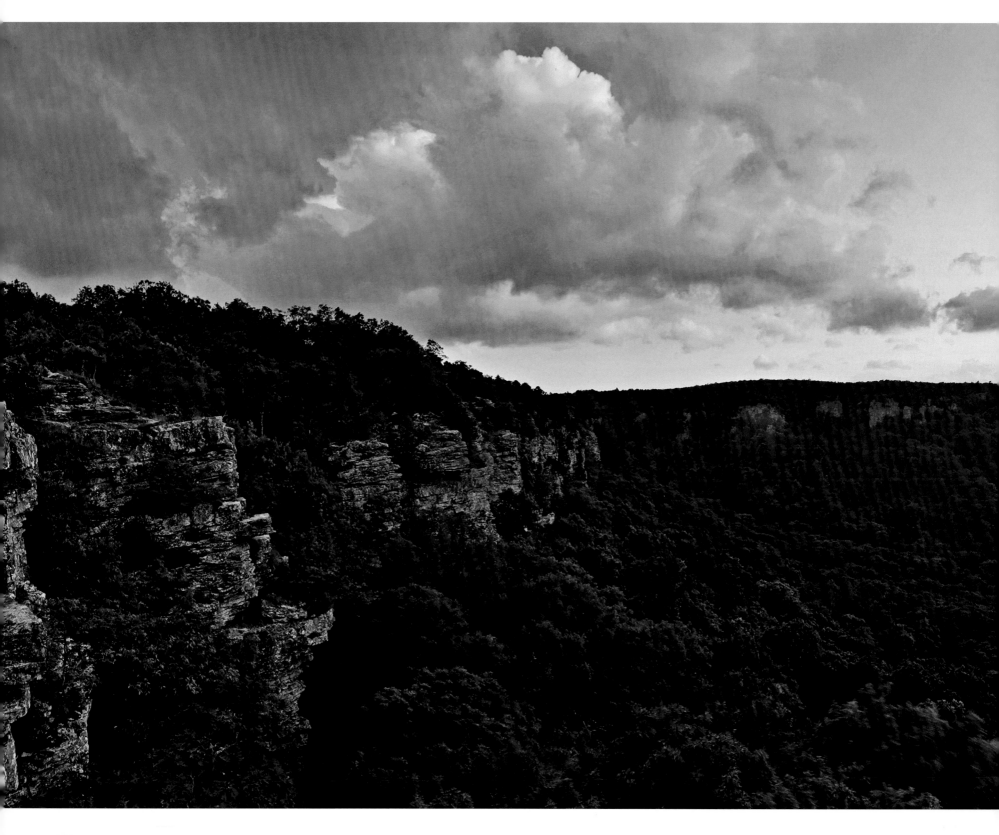

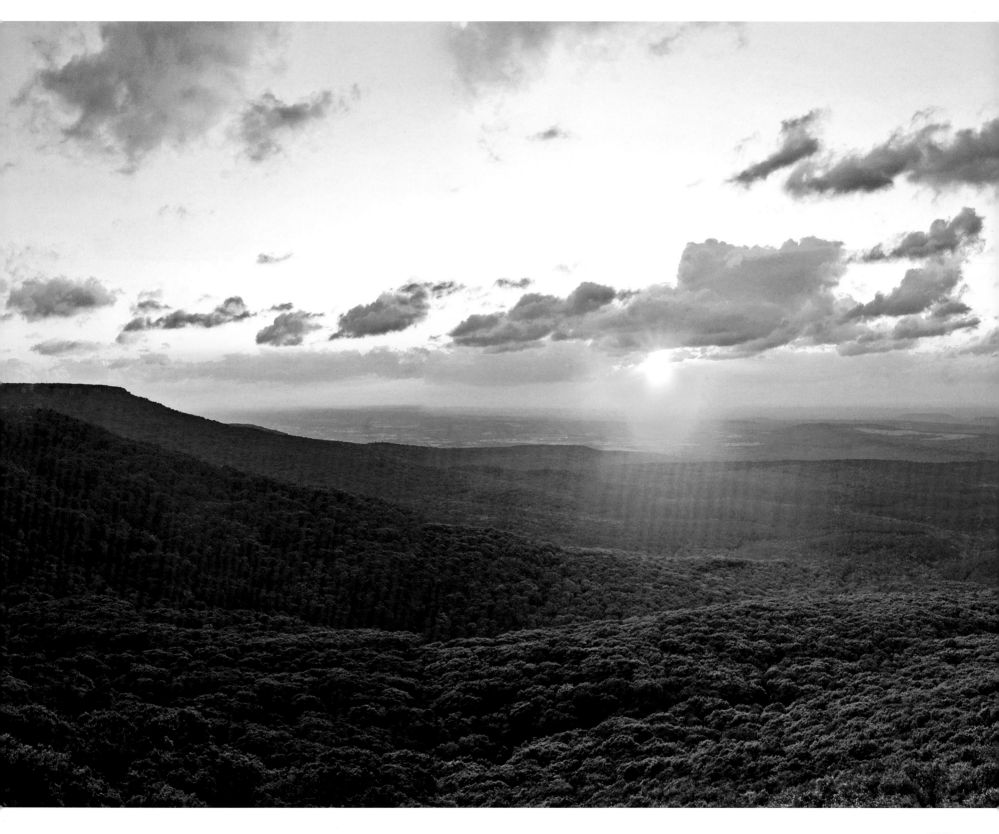

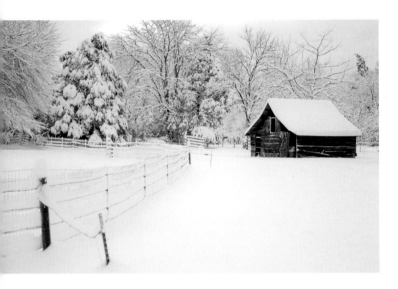

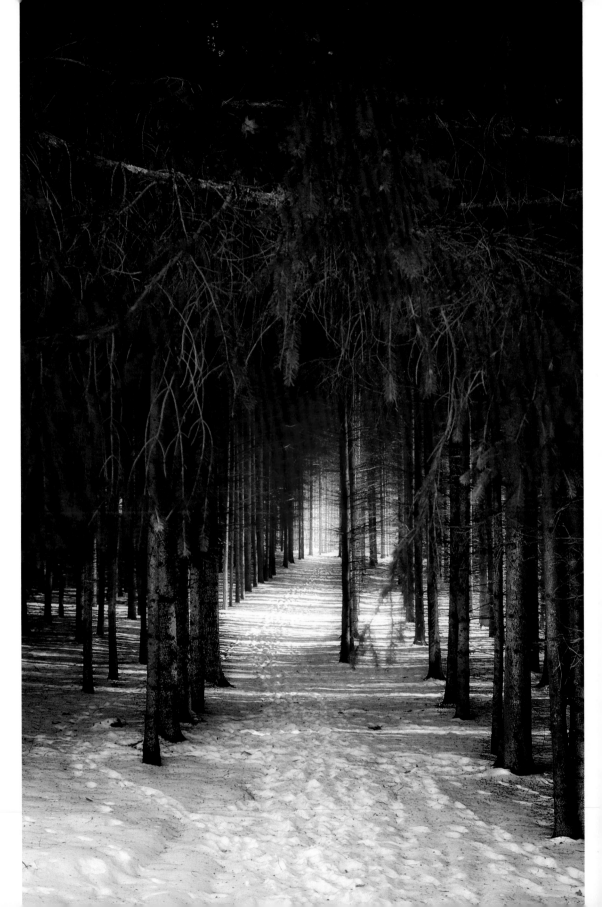

SNOW DAY (*above*): Spring snowstorm blankets western Arkansas.
📷 REX LISMAN

CAMERON BLUFF SUNSET PANORAMIC (*previous*): Panoramic sunset view from the Cameron Bluff overlook at Mount Magazine State Park near Paris.
📷 CASEY CROCKER

WINTER FOG (*top*): In the mountains of the Ozark National Forest north of Dover, winter mornings can bring a wonderous surprise as fog turns to ice crystals on trees and objects. This short-lived phenomenon is an exciting moment that occurs infrequently. 📷 PAT GORDON

LIGHT AT THE END OF THE FOREST (*right*): Arkansas' winters are nothing compared to Wisconsin, but when we do have snow, it's just as beautiful, if not more so. 📷 ROBERT BURAZIN

HAUNTED TREES (*opposite*): Trees on the Southern Arkansas University campus in Magnolia take on a haunted look during a foggy morning. 📷 AARON STREET

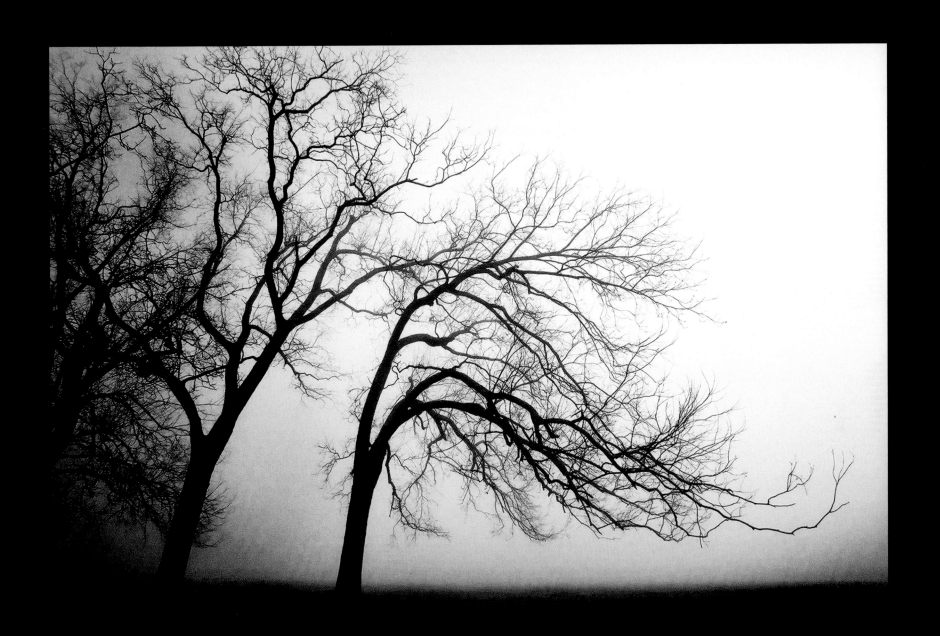

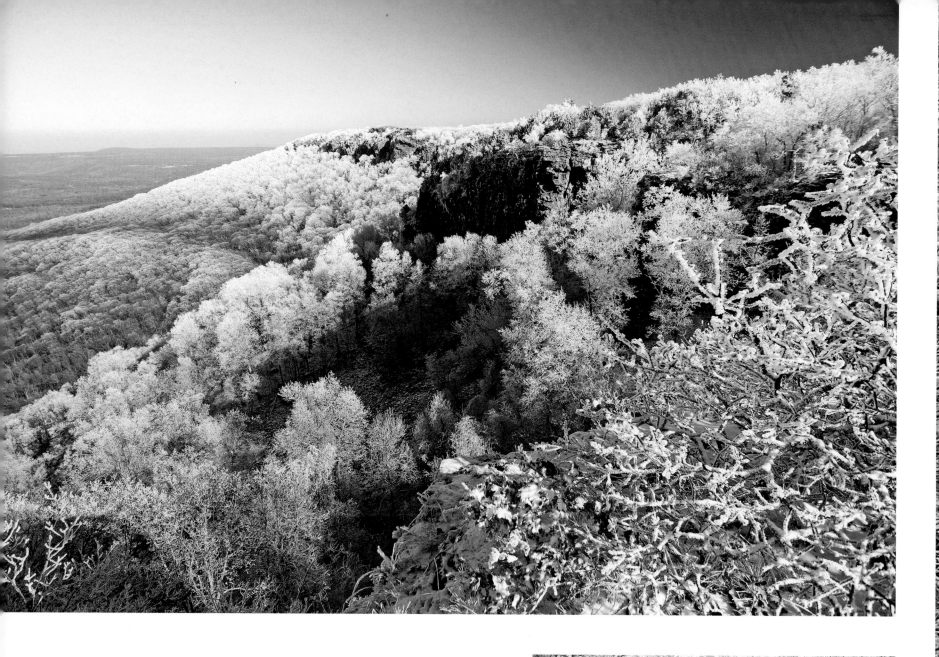

SNOWY MORNING ON MOUNT MAGAZINE *(above):* A strong weather front moved through the area while a light rain was falling, resulting in every tree branch, rock and twig being encrusted in ice and snow. Only the higher elevations received snow. A rare event. 📷 ROGER TAYLOR

THE ROAD HOME *(right):* Winter wonderland. 📷 CLARICE SIEGMAN

YELLOW CENTER *(far right):* Jarandillo Drive in Hot Springs Village is sterilized with the cleanliness of new snow. 📷 FRED GARCIA

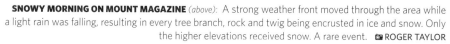

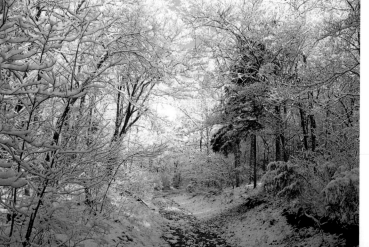

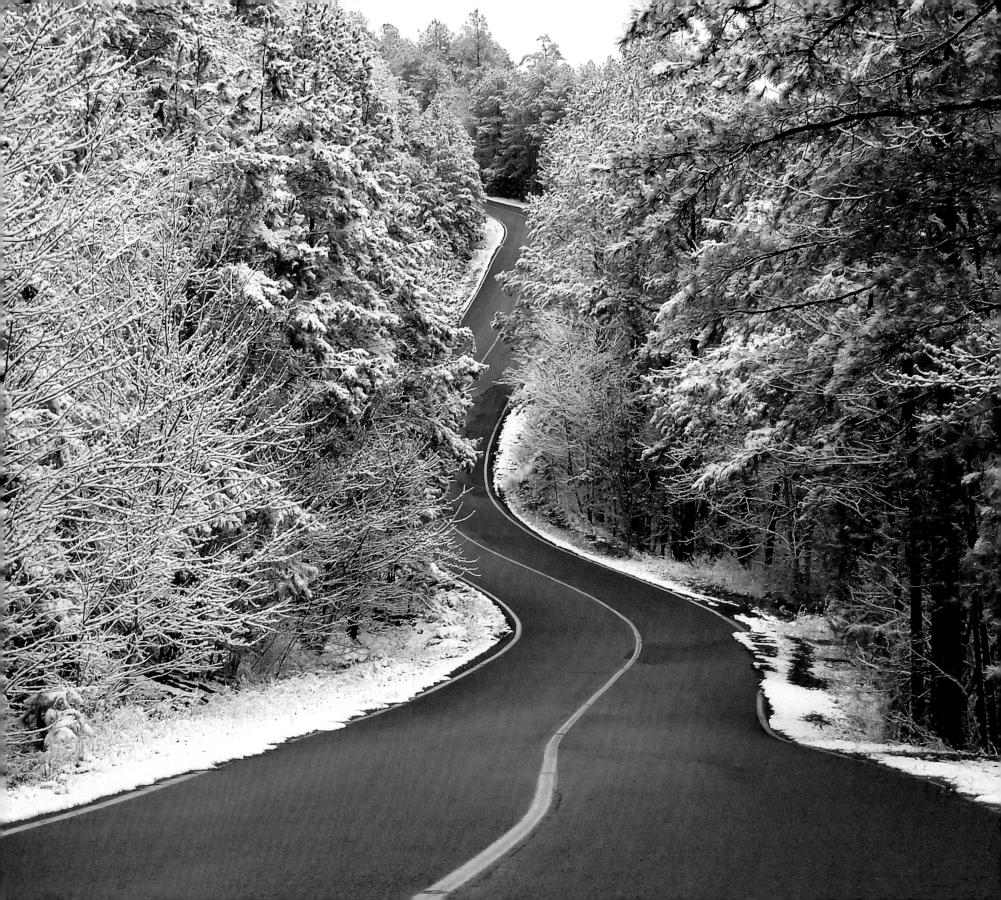

GOTHIC GATES *(right):* The gates to the Governor's Mansion in Little Rock following a Valentine's Day snow. 📷 KIRK JORDAN

COLORFUL SNOWFALL *(opposite):* Snowfall in downtown Russellville. 📷 TONY BELL

WINTER MORNING ON MOUNT MAGAZINE *(below):* I took this shot 30 minutes after daylight on Mount Magazine near Paris after a 12-inch snow. 📷 KIRK EHREN

WINTER OLD MILL *(bottom):* Winter view of the Old Mill in North Little Rock, which was featured in opening scenes of *Gone With The Wind.* 📷 CHARLES CLOGSTON

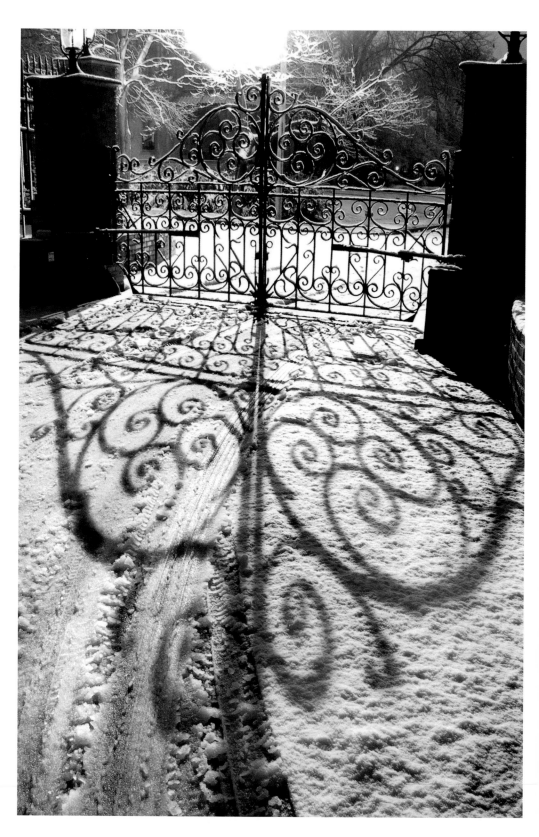

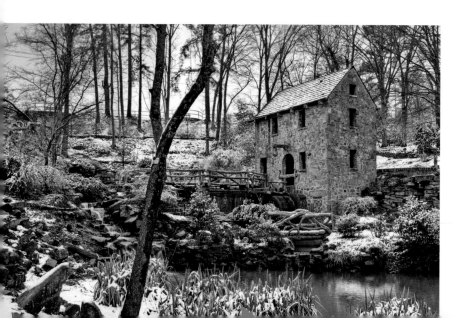

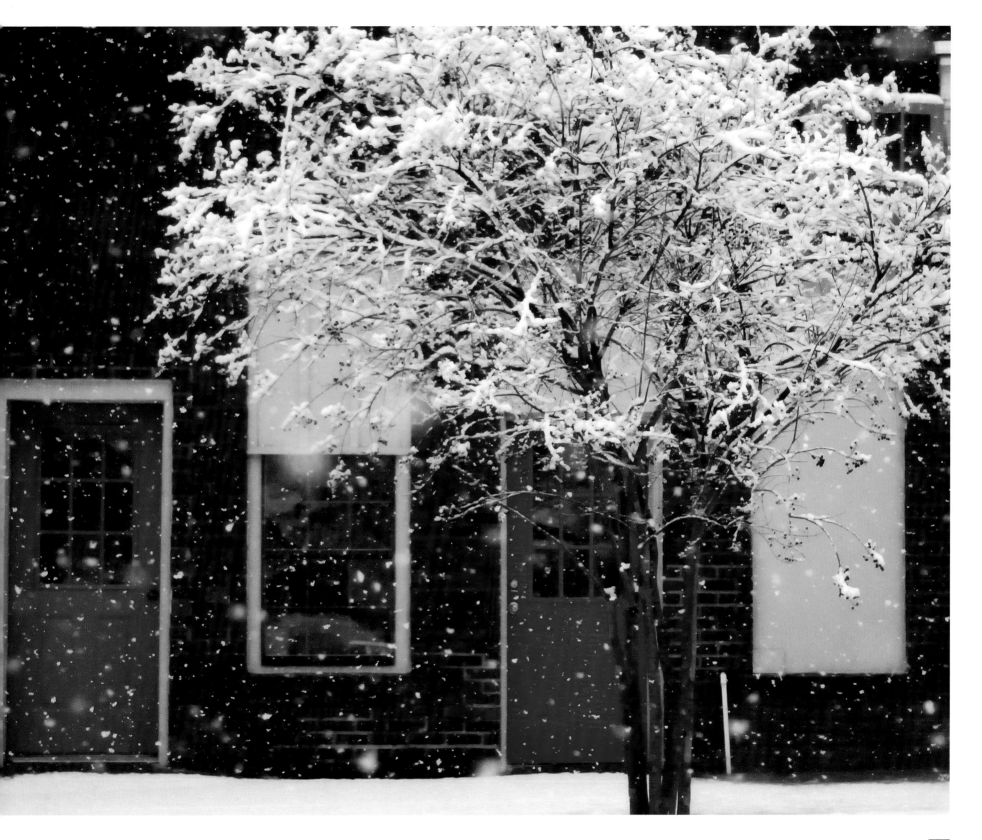

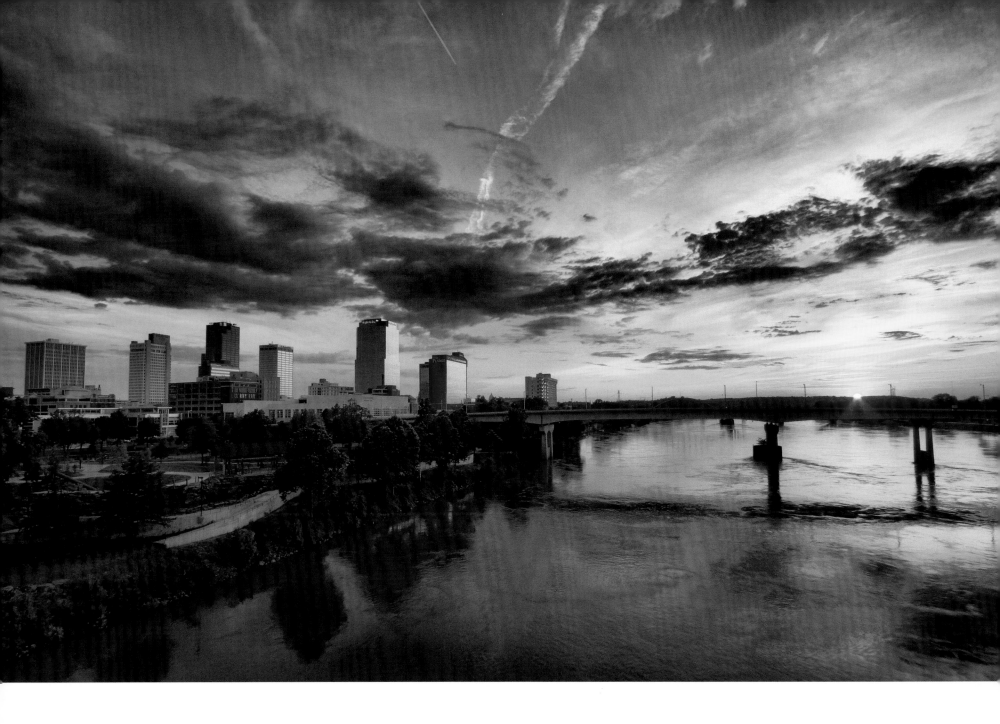

THE ROCK CITY (*above*): Our beautiful city in the last light of the day. 📷 PAUL BARROWS

SUNRISE (*opposite top*): A November sunrise over the Little Rock skyline. 📷 BRAD SCHNACKENBERG

CROSSES AND CLOUDS (*opposite left*): St. Edwards' signature cross-topped steeples are silhouetted by a large thunderstorm cloud, burning red from the light of the setting sun, in downtown Texarkana. 📷 AARON STREET

TRES CRUCES (*opposite right*): A scene from a West Little Rock church parking lot looking east as a spectacular lightning show moved south over downtown near midnight one summer night. This scene is similar to one that occurred some 2,000 years ago. Parking lot lights provided the golden glow on the rocks, God provided the background. 📷 MARTY ALLEN

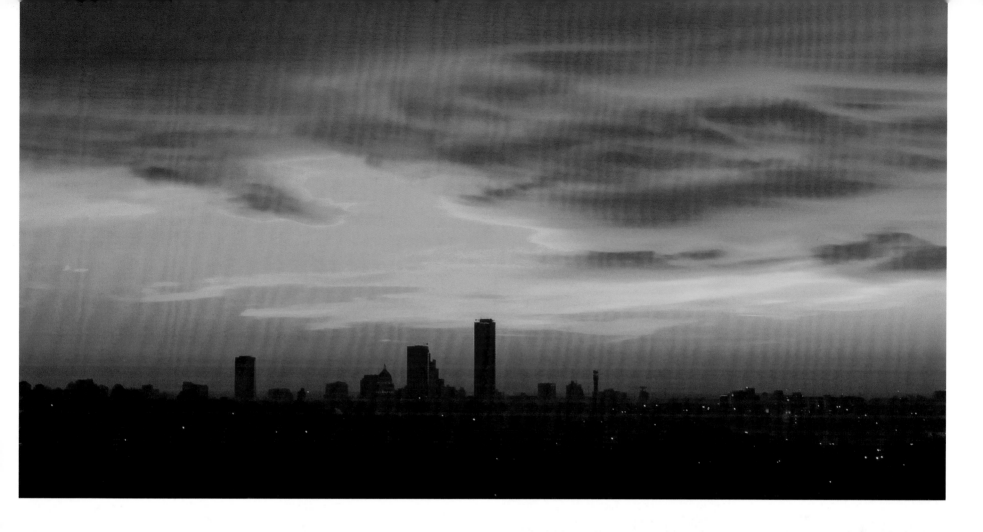

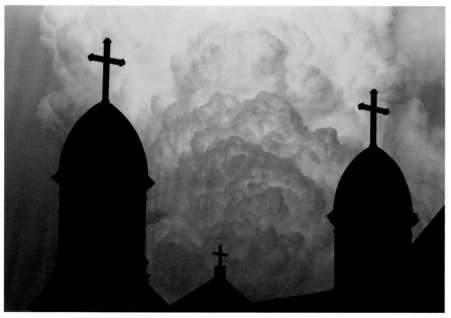

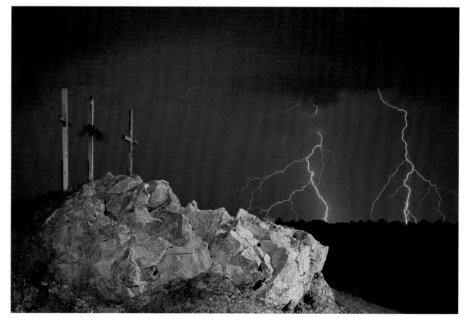

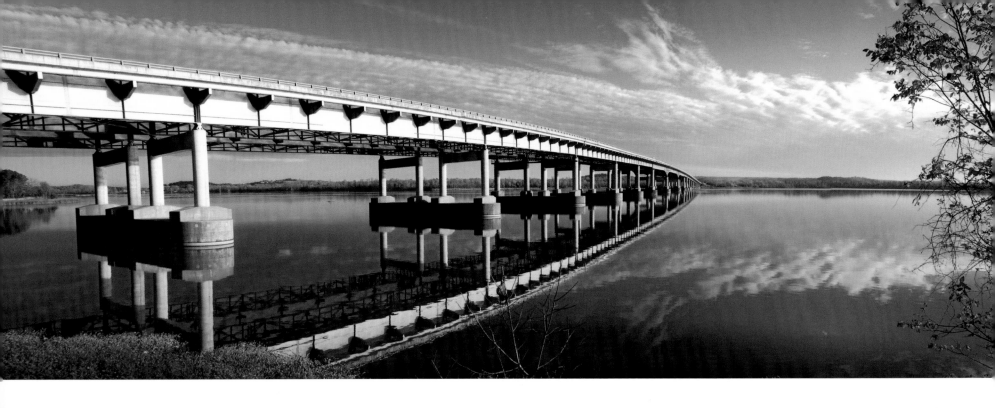

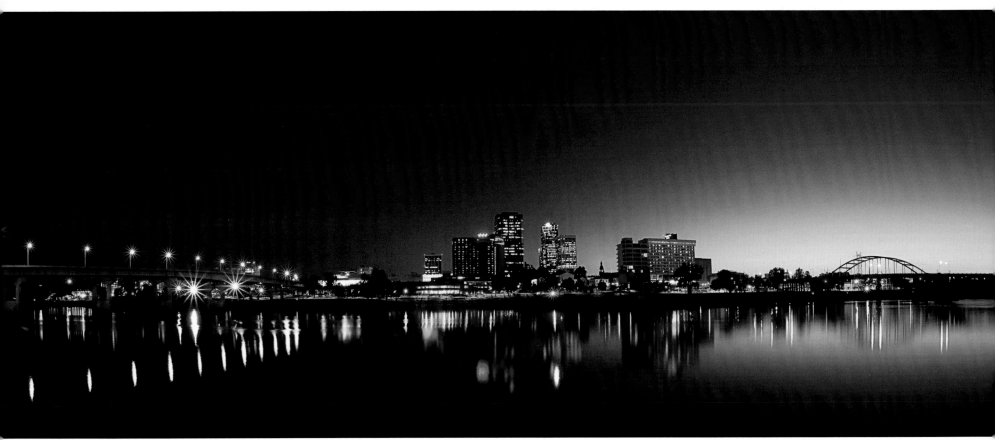

RIVER'S REFLECTION (*opposite top*): We may see this bridge every day, yet how often do we see the art of the bridge? 📷 MIKE ANDERSON

DOWNTOWN (*below*): Front Street in downtown Conway makes for a beautiful evening stroll. The businesses are closed, but feel free to window shop; they'll be glad to see you the next day! 📷 KARLA HALL

UNTITLED (*opposite bottom*): Lights in the city. 📷 ML BAXLEY

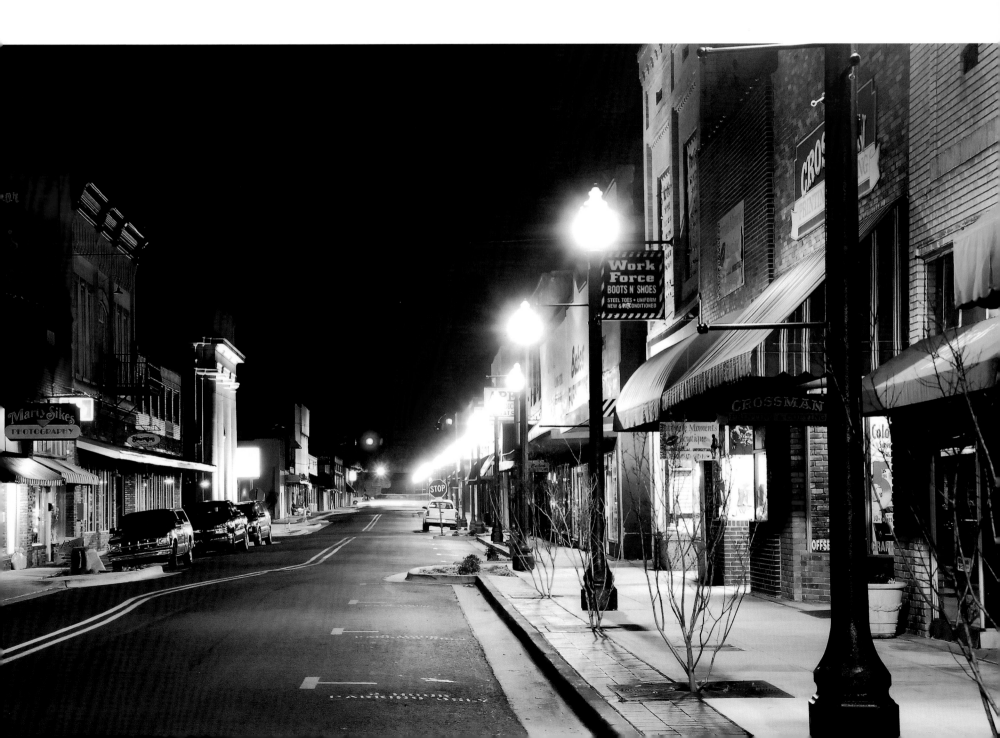

BRIDGE TO NOWHERE *(right)*: A fisherman's view of the Big Dam Bridge in Little Rock. 📷 PATRICK MCATEE

LITTLE ROCK FROM JUNCTION BRIDGE *(opposite)*: Little Rock skyline as seen through the Junction Bridge beams at sunset. 📷 DANIEL SAMPLE

SUNSET ON THE RIVER *(below)*: The beautiful, mile-long Interstate 430 bridge at sunset. 📷 TIM SITLER

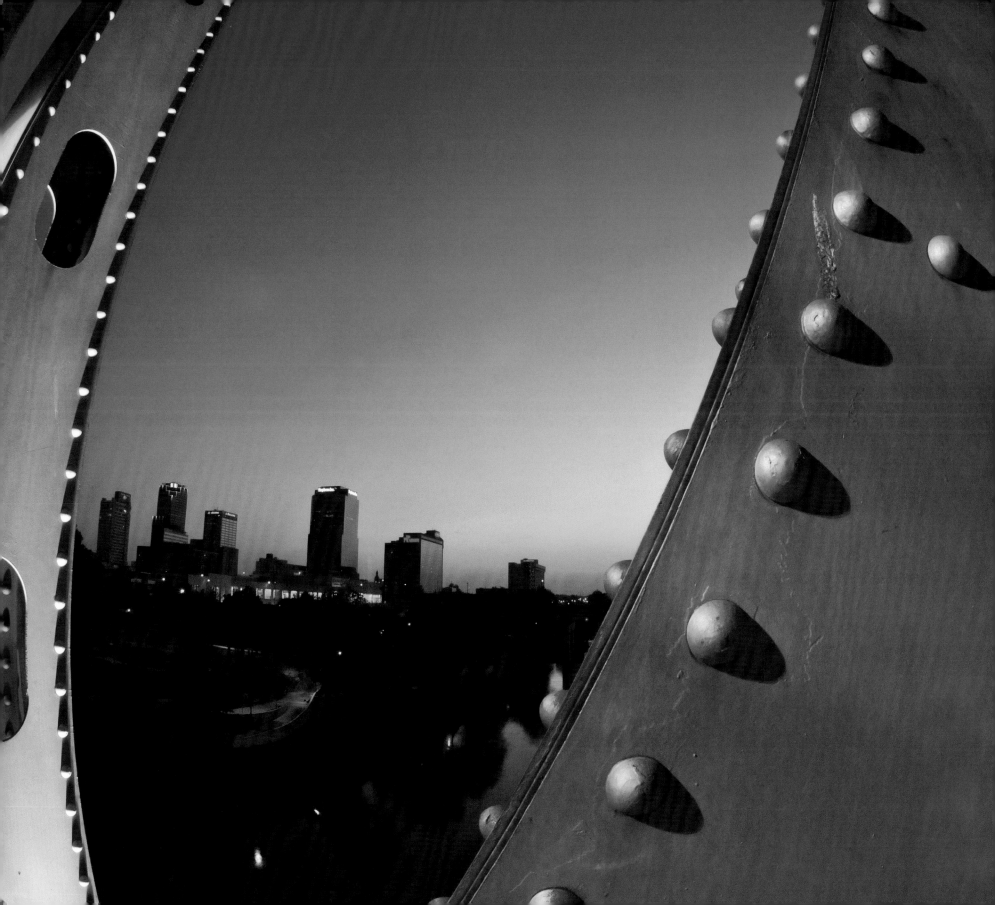

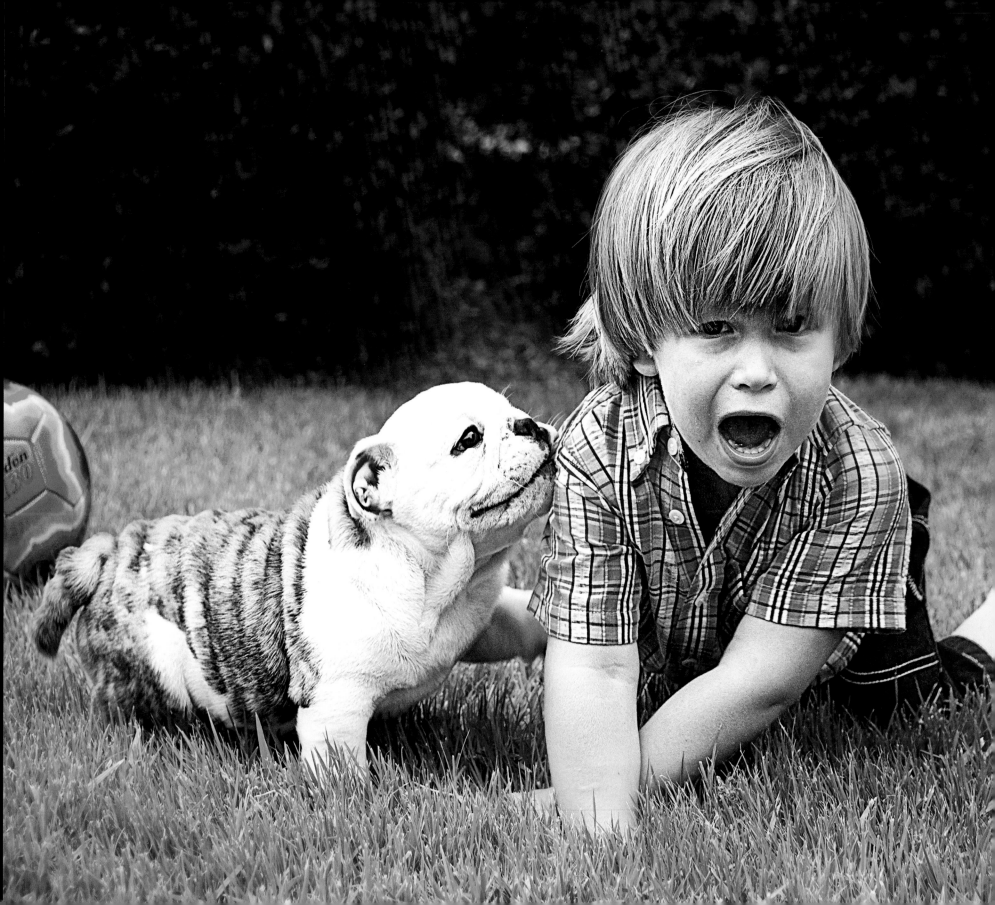

Everyday Life

SPONSORED BY PC HARDWARE AND LIGHT INNOVATIONS

This chapter was a bit of anything and everything. See a young girl honor a military serviceman, a young boy show his big catch and a young couple connect by kiss within a crowd.

We were touched by the sweet simplicity of a dad showing his sons how to shave and could almost hear the sounds as musicians played on stage. Perhaps your mouth will water, as ours did, as we remembered the taste of sweet Southern peaches, an old-fashion burger from a classic joint and sugary sweet black cherry gum.

This chapter, perhaps like they all do, does us a favor by pausing time and allowing us to take in the small and large moments that make life, well, life.

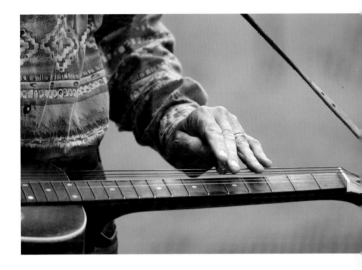

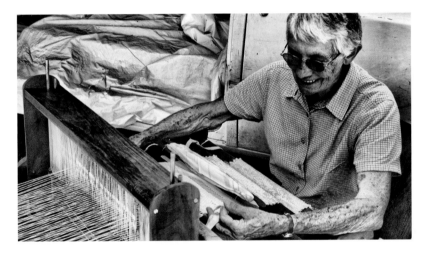

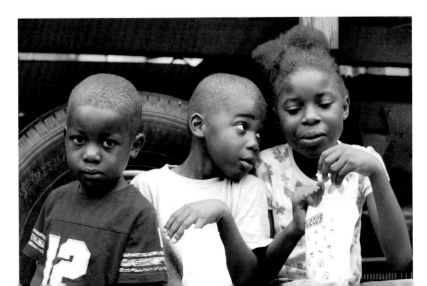

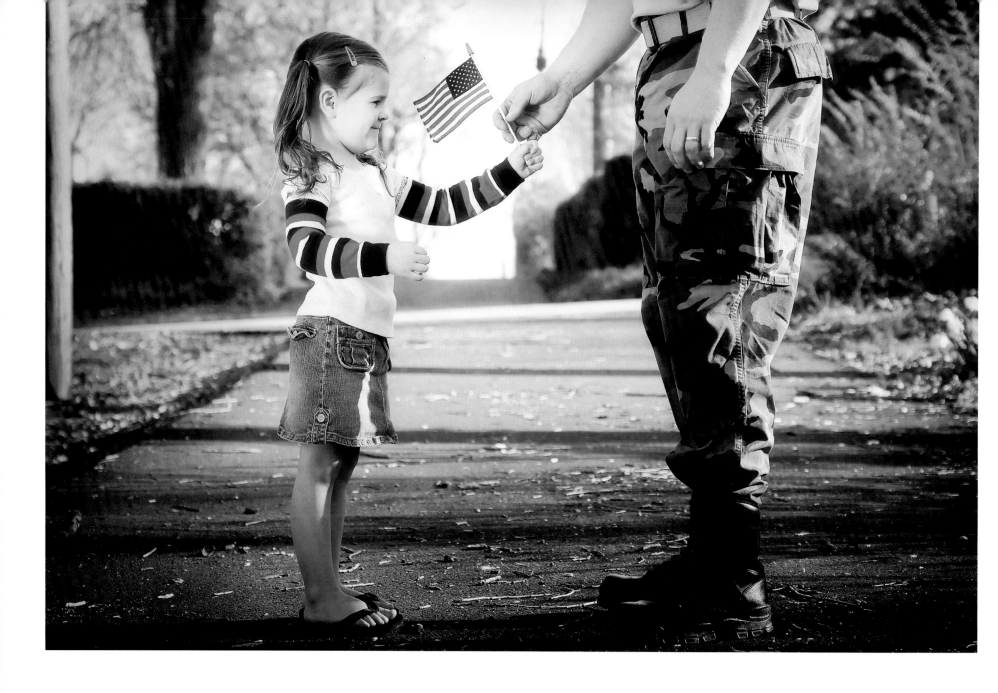

MY HERO *(above):* You are never too young to appreciate a hero. 📷 KERRIE SZABO

PUPPY LOVE? *(previous left):* Who's loving who? 📷 TODD SMITH

WEAVER *(previous middle top):* A morning with the artisans at the Fayetteville Farmers Market. 📷 JULIA NOBLE

WOULD SOMEONE PLEASE SHARE? *(previous middle bottom):* Hanging out at the Farmers Market on a Saturday morning while their parents sell fresh produce. 📷 CINDY BOYLE

MUSIC HANDS *(previous right top):* Folk musician at Arabian horse event to promote Black Stallion Literacy Project. 📷 STACEY BATES

GOVERNOR HUCKABEE AND BUDDY *(previous right bottom):* Former Gov. Mike Huckabee and his dog Buddy look up at incoming ducks. 📷 DANIEL SAMPLE

PAINT THE SKY *(opposite left):* A hang glider is seen in Van Buren on October 29, 2006. 📷 MARK MONDIER

FIRST TIME HOLDING FIRE *(opposite top):* During her granddaughter's second birthday party, held on Petit Jean Mountain near Morrilton, grandmother Kathy Tatus shows the birthday girl, Ella Jones, a sparkler. 📷 EMILY C. JONES

PEEK-A-BOO *(opposite bottom):* My niece hiding behind a basketball. 📷 KAREN CHAMBERS

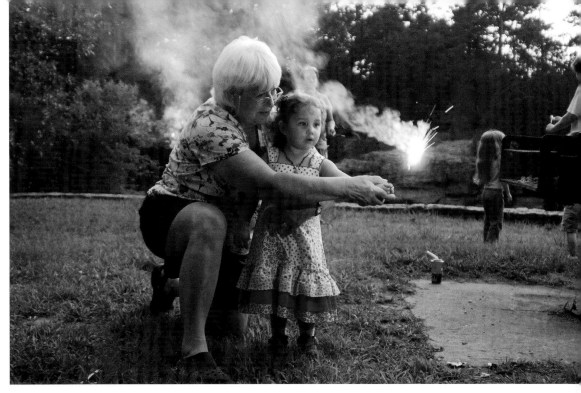

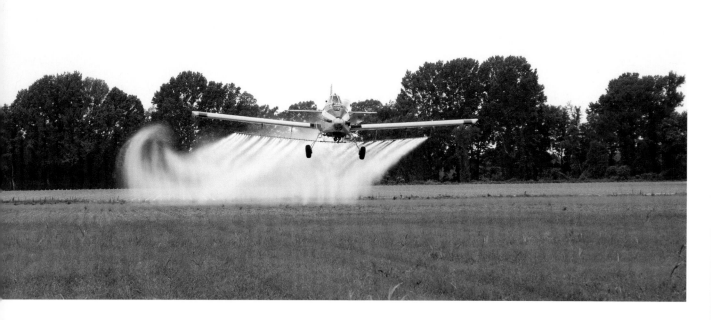

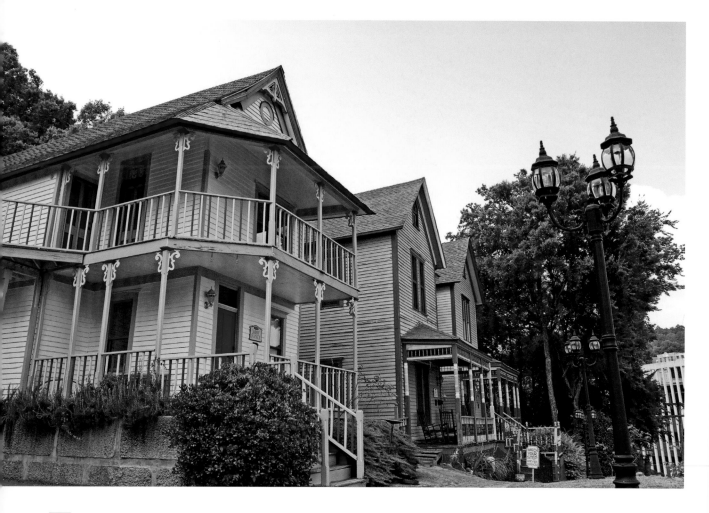

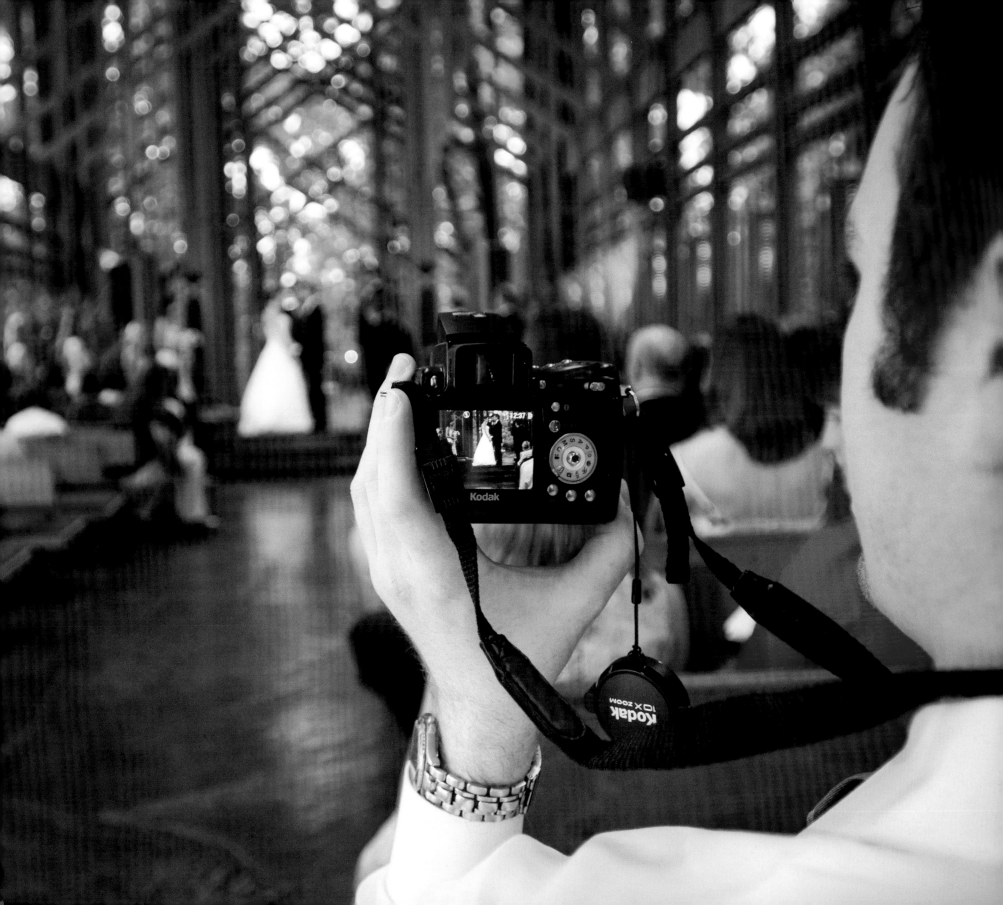

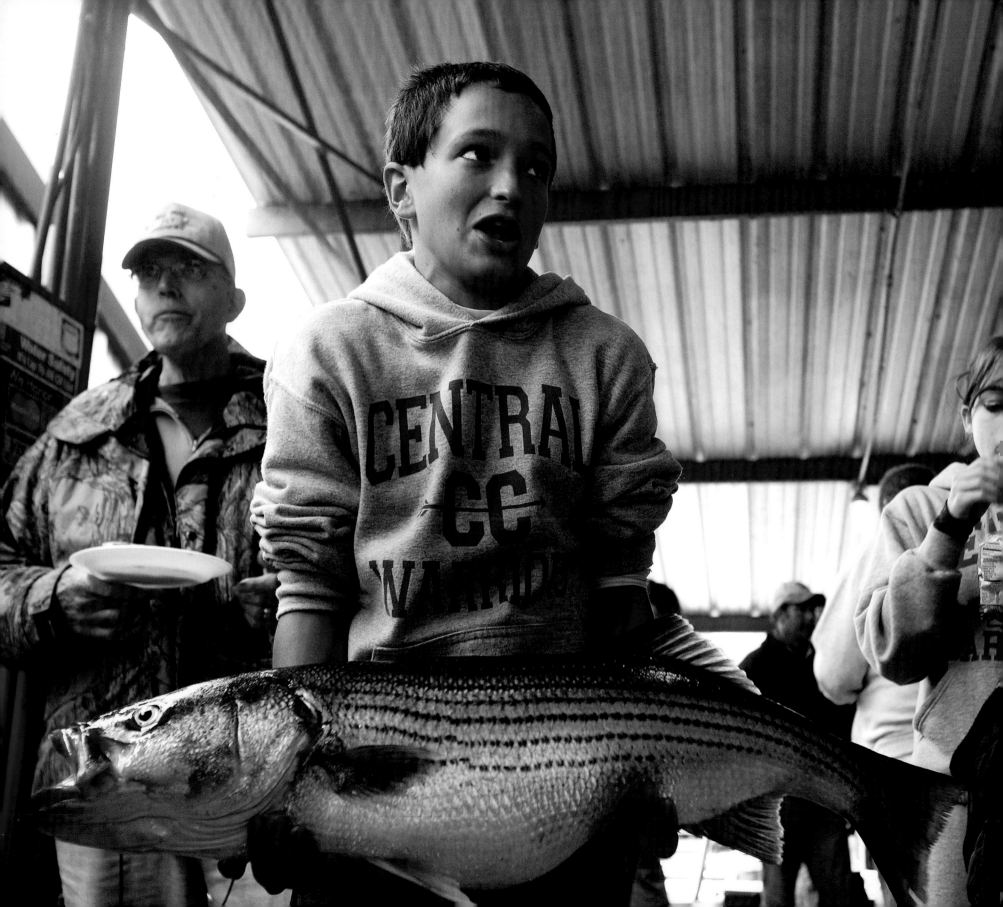

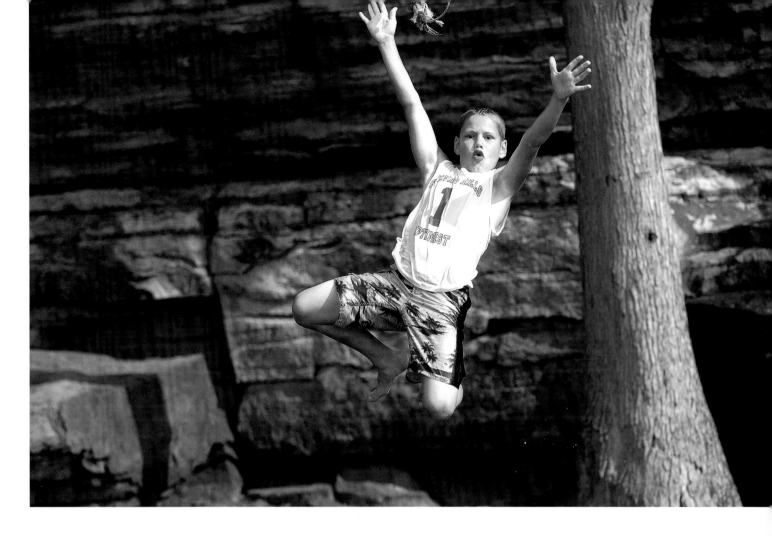

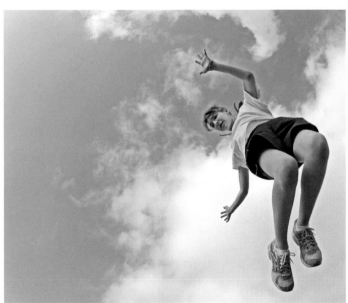

ROPE SWING (*above*): Jace swings into Greers Ferry Lake. 📷 MARK MUSGRAVE

JUMP! (*left*): She almost landed on me! 📷 PHIL TAPPE

FISH CLUB (*far left*): Kenny Semon, 14, of Springdale tries to hold on to a 14.25-pound striper fish at the Hickory Creek Marina on Beaver Lake. Semon joined about 100 students from the Central Junior High Hooked on Fishing Club for the 18th annual Ann Martin Memorial Striper Fishing trip. Each of the students was grouped with a Beaver Lake striper guide to help them catch the fish. 📷 AMELIA PHILLIPS/*ARKANSAS DEMOCRAT-GAZETTE*

NERVES OF STEEL (*previous top*): Ag-pilot, commonly referred to as a "crop duster," spraying a field in Ashley County. 📷 DARRELL CLIFTON

THREE OF A KIND (*previous bottom*): These day-spa cottages along a side-street in Hot Springs caught my eye. After I returned home I noticed that they each had a name; Miss Fancy in yellow, Miss Lilly in blue and Miss Carla in pink. 📷 DARIN MITCHELL

PICTURE ME HERE (*previous right*): Family friend photographing a wedding in Eureka Springs, at the Thorncrown Chapel. 📷 MELODYE PURDY

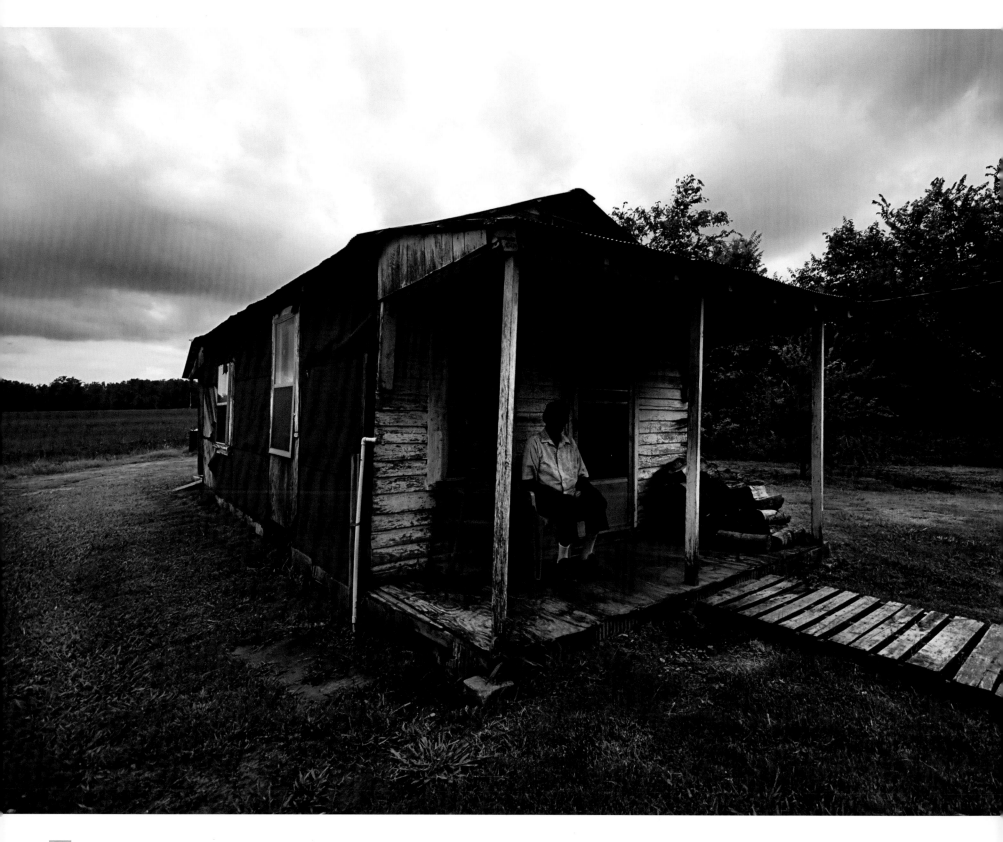

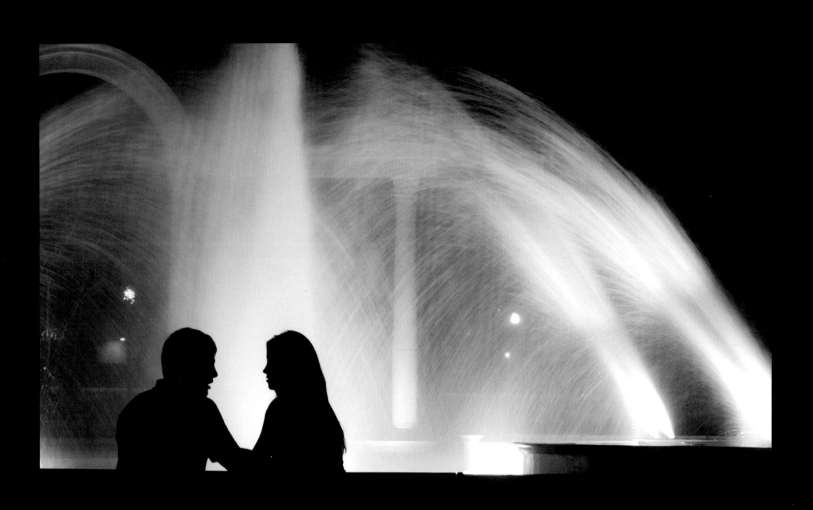

ARTHUR FLOYD (*previous left*): On my first encounter with Arthur, July 5, 2006, he said he was 96, but no one knows his birthday. He has a nephew that checks on him. He built the house he lives in and never married. His only water is the faucet you can see on the porch. I have made three visits since. Arthur is a delightful fellow. 📷ZACK JENNINGS

SILHOUETTE (*previous right*): Silhouette taken at the University of Central Arkansas fountain in Conway. 📷CALLIE-ANNE MCCLURE

YUMMY (*right*): Just a little messy! 📷AMBER LANNING

★ **WE MADE IT!** (*opposite*): The last dance of the night. The crowd picked up both the bride and the groom. 📷GRANT HARRISON

★ **LEAN ON ME** (*below*): Caylen and Jacquez on the bumpy bus ride after the last field trip of kindergarten. 📷BELINDA ROCCO

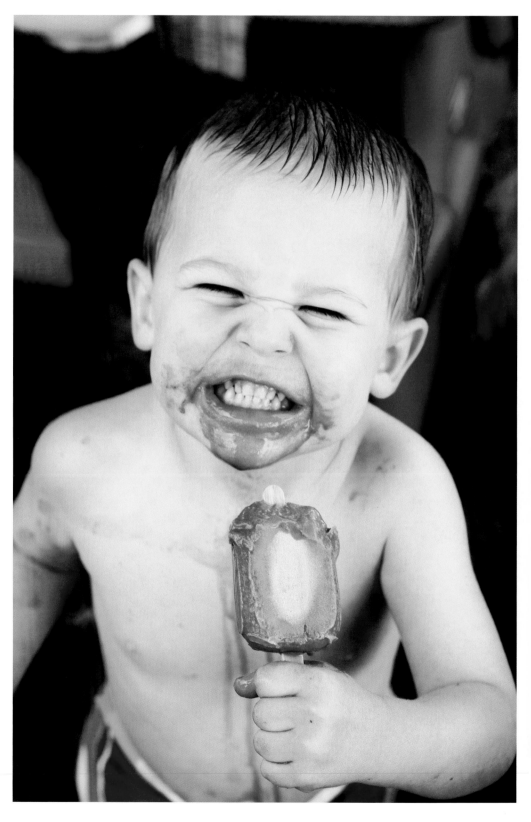

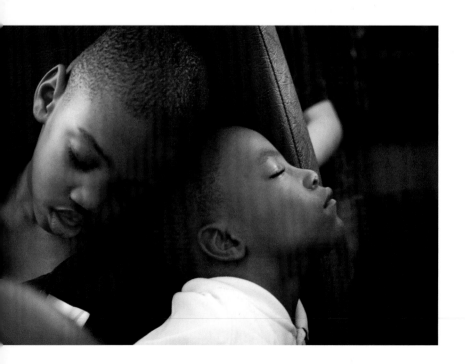

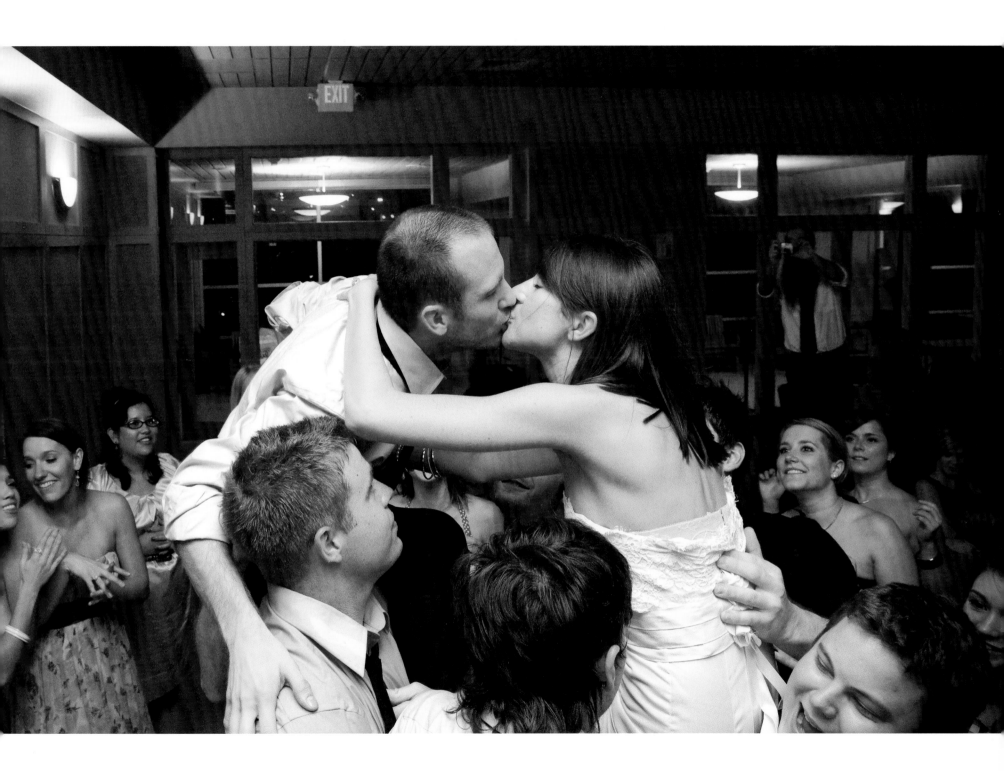

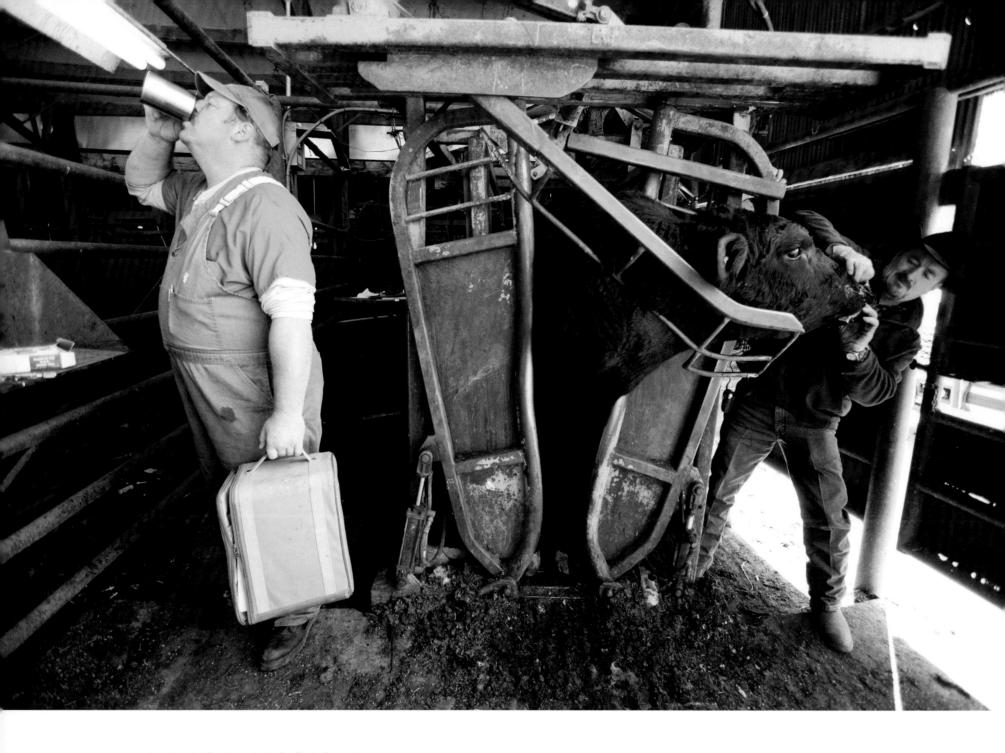

DR. ONEAL *(above):* Dr. Tim O'Neal, left, takes a drink of coffee before taking a sperm sample as Steve Bartholomew checks the bull's teeth at the Fayetteville sale barn.
📷 DAN HALE/*ARKANSAS DEMOCRAT-GAZETTE*

BROTHERS *(opposite left):* Two brothers spend Memorial Day afternoon relaxing on Chittman Hill, an Arkansas Game and Fish Commission pier on Harris Brake Lake in Perry County. 📷 EMILY C. JONES

THE OLD HOT FOOT *(opposite top):* The River Market building boom in Little Rock. 📷 STEVE SPENCER

★ **RED HOT** *(opposite bottom):* Farrier Kevin Bell shaping a horseshoe. 📷 STACEY BATES

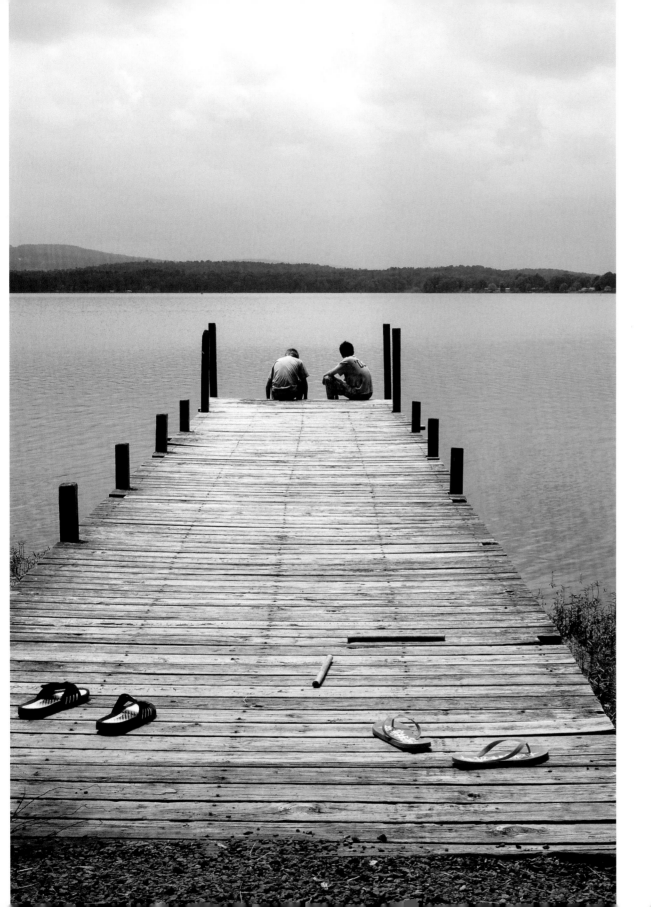
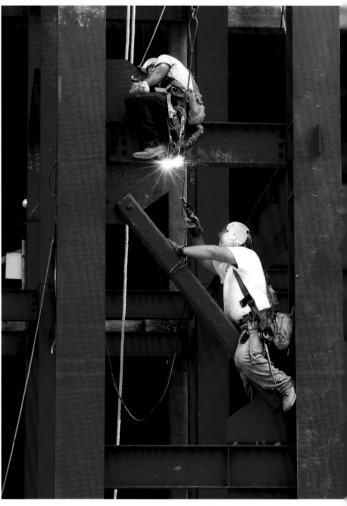
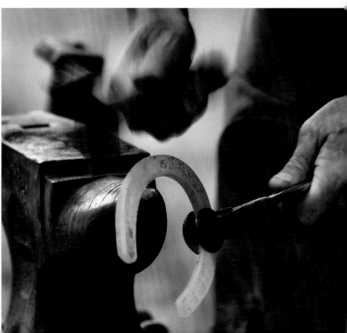

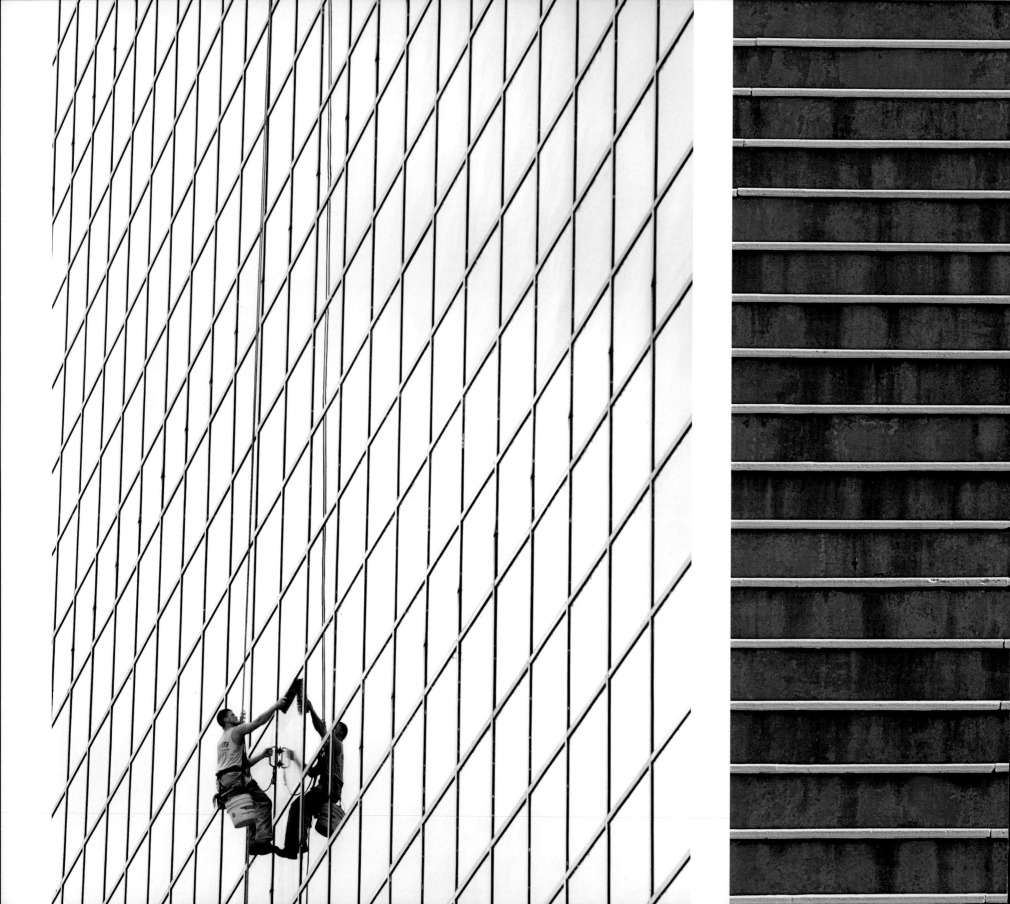

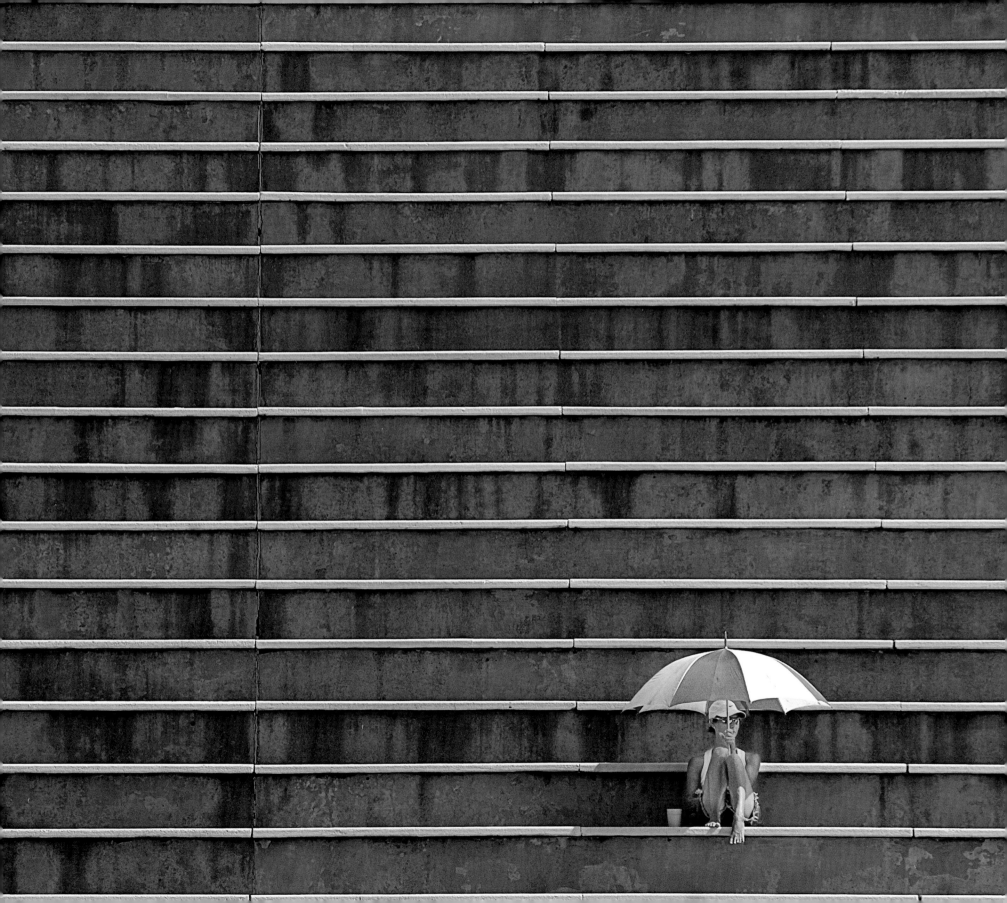

WINDOW CLEAN *(previous left):* Jeff Inmon of Miracle Window Cleaning squeegees the windows of the Peabody Hotel in Little Rock.
📷 RUSSELL POWELL/*ARKANSAS DEMOCRAT-GAZETTE*

LONE FAN *(previous right):* A dedicated mother sits alone in the scorching stands of Razorback Stadium at Texarkana High School to watch her son play in a football summer camp. 📷 AARON STREET

THE APPRENTICE *(right):* One thing I want to pass on to the next generation is the art of photography, and the digital camera has helped me in that area. It is amazing some of the photographs these little ones can get! Lake Willastein, Maumelle.
📷 DOUG TANNER

FORGOTTEN *(opposite left):* Downtown Paragould.
📷 CALLIE-ANNE MCCLURE

BASKETS OF HEAVEN *(opposite top):* Grandma's baskets of mouth-watering "candy."
📷 NATHALIE HUNT

LONELY MR. BURGER *(opposite bottom):* My wife and I decided to run out in the snow and grab a burger (that's her inside). When it snows here in Arkansas, everyone panics and everything closes. This Mr. Burger is a neat spot because it's been around the University of Arkansas in Fayetteville for so long. My dad used to eat here when he went to college back in the late '60s. 📷 JONAS SCHAFFER

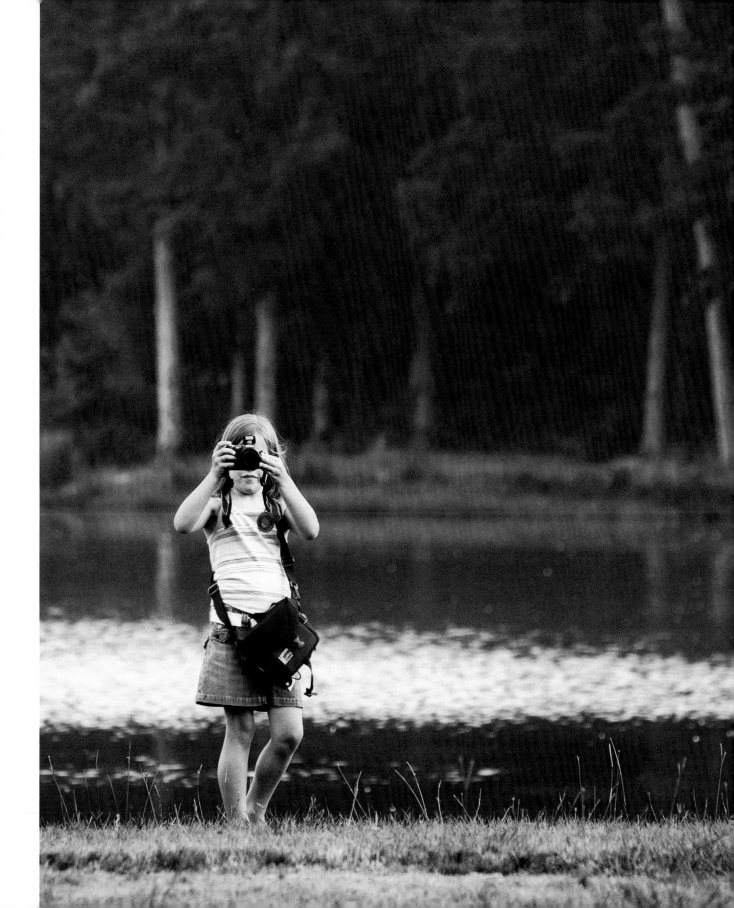

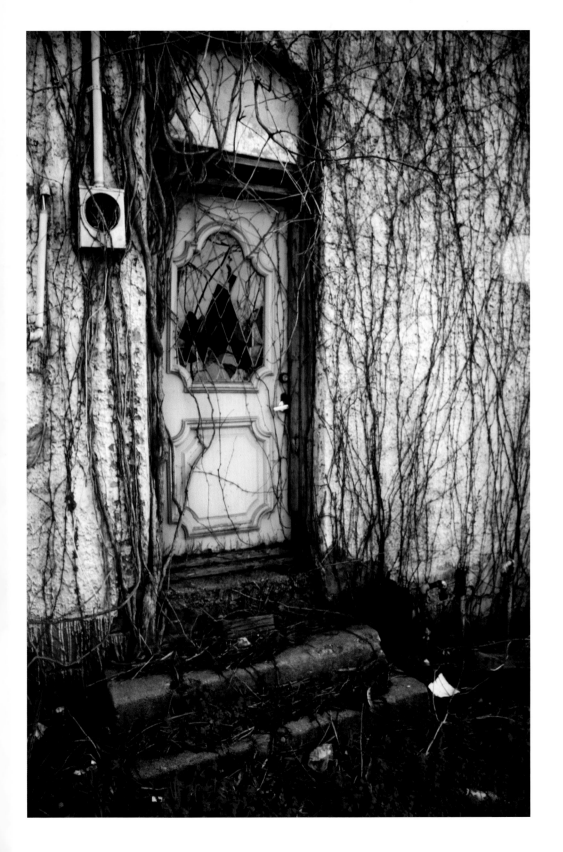

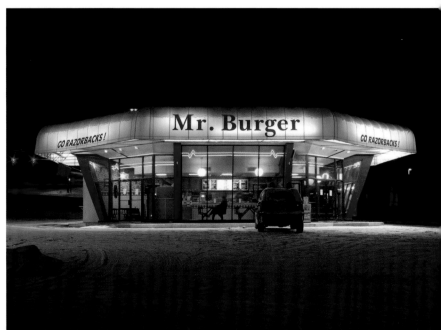

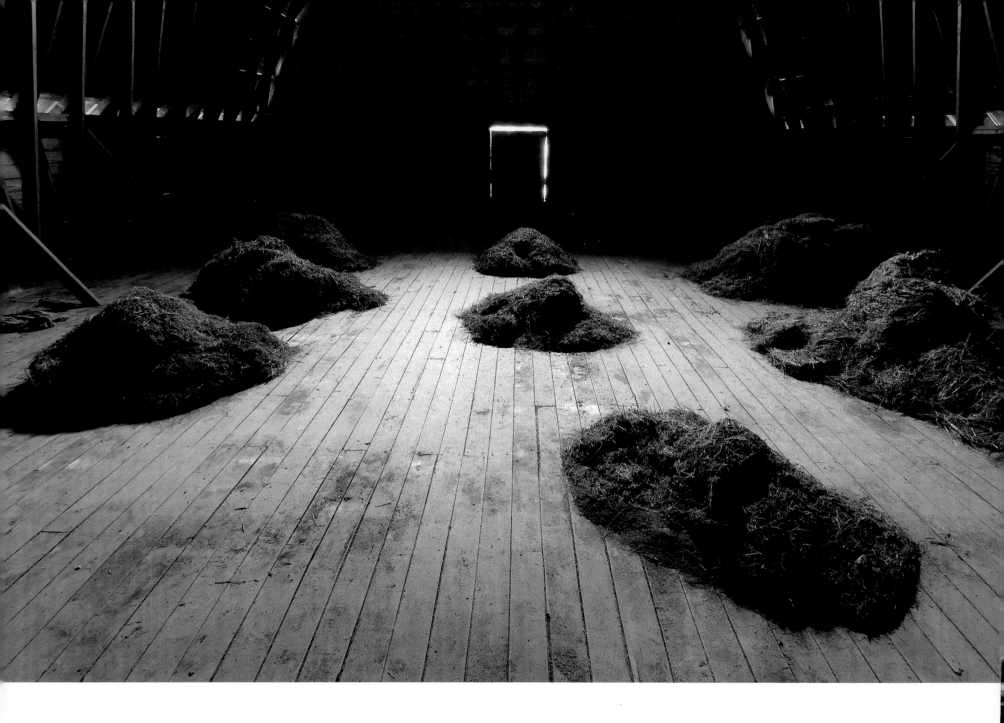

OLD HAY LOFT *(above):* I enjoyed the way the light was shining on the piles of hay in this old barn's loft.
📷 RODNEY STEELE

TRADING POST *(opposite top left):* The Trading Post in Marshall on Arkansas 27 towards Morning Star.
📷 PAUL BARROWS

UNTITLED *(opposite top right):* Liz Lang from Los Angeles and Brie Blakeman from Denver dance with Hula Hoops as the sun sets at the Mullberry Mountain Music Festival in Ozark.
📷 MICHAEL WOODS/*ARKANSAS DEMOCRAT-GAZETTE*

ABANDONED PIANO *(opposite bottom left):* My friend happened to see this piano in the front loader of a bulldozer that was heading for a cliff. He stopped and asked if he could have the piano instead of it being dumped over the cliff. When he got it home he stored it under a tarp. It was in better shape then. At some point the tarp blew off and the elements had their way with the piano. 📷 REX LISMAN

TRAIN RIDE *(opposite bottom right):* Van Buren train ride in the fall. 📷 MICKEY ARLOW

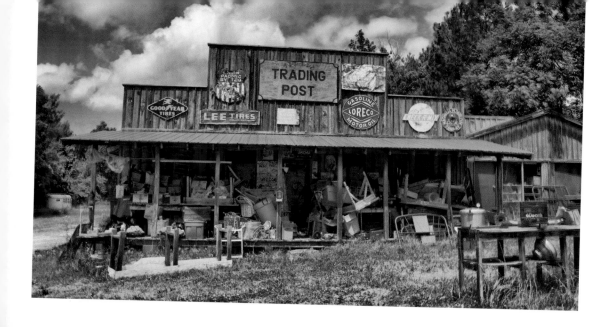

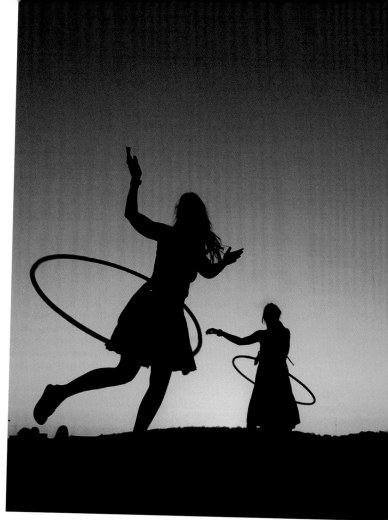

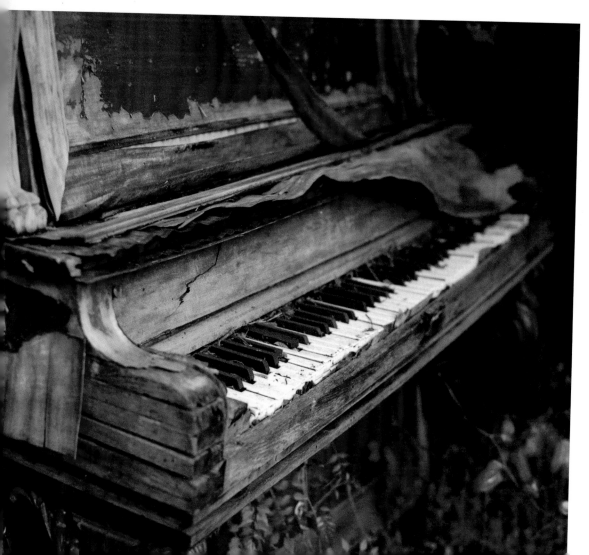

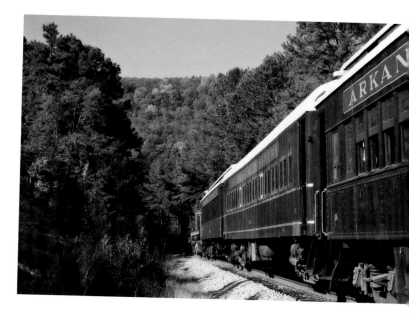

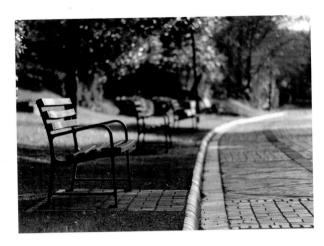

HOT SPRINGS NATIONAL PARK *(above):* Park benches behind Bath House Row in Hot Springs. 📷 STEPHEN LEIN

THRILL SEEKER *(right):* She loves it ... me on the other hand, not so much. 📷 KERRIE SZABO

THE BOYS INVESTIGATING SHAVING CREAM *(opposite):* Daddy was shaving and the boys wanted to know what it was like. 📷 SHARON WHITLEDGE

THE MUNKS *(following left):* Here are The Munks rockin' White Water Tavern in Little Rock. 📷 ALEX KENT

BLACK CHERRY *(following right):* We all need a little sugar fix when taking our kids back-to-school shopping at the mall! 📷 JULIA NOBLE

TRAFFIC LIGHT JAM *(below):* Saturday morning at the River Market. Homemade jam and jelly by the Stutzmans, an Amish family living in Belleville. 📷 CORRINNE TAYLOR HORNE

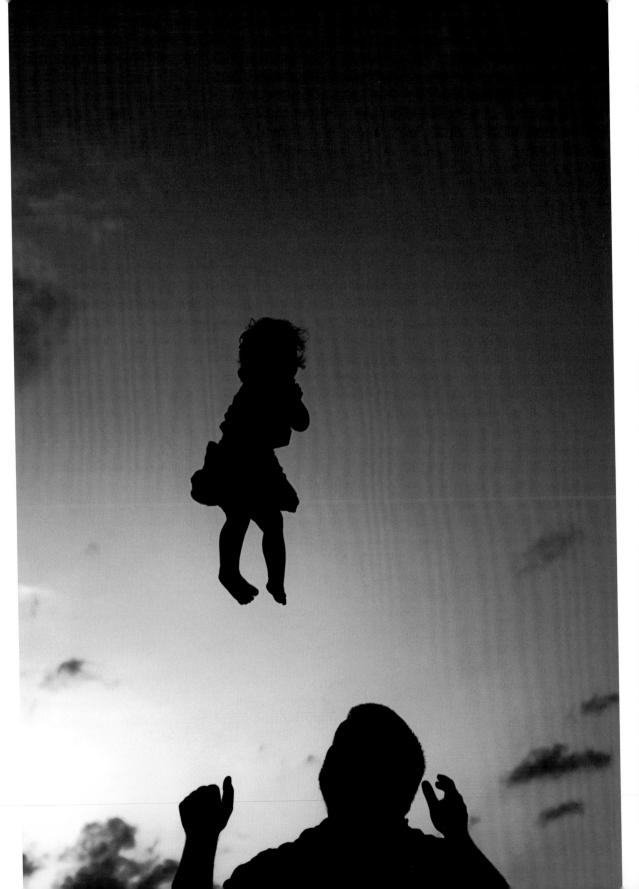

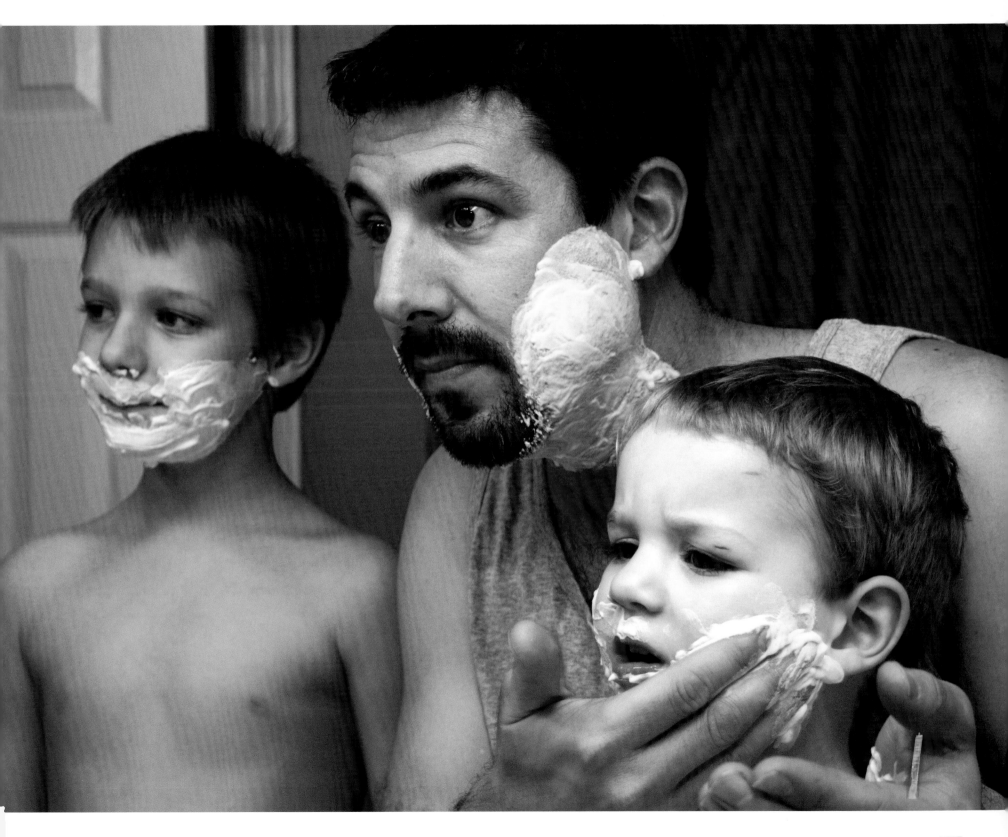

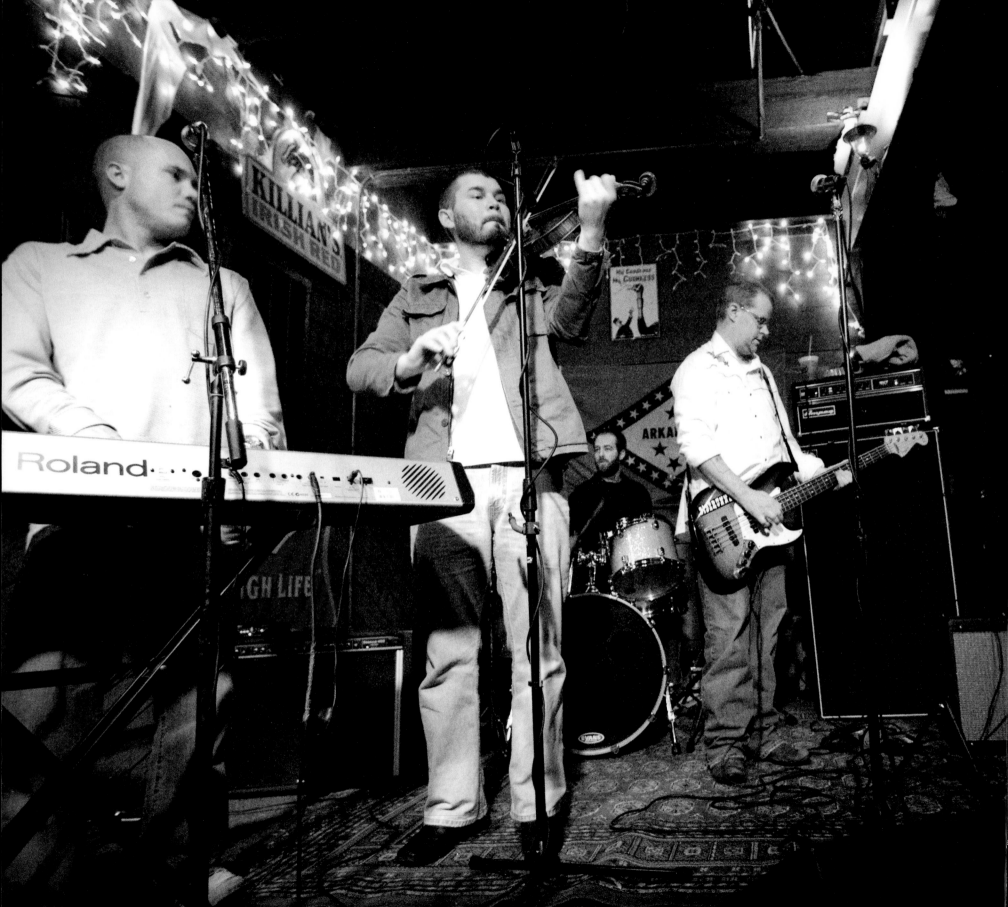

Capture Arkansas was made possible by local photographers who were willing to share their talents with the rest of us. Here's a list of everyone you'll find in these pages and on the DVD. If you know any of these folks, give them a ring and say thanks for the great book!

(Photographers with Web sites on following pages.)

Summer Abbott
Aimee Abbott
Brennan Ables
Darrell Adams
Scott Adams
Courtney Adams
Kathy Aday
Vicki Akins
Tammy Albrecht
Amy Aldridge
Hetherington Alex
Carla Alexander
Kathy Alexander
Brandy Alford Lockhart
Vicki Allbritton
Mary L Allen
Brooke Allison
Joyce Ammann
Suzie Anderson

Mike Anderson
Jeremy Anderson
Shawn Anderson
Arthur Anderson
Melissa Andrews
Mickey Arlow
Keith Armbrust
Cindy Armstrong
Brian Arnold
Larry Ash
J K Ashley
Linda Ashmore
Michael Ashmore
Deanna Atkinson
Shelly Austin
Brandon Authement
Steve B
Janie Baber
Carla Baggett

Ruth Ann Bagwell
Susan Bailey
Gary Baker
Chris Baldwin
Alec Baldwin
Peggy Balentine
Rebecca Balentine
Diana Ballenger
Jordan Ballew
Carole Barger
Wylie Barker
Steve Barnard
Vicky Barnes
Kathleen Barta
Frank Barton
Amber Bass
Suzie Bass
Brant Bauman
Beth Beam

Sally Beam-Rodden
Jim Beard
Marti Bearden
David Beebe
Shawna Bell
Klansee Bell
Denney Bell
Kelli Bell
Karissia Bennett
Brian Bennett
Karen Benson
Melba Benton
Sandy Bernet
Dennis Berry
Carl Bethea
Gary Bewley
Anita Bierbaum
Mindy Bissett
Jennifer Bivins
Cary Bivins
Sherri Black
Aaron Black
Paul Boatman
Kathy Bogan
Bethanie Boozer
Darlene Boozer
Kristen Bordelon
Steve Bounds

David Bowden
Stuart Bowles
Wendy Bowles
Lindsay Box
Claudine Boyce
Melissa Boyd
Tony Boyd
Connie Boyd
Cindy Boyle
Shirley Bradshaw
Amber Bramlett
Larry Brannan
Dani Brantley
Cicely Brave
Grant Bray
Shannon Bray
James Breeding
Staton Breidenthal
Betsy Breshears
Joe Brewer
Teresa Brewer
Heather Brewer
Jennifer Briggs
Ira Briggs
David Brightwell
Alexa Britton
Michelle Brockman
Andrew Brown

Laura Brown
Chris and Linda Brown
Julia Brown
Rebecca Brown
Wendell Brown
Stephany Brown
Kellye Brown-Nichols
Amanda Browning
Pj Bryant
Ketha Buck
Michael Buffington
Mary Buirse
Phillip Bumpers
Meg Bumpers
Kim Burcham
Larry Burchfield
Edward Burgess
Stephanie Burleigh
Chance Burnett
Hannah Burney
David Burney
Katie Burns
Katrisha Burns
Marci Burns
Jeanette Burroughs
Oran Burt
Shana Buterbaugh
Jenifer Butts

William Byers
Silas Byers
Vicky Bynum
Megan C
Monica Cagle
Diana Cain
Jessie Caine
Andrew Cains
Lisa Caldwell
Leesa Caldwell
Erika Caldwell
J Michael Callans
Heidi Campbell
Stephen Campbell
Darla Campbell
Mehmet Cansizoglu
Laura Cantrell
Melissa Cantrell
Jennifer Carlow
Gayla Claborn
Carla Carlton
Sara Carman
Amy Carnahan
John Carney
Maria Carpenter
Shawn & John Carrell
Steve Carter
Kelley Carter
Jacqueline Carter

Jobeth Casados
Karen Caster
Paul Caster
Donna Castiglia
Eric Castleberry
Sara Cater
Nancy Chacon
Mary Alice Chambers
Karen Chambers
Darrell Chatelain
Brad Chilcote
Marcy Childers
Gary Childers
Taylor Childress
Jonathan Childs
Kathi Chism
Shonda Chrissonberry
Rachel Chrissonberry
Gayla Claborn
Jessica Clark
Lauren Clark
Jennifer Clark
Melodie Claussen
Mike Clayton
Rebecca Clifft
Darrell Clifton
Bryan Clifton
Becky Clinton

Brandy Cochran
Amy Coffman
Lori Cogburn
Bob Coleman
Lisa Coleman
Pat Colford
Olivia Collins
Dana Compton
Brian Compton
Debbie Conard
Paige Condray
Dee Dee Conklin
Janet Conner
Jennifer Conrad
Leisa Conrad
Stephanie Conway
Kelley Cooper
Katie Cooper
Ron Cooper
Beverly Cooper
Lorissa Copeland
Rich Cosgrove
Terri Cossey
Amy Cotton
Sam Coulter
Dennis Coward
Deb Cowling
Vicky Cox

Sandy Craig	Nitzia David	Katherine Diggs	Terri Duvall	Jon Felker	Gary Fronabarger	Karen Givens	Ted Grindall	Andy Harp
Steve Creek	Karen Davis	George Dillin	Tammy Dyke	Chanler Ferguson	Lynn Frost	Nancy Glasscock-Doughty	Angela Grossman	Ilene Harral
Sarah Crites	Shari Davis	Matt Disch	Matthew Dyson	Susan Ferguson	David Fuqua	Tracy Godsey	Jason Groves	Diane Harris
Rebecca Crittenden	Steven Davis	Courtney Dixon	Karen East	Gwenda Ferrari	Stan Fure	K Goings	Amber Gullett	Nicole Harris
Robert Crittenden	L. Davis	William Dixon	Teresa Echols	Stephanie Fink	Frank Fusco	Jeffery Goings	Amber Gunter	Rachel Harris
Jim Crocker	Tina Davis	Richard Dixon	Melissa Ecker	Terry Finley	Wanda Gage	Lynda Goodbar	Tara Gurley	Tammy Harris
Bob Croft	William F. Davis, Jr.	Mark Dodson	Michelle Eckert	Allison Finn	John Gallagher	Bill Goodin	Kirk H	Donna Harris
David Crook	Jerry Dawson	Misty Doherty	David Eddy	Mike Fisher	Johnny Gammill	Nick Goodrich	Amanda H	Laura Harrison
Tanya Cross	Donna Dayer	Renee Donaldson	Annaliese Eden	Shirley Fisher	Jeremy Gannaway	Tara Gordon	Maggie Haase	Elizabeth Harter
Mark Cross	Keith De Noble	Tim Donar	Debbie Edwards	Angela Fite	Fred Garcia	Josue Goss	Chad Habig	Ben Hartman
Jeff Cross	Campbell Deann	Dixie Dorflinger	Kirk Ehren	Tiffin Fitzhugh	Susan Garoutte	Deborah Goss	Sasha Hahn	Nancy Hartney
Caren Crossland	Tammy Deberry	Elissa Douglas	Jordan Ehren	Cory Fleeger	Herb Garrett	Robert Gossett	Paula Halbrook	Donna Harvey
Zac Crow	Rita Deblock	Carol Dowdy	Carolyn Eifling	Emily Flora	Megan Garrison	Marilyn Gover	Dan Hale	Doug Harville
Mary Crow	Melanie Debusk	Paul Drennan	Bliss Eldridge	Kathy Flores	George Gatliff	Debbie Grable	Taylor Hall	Elizabeth Hatcher
Caitlin Cruickshank	Kelli Deen	Terri Drennan	Sam Elliott	D Flynn	Walter Gayle	Toni Graham	Megan Hall	Teresa Haustein
Heather Crum	Macayla Defrancisco	Richard Drilling	Fallon English	Amanda Fong	Bobby Geiger	Rowena Gransaull	Shelle Hames	Susan Hawkins
Michael Crum	Sarah Deloach	Leroy Drittler	Fabiola Escobar	Lisa Ford	Marie George	Kathy Gratzon	Barry Hamilton	Tracie Hawkins
Ina Cuba	Anne Delorenzo	Lauren Drittler	Curt Eubanks	Leah Ford	Alexandru Georgescu	Amanda Graves	Kevin Hamman	Bob Hayden
Gay Cullum	Connie Demarco	Bob Dudley	Renate Eubanks	Blue Ford	Marisia Geraci	Christie Graves	Doris Hammond	Randy Hayden
Jonathan Cullum	Jim Demby	Layton Dudley	Charlotte Eyman	Misty Foster	John Gertz	Scott Green	Carrie Hancock	Michelle Haygood
Tabitha Cunningham	Connie Dennis	Bobby Dugger	Jeff Fairman	Tony Franco	Karen Gibson	Arlene Green	Melissa Haney	Dan Haynal
Carson Cunningham	Jennifer Dennis	Dick Duke	Kenny Fairris	Lisa Franks	Leigh Gibson	Mary Green	Lee Hankins	Paul Hayre
Bethany Cunningham	Coop Dennis	Rachael Duncan	Sarah Falasco	Robert Franks	Carla Gilbreath	Karon Green	Carol Hannon	Valerie Hays
Jennifer Cupps	Katie Denson	Jojo Duncan	Kristen Farmin	Coreen Frasier	Debbie Giles	Jana Greenbaum	Kristina Hanry	Julie Haywood
Joy Dachs	Casey Deroche	Jenni Duncan	Connie Farrell	Christie Freeman	Sarah Gill	James Greenhaw	Ceci Hansen	Jesse Hefley
Toni Dale	Tracey Dewitt	Theresa Dupuy	Micheal Farthing	Lori Freeze	Alicia Gillaspie	John Greenway	Lynette Harden	Gretchen Hegi
Trudy Daniel	Ashley Dewitt	Paula Duran	Jennifer Faul	Joel French	Linda Gilliland	Cathey Griffin	Brenda Hardin	Beverly Henderson
Jamie Danuwar	Kara Dial	Dwayne Dush	Donna Favre	Tanner Fritsche	Aaron Gisler	Donna Griffin	Linda Harding	Alison Hendricks

Sarah Hendrix	Jackie Hoffman	Charles Huggins	Dianne Johnson	Randy Kemp	Jim Lancaster	Lauren Long	Kristen Mcbride	Marcia Mcmichael
Ian Hendry	Anita Hogue	Laura Hughes	Donna Johnson	Matthew Kennedy	Kitty Lane	Amy Long	Terri Mccain	Corey Mcmillan
Maranda Henley	Norma Hogue	Jennifer Hughes	Cheryl Johnston	Judy Kent	Kathleen Langston	Sabrina Long	Kimi Mccall	Kimberly Mcmullan
Jeff Henning, M.D.	Sharrell Holcomb	Wanda Hughes	Elaine Jones	Wes Kent	Christopher Lankford	Mollie Long	Curt Mccallum	William Mcnair
Liles Henry	Deb Holder	Jennifer Hui	Gina Jones	Tommy Key	Laura Larue	Shannon Long	Amy Mccalman	Roxanne Mcnulty
Ed Henry Sr.	Carissa Holder	John Humphry	Jennifer Jones	Riley Khoury	Michelle Lasseter	Elena Lopez	Clark Mccarley	Jennie Mcnulty
Laurie Hensler	Zach Holland	Nathalie Hunt	Michele Jones	Jessica Kibling	Becky Latch	James Lovell	Alisa Mcconnell	Lesley Mcpherson
Catherine Henson	Allie Hollon	Alissa Hurt	Neil Jones	William Kiehl	Torasa Lawrence	Teresa Luneau	Sherry Mccosh	Delana Mcquistion
Christina Hernandez	Judy Holmes	Jason Ivester	Karen Jones	Marl Kilgore	Mark Lawrence	Glenna Lybrand	Mike Mccreight	Ken Mcrae
Ray Hernandez	Gabe Holmstrom	Tammy Jacks	Brenda J Jones	Charles Kincade	Teri Laws	Bill Magee	Mary Mccullough	Ellen Mcwhirter
Rory Herndon	Barbara Holt	Cindy Jackson	George Jones	Peggy King	Travis Lazenby	Terry Majewski	Johnathan Mcdaniel	Devon Meadows
Bonita Herrington	Kim Hood	Sam Jackson	Chris Jones	Rachel King	Dennis Leake	Michael Mark	Angi Mcdaniel	Sue Megahan
Clint Herrington	John Hood	Amber Jackson	Andrea Jones	Krystal King	Cole Ledbetter	Greg Marlow	Danielle Mcdonald	Tom Melson
Roy Herron	Gerald Hook	David Jackson	Debbie Jones	Josh Kinsey	Susan Leder	Allen Maronay	Judy Mcdowall	Carolyn Melton
Steve Heye	Stephanie Hopkins	Taylor James	Natasha Jones	Jennie Kirby	Sunny Ledford	Johnny Marshall	Bill Mcentire	Brian Meredith
Jay Hiatt	Shannon Horton	Evelyn James	Debby Jones	Danny Kirby	Rachel Lee	Janelle Martin	Donald Mcfadden	Ashley Meredith
Dena Hickman	Stacey Horton	Virginia James	Amber Jones	Cathy Kirkpatrick	Stephen Lein	Josh Martin	Rick Mcfarland	Jonny Meyer
John Hicks	Linda Horton	Nicole Jastrzebski	David Jones	Janna Koon	Terri Leming Davidson	Mike Martin	Lindsay Mcgarity	Barbara Thomas Miers
K & J Hiegel	Suzanne House	Amanda Jennings	Nitin Kanaskar	Bill Koretoff	Jerry Lemon	Tama Martin	Donald Mcgowan	Lydia Miles
Tim Higgins	Ashley Howard	Sharmin Jennings	James Kane	Benjamin Krain	Birdie Lentz	Bristow Mary	Mandy Mckeehan	Christi Milhollnd
Linda Higgins	Jenece Howard	Zack Jennings	Jenny Karsten	Douglas Kratz	Stacy Leonard	Haley Mattox	Crystal Mckim	Chris Miller
Charlotte Higgins	Jessica Howard	Vicki Jewell	Milligan Kathy	Melissa Krueger	Sandie Lester	Brenda Maurer	Rebecca Mckinney	Ginger Miller
Lauri Hill	Elizabeth Howell	Witt Jim	Josie Keathley	Bob Kucera	Nicki Lester	Jackie Maxwell	Patsy Mckinney	Staci Miller
Arjay Hill	Mary-Phillip Howse	Lisa Johnson	Eric Keeler	Josh Kulak	Matthew Lewis	Mary Ann May	Mikel Mckittrick	Larry Millican
Richard Hill	Nathan Howse	Holly Johnson	Joyce Keithley	Chris Kyer	Edward Licher	Larry Maze	Michael Mclaughlin	Ellis Milligan
Janis Hillman	Margie Huckabay	Jessica Johnson	James Kelley	April Lafferty	Sandra Lloyd	Joel Mcafee	John Mclelland	Cecil Millikin
Chris Hinson	Teresa Hudson	Melissa Johnson	Tami Kelso	Robert Lake	Erin Logan	Patrick Mcatee	Katherine Mcmahon	Mike Mills
Crystal Hinson	Judy Huggins	Larry Johnson	Mike Kemp	Katherine Lamar	Richard Loghry		Gail Mcmanus	Janis Minick

Jeff Mitchell · Heather Mitchell · Angie Mitchell · Lynda Molton · Dawna Monroe · Whitney Moody · Kimberley Moody · Carrie Moore · Sara Moore · Sonya Moore · Ruby Moore · Don Moran · Chuck Morgan · Marsha Morgan · Misti Morgan · Bill Morris · Laney Morriss · Michelle Morton · Danielle Moseley · Ashley Mosley · Alex Moya · Linnea Munch · Nicole Murphy · Billie Ann Murphy · Dylan Murphy · Jim Murphy · Doris Murphy · Mark Musgrave

Megan Musgrove · Larry Myer · Justin Myers · Lyndsey Naekel · Shanda Nation · Kenny Nations · H.D. Nations · David Nations · Carrie Nault · Barbara Neal · Teena Neel Bebee · Trinity Neeley · Aaron Nelson · Heather R. Nelson · Vicki Nelson · Jeanne Nestler · Linda Newbury · Amanda Newby · Jeffrey Newman · Houser Nick · Tiffanee Noack · Ashlee Nobel · Carolyn Noble · Jeff Noble · Elaine Nolan · John North · Alfred Notter · Libby Nye

Kevin O'Brien · Carol Oberste · Edie Obryant · Donald Oconner · Brandy Ogden · Tina Oppenheimer · Suzanne Osborn · Crant Osborne · Laura Otter · Corbin Otwell · Trudy Owens · Marissa Page · Rozana Page · Stacey Paris · Charles Paris · Juanita Parker · Jo Anna Parker · Rhonda Parker · Dawn Parker · Leanne Parks · Dany Partlow · Jacob Partlow · Margarita Passmore · Angela Patterson · Patrick Patton · David Paulsen · Gerald R.R. Paulsen · Jennifer Peacock

Kevin Pearson · Rena Pederson · Lori Pennington · Sherry Perry · Amanda Perry · Josh Pettit · Charles Pharis · Kim Phelps · Amelia Phillips · Jodie Phillips · Kathy Diane Phillips · Don Phillips · Julia Phillips · Victor Phillips · Daniel Phillips · Kristie Phillips · Aaron Phipps · Catherine Piazza · Doug Pierce · Angela Pierce · Alise Piggee · J. David Pincus · Tia Pineda · Jennifer Pipes · Shelly Pittman · Linda Pitts · Stephen Plafcan · Dena Plaisted

Martha Poe · Erin Poerschke · Suellen Poole · Justin Porter · William Porterfield · Daina Potter · Patrice Potts · Russell Powell · Ladonna Powell · Jeanne Presher · David Price · Sherry Price · Alison Price · Don Procop · John Purdy · Jeff Putman · Brooklyn Pyburn · Sharon Pyle · Jonna Quarles · Susan Quattlebaum · Rachel Quinnelly · Becky Ragsdale · Brittany Rains · Matt Rains · Shannon Ramer · Dawn Ramsey · Dan Rankin · Allison Rasheed

Jody Rath · Ben Rausch · Leslie Ray · Jacquie Ray · Andrea Razer · Kathleen Rea · Mitzi Reano · Mandy Reed · Pamela Reed · Leann Reel · Stephanie Reinemann · Geoff Rennie · Christopher Rennie · Sandra Reves · Laura Reves · Mary Rhodes · Bobby Rice · Linda Richards · Hannah Richardson · Patricia Richardson · Sammi Ridgeway · Betti Rippentrop-Pridmore · Jean-Marie Riviere · Brad Roberson · Patricia Roberson · Michael Roberson · Jenny Roberson · Randi Roberts

Thomas Roberts · Lacy Robertson · Ken Robinette · Jason Robinette · Angie Robinette · Debbie Robinson · Denise Robinson · Belinda Rocco · Aaron Rodden · David Roe · Andy Rogers · Ashley Ross · Benjamin Ross · Tara Ross · Cj Ross · Kelly Rostagno · La Shaunai Rostagno · Teresa Rowton · Denis Rubaloff · Dede Rucker · Melanie Runion · Krysta Rupp · Dana Russell · Nickie Russell · Hannah Russell · Shelli Russell · Kristina Salazar · Krystian Samek

Ferdinand Samuel · Julie Sanders · Janet Sanders · Nichole Sanders · Elizabeth Sanders · Johnny Sanders · Shannon Sanders · Kecia Sandusky · Joe Schaffner · Laura Schnackenberg · Mary Schreiber · Ed Schuh · Shayna Schumacher · John Schwankhaus · Elaine Schwenker · Mona Scroggins · Cindy Seals · Marilyn Sealy · Karen E. Segrave · Jill Sewell · Jennifer Seymore · Amy Shadell · Annette Shankles · Brittany Sharp · Travis Sharp · Mary Shaw · Patricia Shay · Kerry Sheffield

Tonya Shelby · Donna Shepherd · Colleen Shepherd · Brian Sherrod · Horace G. Shipp · Jennifer Shoaff · Charity Short · Celeste Siegman · Clarice Siegman · Darryl Sigmon · Debbie Sikes · Jennifer Silva · Jeri Simmons · Jordan Simmons · Leslie Sims · Ashley Sindorf · Carie Siria · Tom Sisemore · Gaberial Sisney · Tim Sitler · Crystal Skinner · Kathy Slach · Christopher Smith · Samantha Smith · Sharon Smith · Josh Smith · Jennifer Smith · Margaret Smith

Jeni Smith
Juleah Smith
Heather Smith
Allen Smith
Anthony Smith
Cindy Smith
Aline Smith
Joe Smith
Teresa Smith
Pamela W. Smith
Tony Smith
Joanie Smith
Scott Smith
Matt Snider
Caroline Snodgrass
Katie Sollars
Hasan Sonmezturk
Brooke Sorrels
Jennifer Southerland
Judy Spahn
Graham Sparrow
Janet L. Speaks
Jayne Spears
Stephen Speer
Steve Spencer

Jack Spradlin
Julie Spratt
John Spurlock
Kimberly Squires
Scott Stafford
Scott Staples
Rebecca Jane Starnes
Brenda Staton
Elizabeth Stauffer
Shannon Steele
Steven Steinbrecher
Holly Stene
Keith Stephens
Marbie Stevens-Mitchell
Laura Stevenson
Debbie Steward
Jerry Stewart
Jason Stewart
Lisa Stewart
Cindy Stewart
Van Stiefel
Missy Stiles
Scott Stine
Jenni Stine
Brittany Stocklas

Julie Stone
Aaron Stone
Tim Stovall
Rebecca Stover
Aaron Street
Monica Strickland
Desha Strickland
James Strickland
John Strickland
Millie Strickland
Kathleen Strickland
Samantha Strong
Alison Suitor
Brenda Sulak
Judy Summers
Catherine Sumner
Kat Swann
Dudley Swann
Justin Swann
Brenda Swisher
Mickey Syzdek
Bre T.
Jennifer Tackett
Terri Talley
Doug Tanner

Matthew Tatus
Cindy Taylor
Kristen Taylor
Roger Taylor
Kay Taylor
Jim Taylor
Ashley Taylor
Cynthia Taylor
Rick Tedford
Linda Tharp
Richard Theilig
Benoit Thibault
Romona Thieme
Tiffany Thomas
Gary Thomas
Kasey Thomason
Cindy Thompson
Dwight Thompson
Amy Thompson
Monty Thompson
Diane Thompson
Rebecca Thompson
Stephen B. Thornton
Michael Thornton
Jeff Thostenson

Cyn Thrash
Jake Tidmore
Diane Tignor
Elsa Tilmon
James Timmer
Missy Todd
Shannon Tolleson
Jennifer Tollison
Renee Tompkins
Chad Truby
Allison Turner
Norma Tyree
Zina Underwood
Veronica Usery
Betty Ussery
Treata Vance
Amber Varn
Melida Vasquez
Teresa Vaughan
Amanda Vaughn
George Vaughn
Michelle Vest
Genevieve Villines
Bart Virden
Jeff Vitols

Bill Wagley
Teresa Wagner
Lyndal Waits
Frank Walker
Maryann Walker
Frances Walker
Shannon Walker
Jerry Wallace
Tracy Wallis
Jeremy Walter
Sarah Walter
Mary Walter
Matthew Ward
Kay Ward
Rance Ward
Christy D. Ward
Denny Warren
Rick Washam
K Waters
Vicki Watkins
Dan Watson
John Watson
Glen Watts
Charlotte Wayman
Craig Weatherford

Margaret Webb
Denny Webster
Cathy Weed
Mike Weed
Carrie Weindorf
Sarah Welch
Jennifer Wells
Patsy Wells
Jennifer "Jay" Welsh
Jennifer Welsh
Cindy Westacott
Kathy White
Audrey White
Stacey White
Laura Whitfield
Sharon Whitledge
Kate Whitman
David Whitt
Alison Whitten
Darrell Whittingham
Regina Whittington
Miranda Whorton
Carole Wilcoxen
Jerry Wilcoxen
Carrie Wilkerson

Amber Willard
Betsey Willbanks
Kenneathia Williams
Summer Williams
Harvey Williams
John Williams
Kristi Williams
John Williams Jr.
Erin Williamson
Dede Wilson
David Wilson
Scott Wilson
William K. Wilson
Whitney Wilson
Angela Wilson
Melissa Wilson
Monica Wilson
Jae Wilson
Misty Wilson
Kim Wilson
Christine Windsor-Parnell
Gina Wingo
Nita Wingo
Lauren Wiseman
Jane Witherspoon

David Wood
Kathryn Wood
John Wood
Michael Woods
Cheryl Woolfe
Michelle Woolverton
Ashley Woolverton
Heather Wray
Lavonna Wright
Penny Wyatt
Joyce Wycoff
Delores Wynn
Brandy Yates
Cheley Yielding
Donna Young
Jim Young
Melanie Young
Ashley Young
Stephanie Youngblood
Kenneth Zelnick
Rivka Zemke
Larry Zeznanski
James Zimmerman
A.J. Zolten

If you like what you see in the book and on the companion DVD, be sure to check out these photographers' Web sites. A few even sell prints so you may be able to snag your favorite photos from the project to hang on your wall.

Michael Adam
mike-photos.smugmug.com

David Albritton
mymochalady.com

Robert Alexander
bign.com/teamnational.aspx?site=rca

TRUE Alisandre
smoothyogabytrue.com

Jamie Allbritton
printscharmingimages.com

Marty Allen
imagesoutside.com

Katy Allison
flickr.com/photos/runningonsunshine

Matt Almond
myspace.com/mattitudeness

Terry Anderson
reeditphoto.spaces.live.com

Lisa Archer
labelladaisystudios.com

Emma & Sarah Bailin
doubletroublets.com

James Baker
flickr.com/photos/jim-ar

Pearl Baker
rainbowheightsphotographyandart.com

Christopher Ballard
ballardcustomworks.com

Quiche Baltimore
associatedcontent.com/quiche

Ben Bandimere
exposuresunlimited.deviantart.com

Chris Baran
possiblybob.com

Candy Barnes
candybarnes.net

Ronald E. Barnett
myspace.com/riverron60

Paul Barrows
flickr.com/photos/haildriver

Jeff Bartlett
caves.org/grotto/lrg

Delani Bartlette
scryberwitch.wordpress.com

Stacey Bates
sabatesphotography.com

MI Baxley
mlbaxleyphotography.com

Betty Beckham
webpups.com

Tony Bell
flickr.com/photos/7829861@n08

Kamryan Bennett
myspace.com/nayrmak

Jack Benson
jackbenson.com

Melissa Bickerstaff
dostafflabradors.com

Alissa Bittner
adventures.smumug.com

Sara Blancett
sarablancett.com

Joan Blocker
designplusofnea.com

Chird Bobbitt
bobbittville.com

Daniel Boyd
boydbirds.com

Jennifer Boyett
flickr.com/photos/jenniferboyett

Brandy Brazeale
myspace.com/brazealenuts

Amy Bryant
gloverbryant.com

Amy Bryant
arkansasfamilyfun.com

Clay Bumpers
cbumpers.blogspot.com

Robert Burazin
kbphotomagic.com

Kaye Burazin
kbphotomagic.com

S. H. Bill Burgin
burgin.info

Brian Burke
314images.blogspot.com

Daniel Burkhead
flickr.com/photos/danielburkhead

Patrick Burnett
patrickburnett.com

Chris Burns
burns529.blogspot.com

Jason Burt
jasonburtphoto.com

Ryan Bush
familybush.com

Michael Caldwell
7cobra.com

Ian Caple
flickr.com/asphyxxed

Bastien Carel
bastiencarel.com

Stephen Carter
stephencarterphotography.com

Deb Carter
eyefetch.com/profile.aspx?user=deb76

Kevin Causey
florissantchurch.org

Johnnie Chamberlin
flickr.com/photos/johnnie

Naomi Chambers
cherryredlipstickandlace.com

Tiffany Chiu
flickr.com/photos/tchiu22

John Citron
jonpierre.smugmug.com

Brandi Claussen
texanweddings.com

Charles Clogston
charlesclogston.home.comcast.net

Jennifer Cole
myspace.com/claynjen

Jackie Collie
petsrockphoto.com

Leslie Coop
youravon.com/lcoop

Mike Cooper
mikecooperimages.com

Brian Cormack
cormackphotos.com

Claire Marie Cosmos
badchair.net

Brad Cossey
myspace.com/bracomadar

Jason Crader
arkansasphoto.com

David Craton
davidcraton.com

Casey Crocker
myspace.com/caseycrockerphoto

Jeff Dailey
flickr.com/jeffdailey

John Davidson
bomber65.zenfolio.com

Chris Davidson
lostriverphoto.com

Brandy Davis
ekioart.etsy.com

Paul Michael Dellostritto
dellostritto.com

Greg Disch
gregdisch.com

Kendrick Disch
kendrickdisch.com

Teresa Dollar
capturethemoment.biz

Kristine Duncan
kristineduncanphotography.com

Wendy Dunn
wendydunnphotography.com

Kristie Dusharm
mycmsite.com/kristiedusharm

Charlene Eason
charleneeason.ifp3.com

Kristi Eddington
princesskphotography.vpweb.com

Aimee Elardo
myspace.com/raimo321

Matt Erickson
flickr.com/photos/arkansasflying

Bill Evans
billevansphotography.smugmug.com

Donna Evans
realliferealart.smugmug.com

Robert Farmer
betterphoto.com/gallery/free/bio.asp?memberid=236137

Monda Fason
ohtheresjustnotelling.blogspot.com

Gary Felker
naturalimaging.com

Jim Finch
jfinchphotography.com

Madison Forbes
savearrebella.deviantart.com

Chip Ford
lovelycitizen.com

Chastity Forrester
myspace.com/xtearsofpainx

James Fortune
naturalstatephotography.com

Tim Foster
fostercustomknives.com

Shane Foster
carsynfoster.com

Craig Fraiser
pbase.com/cmf46

David Frazier
dfrazierphoto.com

Richard Friedle
rickfriedlephotos.com

Linda Fulkerson
picasaweb.google.com/lindafulkerson

Tena Furnish
tena-aroundhere.blogspot.com

Amanda Galiano
littlerock.about.com

Kori Gammel
krgphotography.com

Kristen Gann-Lyons
flickr.com/photos/xoxok

Jim Gaston
jimgaston.com

Doc George
pbase.com/docg

Dsavannah George-Jones
dsavannah.com

Deirdre Gibson
my2blondeangels.blogspot.com

Mark Givens
myspace.com/mainstreeteldorado

Danny Godfrey
godfreyimages.blogspot.com

Johnni Goggans
gogganshotography.smugmug.com

Pat Gordon
saddlebagspress.com

Bryan Gossett
renshawfirm.com

Barbara Grassi
lakehamiltonrealty.com

Amy Green
thepixelgallery.net

Willa Gregg
web.mac.com/willagregg/willaworld

Paul & Lori Ann Gregory
simplemakes.blogspot.com

Sandi Griffin
pbase.com/sandig

Carla Grimmett
blackplanet.com/seejaykaygee

Kerry Guice
kerryguicephotography.com

Dianne Guidice
new.facebook.com/profile.php?id=1286685406

Damon Hair
flickr.com/photos/dhair

Heather Halbrook
deviantart.com

Karla Hall
exploringarkansas.blogspot.com

Mike Hall
enjoyarkansas.blogspot.com

Beth Hall
bethhallphotography.com

Erin Halvorson
melissagracegallery.com

Danny Harris
dannyharrisphotography.com

John Harris
harrisfamilygroup.com/jhharris.html

Grant Harrison
grantharrison.com

Diana Hausam
dianamichellefineart.com

Derek Henderson
flickr.com/derekhendersonphotography

Jane Hill
veritasphoto.com

Tom Holland
flickr.com/photos/livenow

Robyn Holland
myspace.com/punkinmuffin

Teni Hollingshead
sonriseranch.net

Bill Houghton
billhoughtonphotography.com

David Huff
mrnaturalbirdhouses.etsy.com

Jim Hughes
flickr.com/photos/tater48gem

Harold Hull
digitaleyeimages.com

Dorothy Imhauser
daimhauser-art.com

Kara Isham
wewantbliss.com

Heather Jacimore
redbubble.com/people/sophia071

Rod Jacobs
flickr.com/photos/74465517@n00

Mark Jacobs
markjacobsphotos.com

Glenna James
glennphotos.net

Brian Johnson
flickr.com/photos/flickrhawk

Julian Jones
myspace.com/juliworldforever

Emily C. Jones
emilycjones.com

Susan Jones
crossheart-ranch-natural-horse-training.com

Ronda Jones
myspace.com/rondaveooh

Amy Jones
amy-design.smugmug.com

Mike Jones
jmjimages.printroom.com

Neil Jones
nxphotos.info

Kirk Jordan
mightyworksproject.blogspot.com

Vicki Keene-Donaldson
keenesphotography.smugmug.com

Debbie Kelly
flickr.com/photos/debkel

Alex Kent
alexkentphoto.com

Carson Kindy
flickr.com/photos/wild_sh0t

Emilie Kinney
hhmmc.org

Dixie Knight
dixieknightphoto.com

Jason Kratz
jasonkratzphotography.com

Alyce Lachney
alycemarie.com

Diana Ladmirault
photographybydiana.photoreflect.com

Cecilia Lambert
cecilialambert.wordpress.com

Patrick Lanford
patricksprints.smugmug.com

Amber Lanning
lanningphoto.com

Mary Larmoyeux
marymaywrites.com

David Lewis
pbase.com/arkie5700

Timothy Lim
flickr.com/photos/ninjaphotos

Bob Lincoln
carolynskeyboardcorner.com

David Lindsay
myspace.com/deadlikeme62

Rex Lisman
flickr.com/photos/rexlisman

Amber Logan
flickr.com/photos/picsbyamber

Kaylie Long
kaylieslens.blogspot.com

Rachel Love
rachelloveministries.com

Letha Mahan
lethamahan.com

Paul Mansfield
logoweardirect.com

Gary Marshall
garophotography.com

Cheryl Mauldin
mauldinphotography.com

Delos Mccauley
home.cablelynx.com/~edelos

Matt Mcclellan
mcclellandesigns.com

Callie-Anne Mcclure
myspace.com/camphotography

Mark Mccrary
myspace.com/markmccraryphotography

Alexis Mcdade
myspace.com/lexinicole23

Kyle Mclaughlin
studiokgm.com

Ashley Mclelland
flickr.com/photos/ashleymacky

Michael Mcmurrough
pbase.com/mcmurma

Lilyan Mcnutt
flickr.com/photos/21017150@n08

Wayne Meddley
koolpages.com/obrien

Lyle Melton
meltonfamilylife.com

Jennifer Merriott
flickr.com/photos/jamer82

Jeanne-Marie Meyer
obscuraphotography.com

Gale Miller
memoriesbygale.smugmug.com

Stephanie Miller
web.mac.com/stephmiller1214/site/welcome.html

Richey Miller
clearchoicephoto.com

Charles Mills
freewebs.com/afathersson/index.htm

Darin Mitchell
mitchellresidentialdesigns.com

Steve Mitts
freewebs.com/stevemitts/index.htm

Mark Mondier
parabola-pop.deviantart.com

Jeff Montgomery
jeffphotos.blogspot.com

Sharon Morris
betterphoto.com/gallery/gallery.asp?memberid=154789

Dan Murphy
danmurphy.photoreflect.com

Ron Murray
myspace.com/rmurray1967

Eric Naron
ericnaron.fototime.com/welcome

Rick Nation
ricknation.com

Curtis Neeley
curtisneeley.com

John Nelson *jnphoto.printroom.com*	Jimmy Poor *home.alltel.net/firechief/photo1.htm*	Charity Sherwood *flickr.com/photos/silhouettesgem*	Mark Stallings *arkansaswild.com*	Bryan Thornhill *freelanceshots.com*	Darcie Westfall *the-drc.blogspot.com*
Bill Nesbitt *williamanesbitt.com*	Mary Antionette Powell *community.webshots.com/user/mapwest*	Aerial Heli Shots *aerialhelishots.com*	Gwen Stanley *gwenstanleyphotography.com*	Jan Titsworth *jantitsworth.com*	Todd Whetstine *twhetstinephoto.smugmug.com*
Chris Newberry *flickr.com/photos/cal34*	Melodye Purdy *purdyartco.com*	Bob Shull *bobshull.com*	Rodney Steele *pbase.com/steeleumc*	Jen Townsend *jpiphotography.com*	Anna Wiles *flickr.com/photos/a-e-w*
Gayle Nicholson *flickr.com/photos/gayle_n*	Patricia Rains *myspace.com/circlesofglory*	Kris Sikes *beatenpathrecords.com*	Pam Steele *steelecustomphotography.com*	Stephanie Treat *treatsphotostudio.ifp3.com*	Joseph Williams *jwphotoco.com*
Julia Noble *jnoblephotography.blogspot.com*	Cynthia Rankin *crankinphotography.com*	David Simmons *flickr.com/photos/davidsimmons*	Drew Stephens *thisisdrew.com*	Michael Troeger *flickr.com/photos/nuttyirishman*	Robert Williams *flickr.com/photos/30292675@n00*
Dustin Obenchain *stoic.110mb.com/eoto*	Louis Riviere *lacasting.com/louisriviere*	Stephanie Sims *myspace.com/luvs_and_hugs_steph*	Michael Stewart *snapshotdigitalimaging.com*	Christopher Troeger *artheon.net*	Deann Williams *myspace.com/malvernreagent*
Alex Ojeda *alexojeda.us*	Dotti Robinette *flickr.com/photos/dottispics*	Phom Sisoukrath *phomphotography.com*	Jeannie Stone *blesstheirbones.blogspot.com*	Don Turney *goodsamclub.mytripjournal.com/turneytravels*	Krisha Williams Turbeville *blogs.arkansasonline.com/rescue*
Amber Oliver *myspace.com/0oamber_leigh0*	Dominic Rossetti *dominicrossetti.com*	Jacob Slaton *jakefreedomphoto.com*	Kristen Stone *flickr.com/photos/simply_kristen*	Ron Tyne *woodlandsedge.com*	Michael Wilson *myspace.com/razorbacks07*
Aaron Osborne *arkansasimages.smugmug.com*	Richard Ryerson *richardryerson.com*	Carson Smith *flickr.com/eggwithcheese*	Nicole Strickland *capturedbynicki.com*	Tim Vahsholtz *shutterthat.com*	Angela Wiser *flickr.com/photos/happyangei*
Heather Owens *heatherowensphotography.com*	Daniel Sample *samplephoto.net*	Todd Smith *toddmikelsmith.com*	Patrick Studer *studerphoto.com*	Gloria Vaughn *ggphotography.com*	Rusty Wood *eyefetch.com/profile.aspx?user=rusty*
Todd Owens *toddowensphotography.com*	Andrea Sanders *madewithloveorgonics.com*	Illine Smith *eyefetch.com/profile.aspx?user=illine*	Shannon Sturgis *flickr.com/photos/shannonsturgis*	Joe Villines *joevillines.com*	Harold Wright *flickr.com/photos/99346152@n00*
Bill Patterson *bluedogphotos.com*	Shauna Sanders *flickr.com/photos/shaunalea*	Becca Snider *justacrazywoman.com*	James Sybrant *flickr.com/photos/12150004@n03*	Jo Walters *nonnajoann.blogspot.com*	Chris Wright *flickr.com/photos/baronsquirrel*
Madeline Phillips *mruthp.blogspot.com*	Jennifer Sanders *myspace.com/karmajenn*	Sydni Sosebee *nwatraders.com*	Kerrie Szabo *kerrieszabophotography.com*	Lance Waters *watersandwatersrealty.com*	Carolyn Wright *community.webshots.com/user/ccwri?vhost=community*
Chris Phillips *cherished-pixels.com*	Jonas Schaffer *flickr.com/photos/ltb*	Lori Sparkman *lorisparkman.com*	Phil Tappe *flickr.com/ptappe*	Rebekah Watts-Mandelli *rogerdodgerinc.com*	Diane Ziemski *dianeziemski.com*
Bridgette Piggee *myspace.com/1busyb*	Sabine Schmidt *flickr.com/photos/sabineschmidt*	Joe Sparks *staticsparks.com*	Byron Taylor *byrontaylor.com*	Pris Weathers *arkansasties.com*	
Marianne Pitchford *pitchfordjourney.blogspot.com*	Brad Schnackenberg *bschnack.blogspot.com*	Kathryn Speer Whittamore *flickr.com/photos/kaykayzowie*	Katherine Taylor *katiedidproductions.com*	Melanie Wedige *myspace.com/melmel_73*	
Tiffany Poe *myspace.com/tiffanynicolepoe*	Peri Seward *myspace.com/photoperi*	Rebecca Spencer *allenhousetours.com*	Corrinne Taylor Horne *flickr.com/teacup/photos*	Richard Wells *yessy.com/as_i_saw_it*	
Meredith Poland *captionsphoto.com*	Melissa Shannon *myspace.com/missygab*	Tanya Spillane *web.mac.com/tanyaspillane*	Amanda-Lauren Thomason *photoblog.com/amandalaurefoto*	Kenna Westerman *photosbykenna.com*	

Prize Winners

When picking from 32,358 photos, it's difficult to nail down what separates the best photos from the rest — especially when so many photos are so good. To help, we enlisted thousands of local folks to vote for their favorite shots. The response was epic: More than 1.75 million votes were cast. The voting helped shape what would eventually be published in this book. Please note *Arkansas Democrat-Gazette* photographers were not eligible for prizes. Along the way, the votes produced the prize winners below. Beyond the obvious and self-explanatory prize categories (Editor's Choice, People's Choice and Most Loves), there are a few we ought to explain:

Consensus Best: This is a combination of the voters' will and our editors' will, so it was a well-balanced and prestigious award. A complicated algorithm determined a photo's score. This award took the photos the algorithm deemed great and pushed them to the top of the pile. Then our editors picked their favorite of that batch. In essence, it's the best of the best.

Secret Surprise: Every contest needs a wild card. This is ours. We'd tell you what the parameters were, but we didn't know ourselves. At some point a photo jumped out as the obvious Secret Surprise winner, and boom! A winner. Obviously, it's gotta be good, but other than that ... no real parameters.

The Stable One: This award goes to the photo that stays near the top of the pile for the duration of the contest. It may never be the photo with the most "dig it" votes, or the most loves, or the best score, but it's a photo that has stuck around near the top for a long time.

Ninth Best: This award goes to the photo that garnered the ninth most "dig it" votes in a chapter. Why ninth place? We've all seen the first-place, blue, fancy-pants ribbon, and the second-place one, and third, and fourth, and so on. We've even seen an eighth-place ribbon. But we've never seen a ninth-place ribbon. Have you? We think it's time ninth place got some recognition..

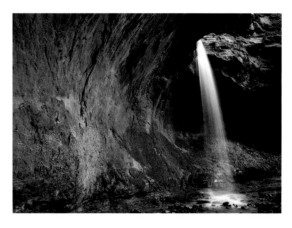

GRAND PRIZE WINNER
PHOTO BY HAROLD HULL
cover

Sponsors

Arkansas Democrat Gazette
Arkansas' *Largest* Newspaper

The *Arkansas Democrat-Gazette* is Arkansas' only statewide daily newspaper, reaching more than 700,000 readers each week. By staying true to quality journalism, the *Arkansas Democrat-Gazette* remains the primary news source for Arkansans and the primary advertising source for businesses. This commitment to quality has made the *Arkansas Democrat-Gazette* the No. 1 newspaper for Sunday city zone penetration in the United States. Its circulation ranks among the top 10 newspapers for the region, which includes the *Houston Chronicle* and the *Kansas City Star*.

For more information, visit www.arkansasonline.com.

ABRY BROTHERS

Abry Brothers is the oldest foundation and structural repair company in the country and specializes in raising, foundation repair and shoring houses. Abry Brothers has a mega-pier lifetime warranty foundation warranty. The company began operations in 1840 in New Orleans by John G. Abry, a skilled shorer. In 1860, his son, Emile, joined him. Emile's three sons joined the company at the turn of the century. Six generations later, Abry Brothers continues to provide high-quality foundation and structural solutions to all kinds of buildings throughout the southern United States.

For more information, visit www.abrybrothers.com.

BEDFORD CAMERA & VIDEO
FUJIFILM

Bedford Camera & Video offers the very latest in the world of pictures, including the state's largest selection of traditional cameras, digital cameras, camcorders and an incredible selection of accessories. Bedford specializes in offering great value, including selection, convenience, quality, price and service. Bedford has a well-earned reputation for providing only the highest quality film processing in only 29 minutes! This service is available from traditional film and from "digital film."

In 1974, Bedford Camera & Video began operations in Springdale and has now expanded to include locations in Fort Smith, Rogers, Fayetteville, Little Rock and North Little Rock.

With a 30 year history under the direction of CEO Stan Bedford, Bedford's has become Arkansas' largest camera store chain, a "picture perfect" portrait of fast growth, in a state famous for opportunity.

For more information, visit www.bedfords.com.

CENTRAL ARKANSAS LIBRARY SYSTEM

The Central Arkansas Library System, the state's largest library system, offers a diverse and ever-changing presence in Little Rock and surrounding communities.

We serve the residents of Pulaski and Perry counties by offering resources for reading, studying and using library materials and meeting facilities. Audio-visual items, a variety of databases, genealogical resources, research assistance and computer and Internet access are also available. Programs are held for children and adults including a variety of book clubs, story times and lecture series. The programs held by the Central Arkansas Library System are free and open to the public.

Twelve branches are convenient to residents of Jacksonville, Little Rock, Maumelle, Sherwood and Perry County. The Central Arkansas Library System is on the cutting edge of technology and is constantly looking for ways to improve services for our patrons.

For more information, visit www.cals.org.

Deltic Timber Corporation

Deltic Timber Corporation is a natural resources company focused on the environmentally responsible management of its land holdings. In addition to owning more than 438,000 acres of timberland, the company adds value to Arkansas by developing residential and commercial real estate in Little Rock at Chenal Valley and Chenal Downs and in Hot Springs at Red Oak Ridge.

Deltic practices sustainable forestry management and is certified by the Sustainable Forestry Initiative (SFI). Practices include reforestation, protection of water resources, forest and soil health and the protection of wildlife habitats.

In addition, the golf courses at Deltic-owned Chenal Country Club are designated as a Certified Audubon Cooperative Sanctuary by Audubon International, making Chenal the only golf course in Arkansas, and one of only 535 courses in the world, to receive the honor.

Headquartered in El Dorado, the publicly held company is traded on the New York Stock Exchange under the symbol DEL.

For more information, visit www.deltic.com.

PC HARDWARE & MACHINERY / LIGHT INNOVATIONS

PC Hardware and Light Innovations are decorative hardware and lighting showrooms that offer a full line of decorative cabinet and door hardware, plumbing fixtures, fireplaces, light fixtures and ceiling fans. Established in 1949, PC Hardware has the quality products and expert staff to help with any project from new-home construction to a single-room remodel. The lighting showroom is American Lighting Association-certified, and the company also provides staff certified through the American Lighting Association who will review your house plans, work one on one with customers and help simplify the selections process from a vast array of fixtures that will satisfy any customer's indoor and outdoor lighting needs.

For more information, visit www.light-innovations.com.